God's Eye:
Aerial Photography
and the Katyń Forest
Massacre

By

Frank Fox

Winged Hussar Publishing

God's Eye: Aerial Photography and the Katyń Forest Massacre by Frank Fox
Cover artwork by: Rafał Olbiński
Images accompanying this text courtesy of Władysław Godziemba-Maliszewski. From
his work *Katyń: An Interpretation of Aerial Photographs Considered with Facts and
Documents*. Copies of this work may be obtained from W. G. Maliszewski at 73 Plum-
trees Road, Bethel, CT 06801

First published in 1999
This edition published in 2021

Winged Hussar is an imprint of Winged Hussar Publishing, LLC

Winged Hussar Publishing, LLC
1525 Hulse Rd, Unit 1
Point Pleasant, NJ 08742

Copyright © Winged Hussar
ISBN 978-1-950423-65-1 PB
ISBN 978-1-950423-79-8 Ebk
LCN 2021946579

Bibliographical References and Index
1. History. 2. Poland. 3. World War II

Winged Hussar Publishing, LLC All rights reserved
For more information
Visit us at www.wingedhussarpublishing.com and www.whpsupplyroom.com

Twitter: WingHusPubLLC
Facebook: Winged Hussar Publishing LLC

Contents

Acknowledgments to the
1999 Edition

I owe more than words can express to two friends whose knowledge of the subject and commitment to historical truth spurred me on to complete this work. Aerial photography expert Wacław Godziemba-Maliszewski and historian Simon Schochet sacrificed many hours to assist me, though I hasten to add they are not responsible for any errors that may have crept into this study. I would also like to pay personal tribute to Professor Janusz K. Zawodny, who at great personal risk alerted the world to the truth about the "Katyń forest" massacre.[1]

I am grateful for the support given me by Bill Anderson of West Chester University publications and his staff. To Professor Walther Kirchner who read an earlier version of the manuscript and who in his long and distinguished career as a teacher never ceased to await results of his patient tutelage, I offer this study as a recompense, albeit a partial one. To my daughter Nina, who has always asked me to find subjects other than massacres to write about, I can only say that historians describe such events so that there may be a future without them. To my son Julian, whose computer skills (and helpful criticisms) have been invaluable in all my writing efforts, I offer grateful thanks. To my patient wife Anne, a fellow writer, my personal reward was the smile on her face when I told her that I had found a publisher. To Rafał Olbiński, a premier illustrator whose talent and friendship I treasure, my thanks for the cover which illustrates this work. Peter Obst, a writer and friend, provided invaluable assistance in preparing the book for printing. Diana Burgwyn read the manuscript and helped improve it. Finally, I dedicate this work to the many who died a cruel and lonely death in that "inhuman land."

[1] It should be understood throughout this manuscript that "Katyń forest" includes sites other than the area cited here (and in other works) as "Katyń."

Preface

1999 was the year of Kossovo. The horrors of that war had been fore-shadowed by the earlier conflict in Bosnia - and both were photographed from the skies. On August 9, 1995, Madeline K. Albright, the chief American delegate to the United Nations, presented to the Security Council a pair of photographs taken by a U-2 "spy" plane. The first showed Muslim "safe areas" of Srebrenica before July 11, the day when this enclave fell to Serb forces. The photograph included an empty field. The second image taken after the town was captured highlighted the same field with the telltale signs of freshly dug and hastily covered surfaces. As for Kossovo, NATO officials released in April 1999 a surveillance photograph that showed Serb forces in the act of "ethnic cleansing" - homes destroyed and villages cleared of inhabitants with what was described as "grim efficiency." On May 19, it was reported that NATO was examining satellite photography in order to determine whether Serb forces were digging up mass graves and rebury-ing the remains. On June 7, the Associated Press reported that stalling on pullback was "to eliminate evidence of war crimes." Now that Kossovo is empty of its death-dealing invaders(except for those who still perpetrate and will undoubtedly continue individual acts of vengeance) those who return find numerous mass graves. The International Crimes Tribunal for former Yugoslavia is ready to do its grim investigative work. Aerial photographs will be an essential tool.

Fifty-five years ago, aerial photography provided a record of history's worst crime. On June 26, 1944, a South African Air Force *Mosquito* flying out of an allied air base in Italy passed over the majestic Alps on the way to Auschwitz. But the complex of concentration camps located along the Sola River in south central Poland was not the target of this photo recon-naissance mission. Several miles from Auschwitz were the Buna works built by I. G. Farben for the manufacture of fuel, rubber and other synthetics. Sweeping the countryside and using large-lens split verticals to include as much of the area as possible, the cameras automatically photographed the Auschwitz-Birkenau death camps. It was, as Roy M. Stanley wrote in his remarkable book *World War II Photo Intelligence,* "an unexpected bonus

coverage." The series of photographs, some of which were made a few days before the camps were liberated, were not made public until 1978, when one of CIA's most experienced photo interpreters, Robert G. Poirier, with the assistance of Gino Brugioni (who discovered the sites of Russian missiles sites in Cuba), decided to look again at the I. G. Farben wartime photography. They knew that the death camps were in direct alignment with that plant, and since the plane's cameras were turned on before the target was reached, they were confident that the concentration camps would be on those photographs. They found a treasure trove of horror. There were twenty cans of films (with about 200 - 250 exposures in each can), clearly showing evidence of gassing and cremation, undeniable proof of the "conveyor-belt" murderous enterprise that was Auschwitz-Birkenau. Fifty-five years has dimmed world's memories, but the photographs were still clear. They showed lines of people lined up at crematoria, the nicely landscaped quarters for those administering the killing process, the roofs empty of snow on the barracks of those still alive and the snow-covered roofs of the medical bloc whose inmates had been put to death. An analysis of some of the key photographs makes one an impotent witness to horror. A photo taken on August 25, 1944, shows a transport has just arrived. Matching it with German and survivor records what one sees are Jews from the Łódź ghetto about to be exterminated. Groups of people are moving from the rail cars to the men's and women's camps. In consecutive pictures the lines of these condemned people end where there is no gate. The only exit leads to the gas chambers and crematoria. The photographs of Birkenau displayed the effects of a revolt the preceding year - one of the gas chambers had been destroyed and two were being dismantled. The condemned did fight back.

Unlike the images from Auschwitz, the photographs from Bosnia and Kossovo were not hidden from the public, but while they provide us with a historical record they are still in the service of leaders and states whose interests may not be to find and punish the perpetrators. The fact is that while the technology available to surveillance today - U-2 planes, spy satellites, video recorders in *Predator* drones and RC-135 *River Joint* that can monitor communications on the battlefield - their usefulness in preventing mass murder or at the very least punishing those responsible, is limited. Governmental secrecy about intelligence gathering sometimes serves interests of bureaucracy more than those of justice. The twentieth century has recorded millions of brutal deaths as well as unprecedented attempts to eradicate or hide traces of mass murder. In recent times, Cambodia, Srebrenica in Bosnia, Sri Lanka, Chile, Guatemala, Honduras, the killing grounds in Africa and the province of Kossovo are proof that the end of Nazi and Soviet dictatorships did not put a stop to massacres and efforts to conceal them. But if perpetra-

tors cannot always be punished it is imperative to find proof of their crimes and at the very least to search and identify victims' remains so that the dead may be honored.

Of all crimes in World War II, the most puzzling has been the massacre in Katyń forest. Not until the fall of the Soviet Union did the new leaders of Russia acknowledge that their government ordered the murder of 27,000 Polish soldiers and civilians. The painstaking and unheralded work of a young Polish-American photo-interpreter has been crucial in this investigation. Wacław Godziemba-Maliszewski came across a hoard of German aerial photographs at the National Archives and began to unravel one of the most closely guarded secrets of the Russian intelligence services-the burial sites for the Polish officers. For the past ten years he has been supplying the Polish government with information that has enabled it, in spite of opposition and interference from the Russian side, to locate many of the remains. It is particularly important for the American public to read this record at a time when American treasure and trust are being invested in a Russia whose leaders until recently concealed the truth about Katyń.

This book is not only about lives cruelly extinguished, but also about the few who have struggled to honor the dead with truth. Professor Janusz Zawodny, the dean of Katyń studies, is one of the few. He told me recently of his trip to Spain to find burial places of Polish lancers who sacrificed themselves at the Somosierra pass during the Napoleonic Wars, thereby opening the road to Madrid. He said: "I always speak for those who can no longer speak for themselves." This spirit has led him to "speak" for the dead in Katyń forest. He has been an inspiration to others and particularly to Maliszewski.

This work should serve as an antidote to those who see contemporary history as a record of failure for individuals who fight against a faceless bureaucracy. The achievements of Maliszewski show us how in a struggle between the expediency of state power and moral principles, the dedication of one person can make a difference.

Frank Fox
Merion Station, Pennsylvania

Introduction

In April 1943, the German forces that had occupied the Katyń forest in the area of Smolensk since 1941, discovered, exhumed and reburied approximately 4,000 Polish officers. The medical examinations proved conclusively that these murderswere committed in 1940 while the area was under Russian control. While Germanpropaganda used the discovery for its own purposes, the Russians blamed Germans for the mass murder and saw an opportunity to break off relations with the Polish government-in-exile that vainly sought an International Red Cross investigation of this atrocity. Prime Minister Winston Churchill for whom the wartime alliance was paramount was unwilling to say that the Russians were responsible.President Franklin D. Roosevelt took Stalin at his word.

As World War II was coming to an end, a cache of millions of German war photographs was found in Bad Reichenhall and promptly sent to America to be analyzed by the intelligence services. These films were part of a 1946 Anglo-American project whimsically code-named Dick Tracy. The captured materials, images gathered over the British Isles, Central and Eastern Europe, Balkans and the Middle East, were assembled in Medmenham, England, the very efficient wartime center of photographic intelligence. Within that index there were individual photographs with geographical coordinates. Still in their original boxes with the mylar overlays kept separately, they framed a flight plan of a particular area and gave the time of day, and other technical data. Known as the GX series, these photographs were eventually deposited at the National Archives. It was within the GXfile that Robert G. Poirier, one of CIA's most-experienced photo interpreters made a startling discovery.

Poirier assumed that German photography of Smolensk might also encompass the area of Katyń forest, only 13 kilometers from the city. Smolensk was an important rail center for the German forces, and Poirier foresaw correctly that the Luftwaffe would photograph it at various times: before the 1941 invasion, after they were in possession of the area (that is until 1943) and following their retreat. He discovered in the GX films that Germans flew as many as seventeen sorties over the site between July 9, 1941, and June 10, 1944. The majority of prints were made after the region was recaptured by the Russians in late September 1943. These photographs,

would, in Poirier's words, allow an insight into the history of Katyń "never meant to be seen."

According to Poirier, there were no differences in the films taken between July 9, two weeks after German the invasion of Russia, and September 2, 1941. But as of September 2, 1941, when the Russians still held the area, there were visible changes in vegetation in the area of Katyń forest and nearby woods that suggested intentional disruption. In February 1943, the same month that Germans suffered the catastrophic defeat at Stalingrad, their 537 Signal Corps Regiment billeted at Gnezdovo located the Katyń graves and proceeded with exhumations. The bodies of the Polish officers were then reinterned in four large graves and a monument was placed there. The Germans took no aerial photographs over the site until after the Russians recaptured the territory in September 1943, but images taken by the Germans in October 1943 show that the area of the mass graves had again undergone considerable alteration. The German memorial to the Polish dead officers could still be seen, but a comparison of aerial photographs with those taken on the ground showed that the Russians had begun to dismantle the crosses placed there the preceding April, and that they were ready to dismantle the monument and level the burial mounds. Successive German photographs showed that by January 30, 1944, the area of the existing mass graves had been cleared and a new monument erected in time for the joint ceremony involving Polish forces led by General Zygmunt Berling, a lieutenant-colonel in Poland before the war who accepted war- time service under Russian command.

Poirier's analysis of the Luftwaffe photographs was not only proof that a crime had been committed, but that the Russians had made extraordinary efforts to conceal the evidence - the bodies of the Polish officers. A Luftwaffe image of April 28, 1944 revealed the presence of a new Russian monument and showed that a major excavation had taken place near it. A bulldozer and striation marks made by the blade could be seen within a dugout pit. It was clear that the existing grave had been excavated and the bodies of the Polish officers removed. As Poirier noted in his startling analysis, this photograph was never made public, even though it had been in the possession of our government since 1945. The photograph of April 28 also showed many new open trenches at the old grave site and shovel marks indicating a considerable effort to locate more bodies. Photographs taken on the May 12 and 28 confirmed a sizable enlargement of the previously cleared area and the filling in of the pit seen excavated in the April 28 image. The change in the depth of that pit could be ascertained by the angle of shadows as well as loss in stereo depth.

The story of the Russian bulldozer explains a great deal about the Russian way of life and death. The NKVD had used the Caterpillar bulldozer to bury and exhume at Katyń, as well as at other places of mass burial, such as Kuropaty and Vinnitsa. There had been a shortage of bulldozers in Russia as a result of Stalin's efforts to collectivize farms. American industrialists, particularly the Caterpillar Corporation of Peoria anxious to do business with Stalin sent him a sample of their wide-track bulldozer. Stalin thanked them, kept the sample, and had copies of the machinery made in the Urals and at Kharkov. These were faithful reproductions of the original, except that in place of the word *Caterpillar* embossed on front of the machine the Russians affixed the sign *Stalinets*. When the Germans retreated many pieces of machinery were destroyed or rendered useless, but enough were left so that the Russians could use them in ways never imagined in Peoria.

• • •

The Germans continued to photograph the Katyń area in the summer of 1944 because of its close proximity to Smolensk and vital rail links. The images of June 2 provided the last glimpses of the forest before the advancing Russian troops drove deep into German-held territories. There were objects in the area of the grave sites that appeared to be lampposts. A truck was parked near the site. The pit photographed on April 28 was now filled. Poirier concluded that prior to April 28, 1944, the Russians conducted large-scale excavations, but removed or destroyed not only bodies but also the monument they had placed there. He wrote that the numerous holes and trenches dug in the area suggested the use of lime pits as the Russians discovered additional graves. The erection of a building, lighting system and fences, clearly involved considerable personnel and machinery.

Poirier summarized that the "search for new graves ... combined with the back-filling of the grave site found earlier by the Germans ... suggested a calculated effort to obliterate evidence of a gross misdeed." The urgent character of the Russian activities at Katyń at a time when they were involved in a life-and-death struggle with the German invaders, showed graphically how important this deception was to Stalin and his fellow conspirators.

In 1981, Poirier wrote a memorandum *"The Katyń Enigma: New Evidence in a 40-Year Riddle,"* (stamped *confidential* by his CIA superiors), about the Luftwaffe photographs that pertained to Katyń.[1] His analysis of

[1]Robert G. Poirier, *"The Katyń Enigma: New Evidence in a 40-Year Riddle,"* (*CIA Document*, 1981).

Katyń was designed as a new approach to aerial intelligence imagery, an effort to aid individuals he termed "aero-historians" who could use declassified intelligence films to fuse traditional and new techniques. The mystery of the Katyń burial sites was to prove the valueof such an approach.

• • •

When I first met Wacław Godziemba-Maliszewski in 1991 he had already made considerable progress in establishing his credentials as an expert in aerial photography analysis for the burial sites of Polish officers in the Katyń forest massacre. In the spring of 1989, a year before President Gorbachev lifted the curtain (partially, to be sure) admitting that it was the Soviet secret services that commit- ted the crime. Maliszewski had telephoned the military attaché at the Soviet Embassy in Washington to inform them that he found proof for Soviet responsibility for Katyń. Not surprisingly the telephone line went dead. That same year Maliszewski sent some Luftwaffe imagery on Katyń and Kharkov to members of Solidarity in Poland.[2]

A strange arithmetic of life had enabled me meet Maliszewski as I came to know of the involvement of two other men of my generation in the history of Katyń - Professor Janusz Zawodny, whose important work on the Katyń murders, submitted as an M.A. thesis in 1951 under the title: *The Responsibility for the* Katyń *Massacre*, and published as *Death in the Forest* in 1962,[3] and Dr. Simon Schochet, a survivor from Dachau, author of *Feldafing,* an account of a Displaced Persons Camp, an historian who made an important contribution on the number of Polish-Jewish officers murdered at Katyń.[4] Zawodny, who had served in the underground Polish army came to the United States after the war to teach and write. Maliszewski read Zawodny's book when he was still in his teens. His work in aerial photography was to be the fruit of that inspiration.

It was Poirier's 1981 classified report that Maliszewski, was allowed to see during one of his visits to the National Archives. Maliszewski had come there at first to find the location of his ancestral estate in eastern Poland when the clues tothe Katyńforest massacre suddenly materialized before his eyes. It was an experience that would change his life and dramatically alter the field of Katyń studies. (Itwas Maliszewski who eventually determined

[2]Zdzisław Rurarz, "Nieznane zdjęcia cmentarza Katyńskiego," *Kontakt*, No. 7, (1988).

[3]Janusz K. Zawodny, *Death in the Forest*, (University of Notre Dame, 1962).

[4]Simon Schochet, *Feldafing*, November House, (Vancouver, 1983); Simon Schochet, "An Attempt to Identify the Polish-Jewish Officers who were Prisoners in Katyń," *WorkingPapers in Holocaust Studies II*, (Yeshiva University, March 1989).

that the bulldozer that Poirier discussed in his 1981 report was the D.O.K. model because of its characteristic verticalprofile recognition features). In a private letter to Maliszewski, Poirier noted that he was the first person outside the government to view his work.

The Poirier report on Katyń did not see the light of day. Though intended forpublic release, it was abruptly withdrawn and classified. It was written, after all, on the eve of martial law declared by President Wojciech Jaruzelski in December 1981. Now we know that our government was informed about the imminent military coup through a defector, a Polish army officer Colonel Ryszard Kukliński, but did not see fit to issue warnings to the Poles or urge the Soviet leadership to desist from their military plans. Our leaders may have thought that revelations about Katyń would create a pandemonium in Poland and among the Polish-Americans.

• • •

Our government's reluctance to release aerial photographs of Katyń was in principle not much different from the decision not to make public earlier the photographic imagery of the extermination process at Auschwitz.[5] In both cases (and in numerous others) the materials were kept from public view not because of the need for secrecy but because of official embarrassment at having ignored the terrible truth of the extermination process. But there was one crucial difference between Katyń and Auschwitz. The majority of bodies at Auschwitz had been reduced to ashes. The Russians more than matched the murderous record of the Germans, but their disposal of victims in the vast spaces of their empire always left open the possibility that victims' remains might one day be discovered. Maliszewski, having acquired a copy of Poirier's classified report, was able to launch his own investigation for the missing bodies in Katyń forest. A crucial question had been left unanswered. Since there were more than 27,000 victims, where

[5]Roy M. Stanley, *World War II and Photo Intelligence*, London, 1982). Richard Breitman, *Official Secrets: What the Nazis Planned, What the British and Americans Knew* (New York, 1989). For more recent advances in aerial photography, see: (ed.,) D. A. Day *et al., Eye in the Sky: The Story of the Corona Spy Satellites* (Smithsonian, 1998). For a discussion of bombing of Auschwitz, see: Richard H. Levy, "The Bombing of Auschwitz Revisited: A Critical Analysis," *Holocaust and Genocide Studies*, X, 3, 267–298 (1996) and Stuart. G. Erdheim, "Could the Allies Have Bombed Auschwitz-Birkenau," *Holocaust and Genocide Studies*, VII, 2, pp. 129–170 (1997). Release of some British documents shows earlier knowledge of the killings at Katyń and Auschwitz, *The Guardian*, June 25 1993, Życie Warszawy,Nov. 29,1993, *Independent Times*, March 6, 1995.

were the hiding places for the remains of so many? Maliszewski found not only crucial information pointing to hitherto undisclosed burial sites but has also written about the decades of deception that made the Katyń massacre one of the most durable examples of disinformation in the history of state relations. The Katyń drama involved the Russians who committed this horrendous massacre and lied about if for more than fifty years, the Germans who discovered it, exploited it but whose truthful analysis of it was not trusted, the British and Americans who failed to reveal the facts in the belief that they must mollify a murderous ally, and lastly and most painfully for the Polish people, its own leaders, Moscow's satraps, who helped maintain the lie for half a century.

Chapter 1

*How the story of the Katyń massacre lay dormant for ten years
until the Cold War forced some of the truth out into the open in
1951. And how to this day, not even the collapse of the Soviet
Empire has solved the mystery of thousands of missing bodies.*

There are forests in Russia where unusual mushrooms grow in abun-
dance. Glabrous, shiny-red, with crisp white gills and white spots, they rise
on thin legs amidst decaying twigs and needles. This is the genus *Maras-
mius Scorodonius*, a fleshy, edible mushroom with a distinct garlic odor.
During Stalin's rule, villagers familiar with mist-shrouded woods realized
that these mushrooms were found in profusion on freshly excavated soil.
The appearance of *Marasmius Scorodonius* was to become the telltale sign
for thousands of Polish corpses, officers who were shot and thrown into pits
by their Soviet executioners. These red mushrooms were seen in the Katyń
forest, an area of pinkish birches, alderwood, pines and spruces, some thir-
teen kilometers west of Smolensk.

Zbigniew Brzezinski, former National Security Advisor to President
Jimmy Carter, in an introduction to a Polish translation of Zawodny's *Katyń*,[1]
quoted villagers from the Katyń area who said that about two kilometers
from their home there was a killing ground for the NKVD. The dense forest
area was surrounded by a tall fence, topped with barbed wire. There were
guards with dogs. From 1937 to 1941, day and night, often three times daily,
those to be executed were brought there by cars. Villagers could not recall
if the killings went on Sundays as well. Muffled moans were heard as the
shootings began. A woman who lived nearby heard the cries. It was reported
that the victims were killed quickly and thrown into prepared pits. Some
were still alive. Another woman remembered that as a seven-year-old she
thought she saw the earth move. Each layer of the dead was covered with
sandy soil and small spruces were planted afterwards. A gravel road leading
to that place was called "the road of death." With constant use the surface
eventually became as smooth as asphalt. The villagers talked about large
red mushrooms with white spots that looked as if they had fed on blood. In
Brzezinski's language, these were the "red spots" in Russia's history, not
the innocuous- sounding "blank spots," (or "white spots") that the Soviet
President Mikhail Gorbachev, referred to in his speeches on *Glasnost* and

[1]Janusz K. Zawodny, *Katyń*, (Paris, 1989), pp. 13–16.

• • •

The paths which led the condemned Poles to forests and killing cellars of the Soviet Union had their origin in the secret German-Soviet Treaty of Friendship of August 23, 1939, which stipulated that the Soviet Union was to invade and annex Polish territory following the German invasion on September 1.[2] In the early morning hours of September 17, even as Polish armies continued their hopeless struggle against the Germans, Russian forces claimed that there was no effective government in Poland and crossed the entire length of their common border. Many atrocities were committed against the Polish forces, such as the slaughter of young students and cadets in Grodno. Soviet attitude towards the Polish officer class may have been gauged by the orders of General Semen Timoshenko who called upon the Polish soldiers to "strike" at their officers. He urged them to join their "brethren," the Red Army. "Trust us," he promised.

German-Russian cooperation, symbolized by a joint victory parade at Brest-Litovsk before the German forces withdrew to their new boundary lines, was soon in full bloom. Foreign Minister Vyacheslav Molotov announced that Nazism was a "matter of taste," and though enemies yesterday, "today we are friends."[3] In exchange for Soviet oil, the Germans sent valuable machinery. The Russian and German secret services worked closely together. They exchanged preferred lists of human cargo destined for imprisonment, torture and death. The Gestapo particularly wanted German communists, some of them Jews, who had been active anti-Nazis. They reciprocated by sending Ukrainian and communist opponents of Stalin's across the border. Russian lists were very specific. They included Polish Red Cross workers, those who had traveled abroad, hotel and restaurant proprietors, philatelists and even Esperantists![4] Obviously all of these, including stamp collectors, would be suspected of some knowledge of the

[2]Anthony Read and David Fisher, *The Deadly Embrace: Hitler, Stalin and the Nazi- Soviet Pact, 1939—1941.* (New York, 1988), pp. 180–181.

[3]The Polish units at Brest were jointly shelled by German and Soviet artillery. The German General Heinz Guderian and the Soviet General Mikhail P. Kovalov jointly held a victory parade at Brest in a show of friendship. Marek Tuszyński, "Soviet War Crimes Against Poland During the Second World War and its Aftermath," *The Polish Review*, XLIV, 2, (1999) p. 191.

[4]Norman Davies, *God's Playground: A History of Poland*, (New York, 1982) II, pp. 447–448.

outside world.

Of the approximately one and a half million Poles who were trans-
ported in cattle cars to the farthest reaches of the Soviet Union, at least one
half were dead within a year. In addition to the civilian deportees, close to
200,000 Polish prisoners of war were confined under most primitive condi-
tions and mistreated. Only about 28,000 of these survived the war.

One group of military prisoners was singled out for special attention
by the Russians.[5] These were an estimated 8,300 to 8,400 of some 27,000
commissioned and non-commissioned officers with unique qualifications
and backgrounds. They were placed in three camps: political leaders and
internal security forces in Ostashkov on Lake Seliger, in the region of Ka-
linin (Tver), members of professions in Kozielsk, not far from Smolensk,
and the bulk of non-commissioned officers in Starobielsk, near Kharkov. In
addition to thousands of high-ranking officers, twelve of whom were gen-
erals (one was a rear-admiral), these prisoners included over 800 doctors,
lawyers, judges, engineers, university professors and members of profes-
sions holding reserve status in the armed forces. Among these were clergy
of various faiths, including Major Baruch Steinberg, the Chief Rabbi of the
Polish Army and spiritual leader for hundreds of deported Jewish officers.
Also included were frontier guards, journalists, social workers, elementary
and secondary school teachers, landowners, and industrialists. Some were
officers disabled since World War I, and of the women officers one was a fli-
er shot down in combat. If there was to be a free Poland after the war, these
individuals, who represented almost one- half of Poland's commissioned
officers, would have been entrusted with the task of national reconstruction.

Families of the captives received mail intermittently until the spring
of 1940. Then all contacts ceased. Inexplicably, at first, although as events
were to prove the Soviet hoped to "convert" some of them, 448 officers
had been separated from the others and were sent first to Camp Pavelish-
chev Bor and then to Camp Grazovec, near Vologda. These men now began
to give accounts of life in the Ostashkov, Kozielsk and Starobielsk camps
whose inhabitants had in the meantime vanished into thin air. These officers
considered more malleable than the others, testified to the mistreatment,

[5]Czesław Grzelak, "Agresja Zwińzku Sowieckiego na Polskęwe Wrzeżniu 1939
r."in *Zbrodnia Katyńska: Droga do Prawdy, Zeszyty Katyńskie* (Warszawa, 1992),
p. 7, ff. Also,Stanisław Jaczynski, *idem* "Obozy Jenieckie w ZSRR," IX, 1939–
VII, (1941), pp. 51–76. Jan Gross, "Polish POW Camps in the Soviet-Occupied
Western Ukraine," in Keith Sword (ed.) *The Soviet Takeover of the Polish Eastern
Provinces, 1939–41,* (London, 1991). Cf. The personal account of Joseph Czapski,
The Inhuman Land, (London, 1951). Cf. Joseph Czapski, "In a Cruel Land," Bos-
tonia(Winter, 1992) pp. 30–37.

the inadequate facilities, the unvarying diet of bread and herring, and the frequent searches. But they were unable to provide any information as to the whereabouts of their fellow officers. Still, there was nothing to indicate that the Soviet authorities had planned anything worse than a temporary confinement. In a country where millions disappeared from view in the 1930s through man-made famine and murder without the world taking much notice, few were expected to pay attention to the fate of thousands during a war that was causing enormous military and civilian casualties. The accounts of the survivors tended to allay the worst fears. Apparently, the officers who remained in the camps were interrogated repeatedly, personal data was carefully recorded, and each one was photographed, some several times. While crude attempts were made to indoctrinate them through posters, pamphlets, films, and ceaseless exhortations via loud- speakers, the officers, almost to a man, resisted these efforts. Strictly forbidden to have religious services, they agreed to a three-minute silence every evening at nine, a custom that was observed by believers and non-believers alike, by Catholics and Jews. The officers tried to maintain a military bearing. Periodically, lists of names were transmitted to the camps from Moscow, followed by departure of transports. The Russians did everything possible to convince the Poles that they were being repatriated.

There were moments of misgiving but how could dark suspicions be voiced when an orchestra played to amuse the inmates, and the NKVD officer said to those leaving: "We will soon meet again," adding, "How very much I should like to go where you are going now." The Poles were inoculated against typhus and cholera. Even the rarest of Russian treats appeared— clean paper with which to wrap food for the journey. The high-ranking Polish officers were treated to fare- well dinners of caviar and wine and cheered by the NKVD when they were driven away. Perhaps they should have had a foreboding when the NKVD officer said to those who wanted to leave with friends rather than the group they were assigned to: "You'll soon meet together, anyway."[6]

[6]*Crime of Katyń: Facts and Documents,* Polish Cultural Foundation, 3rd. Edition, (London, 1965). An NKVD General, Vassili M. Zarubin befriended the Polish officers and made his large library available to them. He was fluent in German and French, knew some English and offered them cigarettes, tea and even oranges. The officers were so impressed with these signs of personal attention that he was the only NKVD officer they saluted. Allen Paul, *Katyn: Untold Story of Stalin's Polish Massacre,* (New York, 1991), pp. 77–78. Clearly the NKVD General had more in mind than socializing. Zawodny cites the opinion of Dr. Kenneth Mark Colby from the Center for Advanced Study in the Behavioral Sciences at Stanford, who saw Zarubin as a calculating interrogation officer whose concerns, in contrast

• • •

The 27,000 Polish officers and civilians disappeared without a trace. Those who fault millions of panic-stricken Jewish civilians for failing to heed what we now see as obvious signs of danger might consider the hopeful attitudes of seasoned, battle-tested Polish officers. It is worth noting that there were similarities in the deceptions practiced by both Nazis and Communists in lulling their victims with a false sense of security. According to Professor Natalia Liebiedieva, whose research into the use of railways in the extermination process has been of considerable importance, the officers were told to give as a return address a resort named Gorky. This tactic was designed to deceive both the officers and their families. And just as the Nazis used the term "special treatment" or "resettlement" as code names for extermination, the Communists referred to "Unloading," when decreeing the transporting of Polish officers to their deaths. In the book *Katynskaia Drama* [The Drama of Katyń], published in 1991, Liebiedieva's article, "Operation 'Unloading of Special Camps,'" details the "bookkeeping" involved in the extermination process.[7] To those who wonder why both Nazis and Communists kept such elaborate records which had the potential of incriminating them, one might speculate that such "bookkeeping" served at least two purposes. The victims felt comforted by this evidence of a bureaucratic "order," while those involved in extermination saw in it an imprimatur of a "higher authority" or at least of historical necessity. But even if the documents were a ritualistic sham, they at least afforded some relief to those who felt distaste for such "work" And surely the perpetrators did not expect failure and eventual judgment in a world obviously blind and deaf to such acts.

to the brutality of others, were designed to persuade the Polish officers that he rep- resented a positive if not the "ideal" face of Communism. Zawodny quotes a conversation between a Polish officer, General Minkiewicz and Zarubin. When Minkiewicz inquired what the Russians planned to do with them Zarubin answered that they would "go mad" if he told them. He said: "I assure you, dear sir, that would be inhumane, … it's better that you do not know what we want to do with you." Zawodny, *Katyń*, (Paris, 1989), p. 117 and n. 38, p. 136. A fairly complete listing of references to Zarubin may be found in Jerzy Krzynanowski's,"Kombryg Zarubin," in *Przegląd Polski*,(June 9, 1992), 2. No. 10, pp. 51–52, also in John Earl Haynes and Harvey Klehr: *Venona: Decoding: Soviet Espionage in America,* (Yale, 1999) p. 121 and *passim* Cf. Allen Weinstein and Alexander Vassiliev, *The Haunted Wood* (New York, 1999) p. 66 and *passim.*

[7] Natalia Liebiedieva, in *Katinskaia Drama*, "Operation 'Unloading' of Special Camps," (Moscow, 1991).

On June 22, 1941, in another masterful deception, the Germans attacked their erstwhile Russian ally. The fate of the thousands of the missing Polish officers was overlooked in the aftermath of the ferocious attack as German forces reached the outskirts of Moscow by October. Stalin, desperate and fearful of a total collapse, decided to enlist the aid of the exiled London Polish government and the many thousands of Polish soldiers and civilians who were scattered in the vastness of Asiatic and Siberian Russia. Nothing was said by the Russians about the 27,000 Poles still assumed to be alive. Both Churchill and Roosevelt, anxious not to do anything that might harm their recent alliance with Stalin, cautioned the Polish government in London not to raise embarrassing questions about the missing officers.[8]

On July 30, 1941, the Soviets signed a treaty with the London Poles and pro- claimed an amnesty for the Polish citizens it had deported, none of whom had been convicted of any crime. By this time, almost half of these exiled and mistreated innocents had died. A wartime deposition at the Hoover Institute from Czesława Maliszewska, a distant relative of Maliszewski, provides a firsthand account of that cruel migration. In April 1940, robbed of their possessions and evicted from their homes in Eastern Poland, Maliszewska and her family were sent in unheated cattle cars on a two-month journey to Siberia. The old and ill that died were buried along the route and the hungry, flea-infested survivors were finally delivered to a collective farm in Kazakhstan. They found out about the amnesty on August 12, 1941, and Maliszewska's family went to Uzbekistan where her husband joined up with the newly formed Polish forces.[9]

Polish General Władysław Anders, imprisoned in the cellar of Lubyanka, the notorious NKVD jail where thousands were tortured and killed during the Stalin purges, was released during this period and named the commander of the Polish forces in Russia. He immediately established the Bureau of Documents to gather information about the thousands of countrymen not heard from since the spring of 1940. Andrei Vyshinsky, then Vice-President of the Council of Peoples Commissar (he was the notorious prosecutor in the purge trials of the late 1930s), and Molotov, the Foreign Minister, both refused to give an accounting of the missing officers. Exas-

[8]Norman Davies, *Europe: A History,* (Oxford University Press, 1996), pp. 1004–1005, John Charmley, *Churchill's Grand Alliance,* New York, 1995, pp. 68–69. Cf. Winston S. Churchill, *The Hinge of Fate,* (New York, 1950), pp. 759–761 and *Roosevelt and Churchill: Their Secret Correspondence,* (Eds F. L. Louwenheim *et al.* (New York, 1995) pp. 65–66, pp. 327–330

[9]Czeslawa Maliszewska, testimony taken by the Underground Polish Army (A.K.), Poland, *Ambasada* (USSR), n.d. Box 46, file 294. Hoover Institution, Stanford, CA.

perated by the evasions, Stanisław Kot, the Polish ambassador to Moscow said to Vyshinsky: "People are not like steam, they cannot evaporate." Kot finally decided to appeal directly to Stalin. With the ambassador standing by his side in Molotov's office, Stalin acted out a macabre charade. He picked up a telephone and called the NKVD headquarters: "Stalin here. Have all the Poles been released from prison?" Puffing on a cigarette and doodling while listening, or pretending to listen, he said: "I have the Polish ambassador who tells me that not all have been." He hung up and waited for an answer. After a few minutes the phone rang again. Stalin picked it up, listened and said to no one in particular: "They've all been released." About a month later, the head of the Polish government in exile, General Władysław Sikorski, with Anders again in attendance, told Stalin that they had the names of thousands of Polish officers who had not been seen. The Soviet leader said with some annoyance: "That is impossible. They have escaped." When asked by an incredulous Anders where they could have escaped to, Stalin replied: "Well, to Manchuria. They have certainly been released but have not yet arrived."

There was another meeting between Stalin and Anders on March 18, 1942. More than fifty inquiries had been addressed to the Soviet authorities. The Polisharmy commander reminded Stalin that not one of the officers from the three campshad been seen. Stalin replied calmly that he had already given orders for all the men to be freed. He said that there was no reason why his government should keepthem. And he volunteered that perhaps they were in territories overrun by the Germans. But the most significant comment was made by Vsevolod N. Merkulov, an NKVD officer who served under Beria, and was sent to Berlin in 1939 to discuss"special problems" with his Nazi counterparts. When General Berling, the Polish officer entrusted by the Russians with forming a brigade of pro-Russian Poles (these were not to see action until the Battle of Lenino in 1944), reminded Merkulovthat there were excellent cadres of officers at Starobielsk and Kozielsk, the NKVD officer replied: "No, not those. We made a great mistake with them." It was a remark those present neither understood nor forgot.[10]

• • •

In the morning of April 13, 1943, Radio Berlin announced that German <u>army personnel</u> had found the graves of 10,000 Polish officers murdered by

[10]These exchanges have been cited by various authors, generally using similar language. Cf. Paul, *Katyń*, pp. 169–174. Merkulov's bloody career is yet to have a biographer. Forsome information about him, see Pavel and Anatoli Sudoplatov, *Special Tasks: The Memoirsof an Unwanted Witness - A Soviet Spymaster* (New York, 1994), p. 25 and *passim*.

the Russian secret services. The Germans, in their eagerness to embarrass the Russians, over- estimated the number of victims in that particular location by some 6,000. The remains were discovered at Kozy Gory [Goats' Hills], an innocently named NKVD health resort in the Katyń forest, thirteen miles west of Smolensk. The graves had been found by Teofil Rubaszinski, a Polish worker in the German *Todt* (Compulsory Labor Organization) railroad repair detail. It seemed that a Polish woman married to a Russian rail employee approached Rubaszinski and his Polish friends, showed them a Polish officer's cap and told them of mass graves in the forest. Digging in an area of newly planted pines, they eventually came across a burial site that contained remains of Polish officers. There was no mistaking the uniforms. The men placed two traditional birch tree crosses to mark the site. Eventually, Germans from the Border Police unit investigated. They interviewed several Russians who lived nearby and who provided important testimony about the executions and burial. The initial excavation revealed the bodies of 3,000 officers stacked in twelve layers. According to the German broadcast these men were from the Kozielsk internment camp. A search for more bodies was to proceed with foreign reporters present.

Two days later the Moscow radio responded to these accusations. Referring to the German broadcast as "vile fabrications ... monstrous inventions ... (and) unscrupulous and base lies," the radio broadcast suggested that the corpses were those of Poles engaged in construction work in 1941 and killed by "Hitlerite gangsters." A Russian radio broadcast noted that the nearby village of Gnezdovo was a site of an archaeological dig and suggested that historical remains were being disturbed. In the midst of these denials, Anders wrote from his headquarters in the Middle East that in a private conversation with high Soviet officials about the missing officers he was told that a "fatal mistake" was made. He also told of hearing accounts that some of the Polish officers were drowned in the Arctic Ocean. Sikorski promptly informed Churchill that he had evidence that 15,000 Poles were buried in the forests of Katyń. Churchill, who believed that the German revelations were probably true and agreed that "the Bolsheviks can be very cruel," was nevertheless determined not to endanger the anti-Hitler coalition. "There was," he said, "no use prowling morbidly round the three-year old graves of Smolensk ... if they are dead, nothing you can do will bring them back." Inadvertently or purposefully, by saying that the graves were "three years old," which would date the killings to 1940, when the Russians occupied the area, Churchill gave lie to the Russian version of events which argued that the killings took place in 1941, when the Germans had invaded. He was anxious to mediate, however, which meant that Poles were expected to abandon their efforts to get at the truth. Churchill thought he had succeeded and wired Roosevelt: "We

have persuaded them [the Poles] to shift the argument from the dead to the living and from the past to the future."[11]

But now events moved rapidly and inexorably. In spite of Churchill's annoyance with the Poles, who had been "very foolish," and his hope that the Katyń dead would not be discussed (to Eden: "We should none of us speak a word of it"),the Polish authorities requested the International Red Cross to send a delegation toKatyń. Moscow radio quickly referred to Sikorski as a "pro-Hitlerite." Churchill characterized Polish action as a "blunder." On April 20, the Polish government asked the Russians to respond to the German accusations. Six days later Molotov handed the Polish ambassador a note severing relations. On May 4, 1943, nine days after the break in relations, Stalin gave an interview to the *New York Times* promising good, neighborly relations with the Polish people after the war. When he dissolved the Comintern three weeks later, he was hailed as a statesman. Churchill said to the Soviet Ambassador Ivan Maisky who came to complain to him of the Poles: "We have got to beat Hitler, and this is no time for quarrels ..." The Ger- mans, seeing that the International Red Cross would not investigate without an agreement with the Russians, published in 1943 their own 330-page report: *Amtliches Material zum Massenmord von Katyn* [Official Materials on the KatyńMass Murder].[12] This German report, the first by three International Commissions that in addition to Katyń were to investigate the massacre sites at Vinnitsa and Odessa, cited an official count of 4,143 bodies in six pits (two more pits were discovered byJune) of varying dimensions. It described amazingly preserved diaries, newspapers, prison camp newsletters, banknotes, letters and receipts, none dated later than May 1940.

Goebbels' propaganda machine seeking an opportunity to split the allies and remove the spotlight from their own atrocities (the Katyń revelations came as theGermans were destroying the Warsaw Ghetto), went into high gear. Polish peoplewere told that the massacre in Katyń was committed by Jews in charge of the NKVD, ignoring the fact that the German lists of Katyń victims included a significant number of Jewish officers. Germany established an international commission from twelve countries, whose forensic examinations provided an account of how the officers were killed. Some bodies bore traces of stabbing with Russian-type cruciform bayonets. Many of the bodies were grouped in pits in the same order that they left the

[11]Martin Gilbert, *Road to Victory: Winston Churchill 1941–1945* (London, 1986) p. 385, p. 389, pp. 664–665. Count Edward Raczyński, Poland's former ambassador to England and minister of wartime government–in–exile, believed that Soviet sabotage was responsible for Sikorski's death in a plane crash at Gibraltar, *Financial Times,* (November 15, 1991).
[12]*Amtliches Material zum Massenmord von Katyn,* (Berlin, 1943)

camps (as remembered by their surviving friends), proving that those who had removed them maintained them in such grouping until they were killed. The experts testified that the victims had been in the ground since 1940, with mounds of young pines over the pits planted to conceal the criminal acts. There was also a Commission of the Polish Red Cross that wrote its own report.

• • •

On July 21, 1943, a Polish officer Józef Czapski, stationed in Jerusalem, penned a thirty-page memoir, "Story of the Lost Polish Officers," that was circulated unsigned over the wires of the Polish Telegraphic Agency. Czapski (an artist who died some years ago in Paris), had rejoined the squadron in which he served against the Russians in the 1920 war, was captured in Eastern Poland and deported to Starobielsk. Miraculously, following inquiries about him by such prominent people as the Queen Mother of Belgium and officials from the Red Cross and the Vatican, he became one of a small number of Poles that the Russians decided not to execute with the others. After a brief stay at Camp Pavlishev Bor, Czapski was freed as a result of the general amnesty granted to the thousands of Poles scattered over Russia's vast interior. On orders of General Anders who asked him to ascertain the fate of the missing Poles, he wandered through Siberia, Turkestan, and Persia before joining the Anders forces in Palestine. His memoir (the original is deposited with the Hoover Institution in Stanford) is a first-hand account of his efforts to locate the thousands of missing Polish officers, many of whom he knew personally.

It is an extraordinary testimonial. Czapski had provided vignettes of a number of Polish officers, many of whom occupied positions of honor in science, medicine and other fields before the war, whose lives posed no danger to the Soviet state, but whose death was decreed because they represented to Stalin an unassimilable element of Polish society. Czapski sketched moving portraits of some of the men he met at Starobielsk - Chaplain Alexandrowicz, Lutheran Bishop Potocki and Rabbi Baruch Steinberg, deported to their deaths a few days before Christmas Eve, 1939. He wrote movingly about Professor Ralski, a specialist in meadows, who collected specimens of grasses on the snow-covered steppes even while suffering from hunger and frost-bite.

Czapski's account also provides glimpses of the mentality of the captors. "What instructions were you given by your Foreign Minister when you left for Paris?", one of his NKVD inquisitors asked. The Russian could not imagine that a Polish artist could go abroad without being ordered to spy

and prepare a plan of the city. "I could not explain that a plan of Paris could be bought for fifty centimes on every street corner," commented Czapski. The cruelty of confinement was not restricted to humans. He told of an incident where his unit befriended a stray dog, "a big black ... great and gentle friend," one of many wandering around the camp. "Those dogs hated the NKVD men and barked fiercely when they came to our barracks," he wrote. One day, when the commander of the camp entered, the dog jumped at him and began to bark. Even though the Poles tried to hide the animal, it was eventually taken away. "Three days later, when going to our daily work, we saw our dog lying dead in a pool of blood. He had been clubbed." Czapski described the indignation felt by the men "though we had really seen and experienced a great deal of cruelty."

Czapski, whose works were approved of or censored by the Bureau of Documents administered by the London Poles, was able to travel and make inquiries about the thousands of missing officers. He knew of the fruitless interviews that Polish officials had with Stalin and NKVD officers, but he continued to hope against hope that many Poles would be found eventually in labor camps in the frozen regions of Siberia. With the news of the German exhumation in Katyń broad-cast three months before he recorded his experiences, Czapski confirmed that information from other Poles that they had seen inscriptions on walls of train stations west of Smolensk that were proof of the deaths of thousands of Polish officers. He also heard a rumor that officers from Ostashkov and Starobielsk, had been placed on barges and drowned in the White Sea.[13]

· · ·

On January 24, 1944, the Russians, having regained the territory on which the massacres were committed and having obviously considered carefully their next step, appointed a commission headed by academician Nikolai Burdenko, and proceeded with their own exhumation. No mention was made of the six fraternal graves or the separate graves of the Polish generals. The Soviets invited foreign journalists, selected guests and delegates of the Polish army on their soil to visit the site. Kathleen Harriman, the twenty-five-year-old daughter of the American ambassador, an employee of the Office of War Information, was there to represent the American Embassy in Moscow. She later wrote a report about her visit, agreeing with the Russian version of the massacre. According to her, a Russian forensic specialist cut away adhesive from the brain of body numbered 808 "like from a piece

[13]Joseph Czapski, in "The Story of the Lost Polish Officers," in *Polish Telegraphic Agency*, Jerusalem Branch, 21.7.1943, Hoover Institution, Stanford, CA.

of cold meat, plunged the knife into the chest cavity and took out the decaying organ. 'The heart,' he said," and held it up for Harriman to see. He also cut the flesh of the leg and according to Harriman pronounced it, "perfectly preserved."

Russians claimed that their exhumation of the bodies contradicted all the German findings. The Burdenko report sought to explain through testimony of witnesses that the Poles who were engaged in road building were in three camps (location unspecified) and could not be evacuated as the area fell to the Germans. The Burdenko Commission argued that the witnesses originally used by the Germans gave false testimony under threat, or were bribed, and concluded that the Polish officers were murdered by Germans between September and December 1941. This dating was crucial, because if the bodies were buried in 1940, as was claimed by the German Commission, the crime could only have been committed by the Russians who controlled that area until the German invasion in June 1941. The report by the Burdenko Commission in trying to come to grips with incontrovertible evidence argued that the Germans used 500 Russian prisoners (whom the Germans supposedly then killed, but whose remains the Russian government never found) to exhume from graves thousands of corpses that had lain there for two years. The compressed and decomposed corpses were then supposedly searched, the pockets emptied, and coats unbuttoned to remove all materials that had a date later than April 1940, with forged documents substituted for the original ones. The Russian report expected its readers to believe that the Germans not only managed to find and destroy every paper dated later than May 1940 but were also able to place in the pockets of the victims thousands of copies of newspapers, artificially aged and creased (some would have to be inserted into soles of shoes), all dated no later than May 1940. These year-and-a-half old newspapers, the Russians claimed were kept by the victims for some unaccountable reason until the winter of 1941.

But perhaps the strongest argument that branded the Burdenko report a lie had to do with the simple act of letter-writing. Poles are inveterate letter writers. While confined in Starobielsk, Kozielsk and Ostashkov, the officers maintained contact with their families and friends through the mails. Yet no letters were sent by them after April 1940 and letters sent to the camps by their families remained unanswered or were returned.

As a final act in the cynical *Grand Guignol* investigation, the Communist-sponsored division of Polish soldiers led by Berling was asked to march at the gravesite after re-burial. A collection was taken to raise money for a tank division to be called "Avengers of Katyń." Burdenko confessed to a friend in 1946 that "these 'Katyńs' have happened and will happen. If you

begin to dig around in the soil of our Mother Russia, you will surely come across a goodly number of similar archaeological discoveries." Many years later, with death approaching, Burdenko hinted to acquaintances of a version very different from the one he originally presented.

• • •

The odyssey of the crates containing the personal effects of the Katyń victims symbolized the struggle by the Polish people in the midst of wartime suffering to remember and memorialize the dead. In a recent Polish edition of *Zawodny's Pamiętniki Znalezione w Katyniu* [*Diaries Found at Katyń*], he has summarized efforts to save the precious evidence.[14] The Germans realized that the Russians, upon recapturing Katyń, would blame them for the murders. It was crucial for them to retain custody of the evidence found with the bodies. As they retreated, they preserved over 3,000 items, including a significant number of legible diaries. These materials which clearly implicated the Russians, were packed into nine crates, the twenty-two diaries packed in a smaller container. When this cargo reached Kraków, four copies were made of the diaries. Armia Krajowa (AK) [Home Army], (an underground force) forwarded a set to the Polish government in London. Seven of the diaries were lost but the remainder reached their destination. At the end of 1945, the 3,000 items still in German hands after being repacked in fourteen crates were destroyed in a fire at a railroad siding near Dresden. Two copies of the documents were made surreptitiously and surfaced in 1991 during repairs made in a Kraków attic. Stanisław Mikoła-jczyk, the last legally appointed Deputy Prime Minister of Poland told Zawodny that one of the crates survived. The small crate with twenty-two diaries was never found.

Excerpts from the diaries are poignant and painful. The prisoners tried to leave a chronicle of their existence as determinedly as the Russians sought to prevent it. In an entry dated April 8, 1940, Wacław Kruk on whose body was found a diary with pages sewn together, wrote as the train was carrying him with fellow officers to a rendezvous with death: "I used to be optimistic but now I am coming to a conclusion that this journey does not bode any good ... we are allowed to go to the lavatory only when it pleases the guards and neither begging nor crying helps." His last sentence was: "Since yesterday's breakfast we've been given only a ration of bread and a little water." Major Adam Solski wrote on April 9: "It is five in the morning. It's been peculiar day since dawn. We're being taken in prison vans with separate

[14]Janusz Zawodny, *Pamiętniki Znalezione w Katyniu*,(Paris, 1989)

compartments. It is terrible! They have brought us to a wooded area that looks like a summer resort. There's been a thorough search. They've taken my watch which showed that it was 6:30. They've asked for my ring … they've taken, my rubles, my belt and my penknife." Here the diary breaks off. Włodzimerz Wajda left one of the longest diaries. The last entry on April 12, read: "It is morning. We're still on the train. We've barely reached … Smolensk … The night was hellish. We're cramped. Naturally, still no food … From slips of paper we have found we know that they will disembark us past Smolensk. We shall see."

With the inevitable surrender of Germany in the spring of 1945, the continuing wartime alliance and the growing horror at the discoveries of the German death camps, it was difficult to challenge the official Soviet version of what had transpired at Katyń. The Russian prosecutors at the Nuremberg Trials (with Allied acquiescence) made sure that Katyń was not be mentioned as a war crime. Those who came to Russia and asked about Katyń were taken to a village named Khatyn, near Minsk, a site of a Nazi atrocity made into a tourist attraction. "Katyń" was consigned to a "memory hole." And the word "Katyń" did not appear in the Polish encyclopedia.

Chapter 2

How I first met Maliszewski at Schochet's apartment and learned at first hand that in spite of many setbacks Maliszewski has continued his detective work to dis- cover sites of massacres and burials. He remains convinced that crimes committed on earth can be discovered from the sky.

I first met Professor Simon Schochet in 1984 at a Polish auction in Greenpoint, the Polish-American "village" in Brooklyn. Schochet (who holds a doctorate in history from the University of Munich) was a tall, elegantly dressed man in his late fifties whose aristocratic bearing drew attention in a room filled with noises and gestures of bidding. Both of us were interested in a drawing by Bruno Schulz, a writer-artist whose growing fame had been cut short by the bullets of an SS policeman in Drohobycz. Schochet quickly outbid me. I lost the bid, but I gained a friend. After the auction I discovered that we had more in common than respect for the works of the "Polish Kafka." We were in fact both from Łódź, had attended the same gymnasium but never met since I was a few years older. However, what separated us was not age but an unbridgeable chasm. I left for America as a thirteen-year-old in 1937. Schochet remained in Poland. He was liberated by American troops from the Dachau concentration camp in 1945.

The meeting in Greenpoint occurred just as my interest in Poland began to revive. I had specialized in Russian studies and had little if any contact with Polish life or culture for almost forty years. While on a grant in Paris in 1970 I met a young woman born in Łódź, a Polish economist. We stayed in touch and when I came to Warsaw in 1975, she suggested that I should see my birthplace again. I went to Łódź drawn by that indefinable urge to revisit one's birthplace and especially anxious to find my father's grave, though this proved impossible at that time. Łódź had a pre-war Jewish population of quarter-million. In its death-dealing ghetto only 877 Jews remained alive by 1945, that remnant ordered to dig their own graves at the Jewish cemetery (the holes are visible to this day), saved only by the entry of Russian forces. Not one of my family or friends escaped the carnage.

Six years later my wife and I sponsored that Polish lady who arrived at our home in September 1981, a few months before martial law was declared. It was she who introduced me to Polish students, some of whom

brought with them Polish posters. I soon acquired a sizable poster collection and began to publish articles about them. In 1984 I was ready to stage a large exhibit in Philadelphia's Port of History Museum. A year later, I displayed my Polish film posters at New York's Lincoln Center.

I returned again to Poland in 1986 to attend the famous poster *Biennale* at Wilanów, a unique poster museum on the outskirts of Warsaw. It was the time of Chernobyl and people were avoiding fresh fruits and vegetables while their government admonished them to wash sidewalks to avoid contamination. I went once again to the Łódź cemetery and walked amidst the toppled stones and weed-infested paths. But this time I succeeded. Jewish community officials had found old burial records amid discarded trash, and I was able to locate my father's memorial. A Polish friend who assisted me in this search photographed me with my arm draped around the memorial stone.

Another trip to Poland in 1989 led to my interest in the Katyń forest tragedy and an eventual introduction to Maliszewski. I retired that year from teaching Russian history and embarked on a career devoted mainly to writing about Polish artists. Schochet, who had a longstanding interest in Polish art, had commissioned seven young sculptors in Poland to design very unique bronze Chanukah menorahs. He asked me to write about these artists and I agreed to interview them. The talented artist-photographer Katarzyna Gruda who had already photographed the menorahs was to work with me on an essay dealing with the sculptors. Our trip coincided with the observance of *Dzień Zaduszny* [All Souls' Day], a time when millions visit cemeteries to honor family members and national heroes. Gruda planned to photograph scenes in Warsaw cemeteries as well.

I had seen the menorahs in Schochet's apartment. They were massive, most of them horizontal rather than vertical. I had the impression that one particular menorah had special meaning for Schochet. Designed by Anna and Krystian Jarnuszkiewicz, it presented a powerful image. A flat tablet, its top pitted and scarred like a lunar surface, it held randomly scattered stubs for candles that cast unearthly shadows. There was a trough-like tray attached to one end of the tablet, its sloping surface streaked like a shimmering riverbed. In a video of the artists' work that was made in Poland a year earlier, one can see the sculptors slowly untie a velvet bag, the sort that might contain the *Tefillin* [phylacteries] of observant Jews and pour white sand into the trough. Slowly, gently, like falling rain, the grains of sand brought from the bed of the Vistula River filled the tray. Another striking and truly unforgettable menorah was by the talented Ryszard Stryjecki. On one side of the upright bronze candelabra one can see the rails that converge on the gate of Auschwitz, the last station for millions of sufferers. The

watchtowers, the electrified barbed wire fence and a few indistinct trees frame the scene of man-made horror. On the reverse side, Stryjecki had juxtaposed images of toppled tombstones. My article about these unusual sculptures was entitled: *Menorahs of Victory,* although it was difficult to see anything triumphant about them.

• • •

To travel in Poland in 1989 was to experience simultaneously several decades of Europe's troubled century. There was the hyper-inflation of the 1920s, the growing nationalism (and its junior partner, anti-Semitism) of the 1930s, the unfinished reconstruction of the 1940s and 1950s, the street theater and student demonstrations of the 1960s and the unmistakable signs of the "me" spirit of the 1980s. It was all there on a roller coaster of emotions. But above all, it was the year when Polish elections featured a poster by Tomasz Sarnecki who used Gary Cooper's image from *High Noon* and boosted Solidarity's chances (some said "assured") at the ballot boxes. The hero of American westerns sported the familiar Solidarity logo above the sheriff's badge as that militant organization ceased being an outlaw and became a government. I sat in the living room with Jan Młodożeniec, one of the premier Polish poster artists and watched on television as Lech Wałęsa (only the third person in history after Lafayette and Churchill), gave a speech before a joint session of the U.S. Congress. Młodożeniec and his wife were close to tears.

Warsaw was full of exhibits. In a foreshadowing of the change that was soon to sweep all of Eastern Europe and crumble the Berlin Wall, Poland was visualizing its past as never before. It resembled a worn and cherished family album dusted off after years of neglect. Photographic exhibits drew large crowds. One in particular was very striking. It was called *Labirint.* Assembled in an unfinished church in the suburb of Ursynów, it led the viewer through a maze of passageways, some barely wide enough to allow one person to pass. The walls were covered with thousands of images. Faces of brides and grooms from the nineteenth century, children dressed for communion, Hasidic youths bowing in prayer, craftsmen at work, statesmen and revolutionaries, the sick in hospitals and memorials for the dead - many, many dead. History was not only studied in Poland - but it was also being exhumed. At *Labirint* there were photographs of newly discovered mass graves side by side with old burial sites. Throughout the exhibit there were alcoves where artists displayed found objects of their impoverished country. The final assemblage was most moving. In a tiny room faith was reduced to one simple symbol: a loaf of bread in the middle of a crudely built table.

The effect of so many photographs was staggering. The age of lies had left a terrible void. Where the beliefs of so many had been shattered, a realm of things acquired a truth of its own. In Poland, perhaps more than in other countries, a land whose soil had absorbed the blood and ashes of millions of innocents, the veneration of photographs had assumed a quality of deep spirituality.

As I traveled around Warsaw, I saw a growing number of memorials to the victims of Katyń and bookstores displayed works dealing with that once-forbidden subject, Young and old were told what most of them knew anyway, that the Russians were responsible for the massacre. For half a century Polish scholars worked in secret accumulating evidence about a crime both unspeakable and unspoken. Even Gorbachev's *Glasnost* had not chipped away at this wall of silence. But 1989 was a time for walls to come down.

On November 1, 1989, I made a journey through the cemeteries of Warsaw. It was a rainy, gloomy day. The city's mud-covered streets, a by-product of the sea- son's rain and an antiquated drainage system, were filled with crowds. *Dzień Zaduszny* [All Souls' Day] was a day of the most solemn commemoration in Poland. It was a time to visit the cemeteries, a day when the souls of the departed were honored and propitiated, when life was celebrated in an atmosphere of sorrow, when the living realized, however dimly, that they were alive because others had gone before them. There are few lands where the need to fight death's meaninglessness and anonymity is more compelling, for in twentieth century Poland dying had become terrifyingly commonplace.

I visited the *Stare Powązki* [Old Powązki], one of the oldest cemeteries, a necropolis, a veritable city of the dead, broad avenues intersected by tree-lined "streets."[1] A sign at the "grave" of a Piotr Woydyno noted that it contained only "symbolic remains." (His body rested in a distant town). The tablet stated that two of Woydyno's brothers lay in graves in Romania and Australia. Another brother died in Katyń forest. Four brothers, all absent from their family grave, all reunited in the city of their birth only by a sign bearing their names. I visited the St. Stanisław church where the martyred Father Jerzy Popieluszko killed by the Polish secret police lay buried, and where I saw for the first time a public display of works dealing with the Katyń massacre. I bought at a church kiosk a postcard showing Matka Boska Katyńska, a Madonna-like painting of the Mother of God, cradling the shaved head of a fallen soldier, a gaping bullet wound in back of his head.

[1]Frank Fox, "Menorahs of Victory," *The World & I*, (December, 1990), pp. 218–225, also,"Visiting the Deceased: Poland's All-Saints' Celebration," *The World & I*, (November, 1991), pp. 632–639.

This was the method of execution in Russia. (Today there is a postage stamp with that image).

The Polish cemetery resembled a gallery of family portraits. Watching grieving visitors, one was struck with the expressions of domesticity, with gentle and loving motions that permeated every act. The mourners swept up leaves with makeshift brooms, wiped away dust to reveal the lifelike veins of the marble, care- fully arranged flowers and lighted candles around the graves as if setting a table at home. The air was filled with the familiar aroma of foliage and smoke. Multicolored oak leaves swirled down gently. Only the sound of a hissing flame could be heard as the orange wax sputtered and overflowed the traditional dish. For a moment the cemetery came to life.

A few days before the end of my trip I saw a crowd trying to topple the statue of Feliks Dzierżyński, Polish-born founder of Lenin's secret police, *Cheka*, forerunner of the NKVD, letters synonymous with the oppression and deaths of millions of Russians (and non-Russians) since 1917. It was the NKVD whose executioners were involved in the killing of Polish officers in Katyń and other still secret sites. For a whole day a crowd of people tried to move some of the stones that sur- rounded the base of the monument. Embarrassed city officials decided that the status would have to go, claiming that a subway was being built underneath. The next day, I watched while workmen brought cranes to remove the massive figure that dominated a square named for a for man who invented modern state terrorism. As the statue rose above the crowd it suddenly cracked in several places. The head and torso fell to the ground while the rest of it tottered dangerously. It was made of plaster and painted to give it a bronze patina. Concern soon gave way to laughter as people began to collect pieces for souvenirs. Art students from the nearby school made up signs that mocked the man. "Don't leave us, Feluł," one sign pleaded. A student pried away two last bronze letters of the word that spelled *duch* [spirit] and crayoned in two others, so that the word now read *dupa* [arse].

• • •

After I returned from Poland I found out that Schochet had made an important contribution to Katyń research with the publication of an article: "An Attempt to Identify the Polish-Jewish officers who were Prisoners in Katyń."[2] Starting with the list of names compiled by the historian Adam

[2]Schochet, "Working Papers in Holocaust" also, "Próba Okreł lenia Tożsamoł ci Polskich Oficerów Pochodzenia Õydowskiego - Jeńców Obozów Sowieckich," *Nowy Dziennik,* Przegląd *Polski,* New York, (November 21, 1990). Cf. Frank Fox,

Moszyński as well as the list assembled by a German-sponsored Commission that exhumed several thousand Polish dead in April 1943, he was able to shed light on one of the lesser known aspects of the Katyń tragedy. Schochet identified 262 names of Jewish officers, about 5 percent of the officer population. With additional research he had estimated that there were at least 700 and perhaps as many as 800 Jewish officers in the three camps, including Major Baruch Steinberg, Chief Rabbi of the Polish Armed Forces who was imprisoned at Starobielsk and deported with two of his Christian fellow clergymen to an execution site on Christmas Eve, 1939. The fact that many of the officers were members of professions such as medicine (fifty per cent of Poland's pre-war physicians were Jews) accounted for a disproportionate number of Jewish officers compared to their numbers in the general population.

In 1990, the year that Gorbachev made the lists of Polish officers available to the Warsaw government, Schochet traveled to Poland to meet with other scholars who had established a clandestine Katyń institute in 1978. Their research could now be conducted in the open. The Russian lists with the names of the prisoners' fathers made the identification of Jewish officers easier. The Bulletin of the Katyń Institute, which had dedicated its June 1990 issue to Major Steinberg and his fellow Jewish officers concluded that among all the Katyń victims fifteen per cent were Jewish.[3] Professor Zawodny had concurred with this estimate. It was Zawodny who told Schochet in 1989 of Maliszewski's pathbreaking work with aerial photo- graphs of Katyń and suggested that they meet.

As Schochet described to me the start of his collaboration with Maliszewski, it became clear that in spite of the disparity in ages and backgrounds, they were kindred spirits. When I remarked on Maliszewski's success as a businessman, Schochet, who had managed to combine a career as an historian with that of a commodity broker, corrected me. Neither he nor his young friend should be defined that way.

> Look, he has succeeded in what some may call a business. But what
> he truly wants has nothing to do with being a businessman. He is re-
> ally an artist and a poet. I have read some of his poems and I think they

"Jewish Victims of the Katyń Massacre," *East European Jewish Affairs,* XXIII, No. 1, (1993), pp. 49–55.

[3]Schochet, "Working Papers in Holocaust" also, "Próba Okreł lenia Tożsamoł ci Polskich Oficerów Pochodzenia Żydowskiego–Jeńców Obozów Sowieckich," *Nowy Dziennik,* Przegląd *Polski,* New York, (November 21, 1990). Cf. Frank Fox, "Jewish Victims of the Katyń Massacre," *East European Jewish Affairs,* XXIII, No. 1, (1993), pp. 49–55.

are extraordinary. I have alsobeen described as a businessman but that is not how I see myself. I am sustainedby my books and projects. I correspond with many people who have similar interests. So Wacław and I (Schochet used the more formal first name for Maliszewski) have an affinity for one another. And we are also people who want justice.

As befits Europeans the two who have worked closely together on their projects without inquiring into each other's private life. They have an intuitive understanding "I know that underneath there was a pain, that we were both hurt and bewildered," Schochet said. They exchanged materials on Katyń. Maliszewski, whose Polish was rusty, came to rely on Schochet's translations. The latter, trained as an historian, understood the importance of Maliszewski's work. "I was a new source of information for him because I knew about books published in Polish," Schochet continued. "I translated items from *Kultura* (a highly-regarded Polish periodical published in Paris) that Maliszewski was unaware of. Of course, his extraordinary discoveries in aerial photography were of great interest to me."

I soon realized that both of them felt they were involved in a work of profound significance. The reasons were historical and personal. This century has not only witnessed a world accustomed to killing, but to desecrating the bodies of the victims. The totalitarians of the Left and the Right had turned into mockery what the earliest humans surrounded with awe and ceremony. For burial not only binds the world of the living to those who made their own lives possible but unites all human life in the mystery of and respect for death. As Leo Tolstoy wrote in his incomparable story: *The Death of Ivan Ilyich,* "(Gerasim) ... did not find waiting on Ivan Ilyich irksome because he was doing it for a dying man, and he hoped that someone would do the same for him when the time came."

Schochet, a Holocaust survivor, and Maliszewski, whose father's cousin Bolesław was murdered at Katyń, were trying to seek answers to a problem that defied understanding. As Schochet put it: "This search is a leitmotif in our lives. Let me give you an example. I have a question that I know will not be answered, although I will continue to ask it to the end of my days. How can a man listen in the evening to Bach or Beethoven, and then get up in the morning, finish his break- fast, and go out ready to slaughter innocents?"

• • •

On October 4, 1991, I traveled to Schochet's apartment in Brooklyn Heights to meet Maliszewski for the first time. Maliszewski walked in carrying a large leather case, a young man looking very much like the tra-

ditional version of a family physician. He wore a suit and vest although
it was a warm day. His manner was quiet. Clearly he was very much at
home with Schochet and his wife Sally. Within minutes he was distributing
furniture polish that he has patented for the work that supports his very ex-
pensive interest in aerial photography, that of an antique furniture restorer.
He was obviously an old-fashioned kind of guest, one who doesn't come
empty-handed.

There was very little small talk. Maliszewski proceeded right away to
show me the results of his research. The dining room table was soon cov-
ered with maps and photographs. Schochet stepped into another room with
Sally. I assumed he had seen these maps before. Maliszewski's voice had a
curious literary quality, unaffected, but like that of someone who had done
more reading than speaking.

"It's incredible. The Nazi criminals shot these films which are help-
ing us to discover their own crimes and the crimes of the Russians." Mal-
iszewski had found out recently that the German air force had taken aerial
photographs over most major concentration camps and ghettos. Even as he
praised the skill of the German photographers and cartographers, he was,
like the rest of us, bedeviled by the monstrous character of their technical
excellence, particularly the photographing of their own crimes.

Maliszewski's recital was filled with some fascinating historical asides.
"The best maps of Russia before the Bolshevik Revolution," he said, "were
made by the Austrians on orders of Nicholas II, but the Germans improved
on these by the use of aerial photography, and expert geologists, geogra-
phers, photogrammetrists, people 'planted' in Russia before the war, and
members of the Russian nobility who fled after 1917." He mentioned one
such agent, Boris Shmislowsky, who had assumed the name of von Ra-
genau and worked for both the *Abwehr*, German Army Intelligence, and,
after the war, the Americans. It was quickly apparent that Maliszewski's
interests were encyclopedic, his memory prodigious.

I looked at one of the German maps on the table. It was a copy of
one he discovered in the New York Public Library. Printed in 1942 and
little known, it showed all the Jewish population centers in Poland and in
Northwestern Russia where more than ten Jews resided. It was made for the
Einsatzgruppen, the Nazi killer-detachments who went methodically from
one Jewish community to another and inaugurated the killings that were
the start of the Holocaust. Its symbols were all in blue - dots, squares and
triangles, each signifying population densities from 10 to 400,000. It was a
map of death.

"We are looking at the photograph of Kharkov, dated August 15, 1943,"
Maliszewski said, placing another map on the table, as he began to explain

some of his recent discoveries. He was pointing to an area of western Russia as if it were one of the boroughs of New York. I had taught Russian history for many years, and I was astonished how familiar he was with the terrain.

> We can see the German military positions, including tracks of military vehicles. Here's the road *Czarna Droga*, and to the left, an exit from the forest. This is obviously a very deep ravine. By 1943, the Germans had cut down the trees and the whole region was militarized. But you see these white marks about two kilometers from the village of Piatachatka? These are graves. But whose? There are about eighty such marks. These are very big pits, about ten meters wide. Here are marks made by a bulldozer. The people from *Memorial* [Maliszewski was gettinginformation from a group in Russia dedicated to finding and memorializing sitesof massacres] tell me that these may go back to *Yezhovschina*, the period from 1937–38, when Stalin's NKVD Chief Nikolai Yezhov carried out the executions ofmany thousands. There is a mountain and a village about fourteen miles south ofKharkov called Bezludovka. The Polish investigators have told me that many Poles were killed here.

I was astounded and not a little confused by the enormous amount of detail. Maliszewski, seemingly oblivious to my unfamiliarity with a subject so close to his heart, continued uninterruptedly. He bent over a stereoscopic viewer, that simple contraption that has had such a tremendous impact on aerial photography. I was now getting a crash course in photo interpretation. "Vertical photography has its limitations," he explained. "But elevation can only be ascertained with a stereo- scope or with an accurate contour map." He explained the methods of the German aerial photography. "The photos were shot in sequence with about 60 percent overlap, from which could be created a composite photograph called a mosaic, which was then used as a photo map. Each photo was accompanied by a flight plan, date, time, weather, elevation and scale. An oblique photograph, that is one taken at an angle, was also very useful because it showed what the earth surface looked like without the use of stereo pairs."

"Sometimes the notation on film by the German photo-interpreter could be very useful. The first clues about the burial sites in Kharkov luckily came that way. A German photo interpreter wrote 'Alexeyevka' on the print because the village had ceased to exist, having been incorporated into Kharkov proper already in the 1920s. It wasn't on any maps. In this 1941 photo, the photo-interpreter also circled the air force academy, the airport, an artillery position as well as NKVD military installations. Through an

analysis of the photo, I found that the entire perimeter of the forest was militarized. And as soon as I located the village of Alexeyevka I could see ground scars. When we blew up the photograph, we saw a road to a clearing where the ground disturbances were visible." I soon learned that the word "disturbance" had great significance. It frequently meant that the area was used for burial.

The discovery of a site at Sokolniki came as a result of research Maliszewski had done at the Wiener Library in London, one of the important repositories of World War II materials. There he found an issue of a *Soviet War News Weekly* published in December 1943. The publication described a forest near the Sokolniki settlement on the outskirts of Kharkov that was "densely covered with graves of victims of German Fascists." This was published several months after the discovery at Katyń.[4]

"To me it was a denial in advance of discovery," Maliszewski explained. The Russians, aware of the possibility that more graves would be located, wanted to identify the sites with casualties of the Germans rather than the victims of their own executions. We have the German maps and photographs of that area before October 1941, that is before the German entry into Kharkov, so we know that whatever happened on the ground was there before the Germans started their own bag of tricks. What we see are two very large trenches and smaller pits near Alexeyevka and the ravines and ground scars near the *Czarna Droga* of Piatachatka.

I've checked this against other photographs from 1940 - 1944 so there aren't any other phenomena such as lint or burn-in. Here is a trail at the perimeter and a footpath. Through the forest canopy we can see a broken line that I first thought was a rivulet or a floodwater brook. But when I studied additional photography of the area when the forest was bare because of bombing it became clear that there was a brook there. So how could Polish eagle buttons or uniform parts come to the surface to be discovered by Ukrainian children? One of the missing parts of the puzzle was that there was reportedly a Jewish cemetery in the area, but in the photographs of that time there was no sign of a cemetery. So, I appealed to Zbigniew Brzezinski, former National Security adviser to Jimmy Carter. The cemetery was crucial. I asked him if he could get me a recent photograph of Kharkov. He then called Director William Webster of CIA and gave him the German maps and photos I found. Webster said that CIA satellite photos were classified but agreed to have an "interest" plan reproduced using

[4]Alexei Tolstoy, "Nazi Gangsters Face Soviet Judges," *Soviet War News Weekly*, (December 23, 1943), p. 3.

the German map, the CIA photos and features of my specific interests. These, by the way, are so good that you can read a license plate on the ground - better even than the Luftwaffe wartime photos - and they made a composite and produced a plan for the region.

This was the first time that I had heard Maliszewski refer to help he had received, unofficially to be sure, from some of the highest officials in our intelligence community.

Maliszewski on more than one occasion asked the rhetorical question why the Russian and Ukrainian authorities would not allow the Polish teams to dig at Alexeyevka and Sokolniki. He suspected that this was because the Poles who were buried there were close to the mass graves of Italian and Hungarian officers who formed part of the Wehrmacht forces at the 1942 battle of Kharkov. Their remains have never been found and clearly such a discovery would be a major embarrassment for the Russian government. More recently Maliszewski found out that when Poles conducted exhumations at Piatachatka and asked if they could cross a fence, a KGB soldier responded: "We don't want to disturb our Hungarians." He was referring to troops serving in Hitler's armies, captured and executed in 1942 - 43, whose place of burial was never found.

He stopped momentarily. Alexeyevka, where no exhumation had taken place as yet, was one of his very important discoveries. He clearly wanted me to savor this.

> Here, look, in this area marked "B" we find a radio tower and there is the cemetery. Sometime in the past forty years a cemetery was established here. We know that men from the Starobielsk camp arrived not far from here and are buried quite near Piatachatka. There are many graves in this area because of the forests. The CIA tells us that there was extensive reforestation here and the 1944 photo- graphs indicate an intentional disturbance of the Czarna Droga-Piatachatka graves. Structures very similar to the *dachas* built by the NKVD can be seen. In area "B" near the radio tower is a flood rivulet. Buttons from Polish officer's uniforms were found through the washing effect of the water. As the tower foundation was being excavated, these items were brought to the surface. That's how the Ukrainian children played a game with eagle buttons from the coats of the dead Polish officers. It was like panning for gold.

• • •

Maliszewski's story about a recent visit to one of the men who went with a team of Polish-Americans to the exhumations at Miednoje and Piatachatka showed that not everyone was panning just for Polish eagle buttons. He had read in the New York Polish language paper, *Nowy Dziennik*, about a Kazimierz Lichnowski, a New Jersey man who had organized a truck convoy to carry gigantic steel crosses to the gravesite in Russia. Maliszewski who was not invited by Polish authorities to accompany this group, wanted to get some first-hand impressions of the terrain and took with him to New Jersey some maps of Kharkov and Miednoje to find what particular sites they were exhuming. Lichnowski, for whom Maliszewski had a uniquely Polish expression "Pierdzikrzyczywół" [farting-shouting ox], admitted that a great deal of drinking had taken place at the gravesites. He showed Maliszewski a photograph of himself sitting propped up against a birch tree, his lap filled with skulls and bones which playful companions put there while he was asleep.

Maliszewski who has seen many photographs of atrocities, still finds it difficult to describe what happened next. Lichnowski opened up a bag filled with body parts and military paraphernalia that he brought from the exhumation site. There was a jaw bone with teeth, the mandible still with shreds of flesh on it. "Officially we were not permitted to take anything away, but we all did it," Lichnowski con- fessed to Maliszewski. He intended to give the body parts away to various Polish clubs. He also brought back an embroidered banner that was sent by Polish President Lech Wałęsa to be interred with the remains. He confided to Maliszewski that he wanted to take back with him a tunic of a Polish general found at a grave in Kharkov but a member of the Polish Commission there would not allow it. He recalled that Father Zdzisław Peszkowski, a survivor of the Polish forces in Russia, and one who was there to bless the remains being exhumed, hid relics in his rubber glove. His rosary got stuck in an eye socket of one of the skulls. The Russian soldiers who did the digging apparently paid no attention to such desecrations, nor did the chief of the Polish expedition.

Lichnowski insisted that Maliszewski take a small bag with some parts of fingers with him and Maliszewski did so, torn between disgust at Lichnowski and his desire to respect the remains. He made up his mind to take this grim "souvenir" back to Poland, a mission he eventually accomplished. The finger bones were deposited in the cathedral at Kraków's Wawel, the resting place for Poland's heroes.

. . .

It was now late in the afternoon and Maliszewski wanted to show me photographs of Suchoje, an important area for a possible burial of Polish and

Finnish officers. "Here is Suchoje, on the same road as Miednoje, between Moscow and St. Petersburg. It was George Wildegrube who first brought it to our attention." Maliszewski was referring to a Russian Jew who settled in Houston about 1979. Wildegrube's father was an engineer who bought a *dacha* in Suchoje in the late 1960s. George, then a youngster, drank with many of the villagers. They trusted him enough to tell him stories of what happened in that region during the war. Prior to Barbarossa, the Soviets built anti-tank defenses around Suchoje. The villagers remembered that Poles built a road in that area in 1940. "I have studied the area intensively," Maliszewski said." I can identify in the aerial photograph what is a pig farm and what is a machine gun position."

What Maliszewski found in the photos of the Suchoje region was that the anti- tank positions that were meant to serve as an artillery redoubt were never actually used. The Germans did not seem to have much interest in Suchoje and never occupied it. But before the Germans invaded, machine gun positions were set up by the Russians, barracks were constructed and there was even a narrow, pre-existing gauge railroad to take the wood out of the forest.

"What's extraordinary about the road we are looking at," Maliszewski said, "is that it does not really lead anywhere. It shouldn't be there. One of the villagers told Wildegrube that Polish 'people' were buried in the anti-tank defense line." Maliszewski pointed to the dark area on the map which he described as an enormous anti-tank trench earthwork It was covered with surface vegetation, some wild legumes of the pea family that grew very quickly in calcified soil - that is soil filled with human bones. "These anti-tank defenses still have not been excavated," he said.

His voice was insistent. "Look at this area. No one has really talked about it. It's most curious." He placed the stereoscopic viewer over another aerial photo.

> There is a phenomenon called halation. It has to do with moisture rising from the ground. It may appear on film as a smudge. In order to distinguish that from a real image, you have to take a duplicate negative without losing a generation, and put it into a 50 mm enlargement. Here is an inlet to Lake Suchoje. It is a swampy region, rendering the word "suchoje," which means "dry," a cruel joke for the prisoners who were there without any shelter. This area shrinks in the months of August and September and becomes a bigger floodplain in the spring. Neither Wildegrube nor the villagers talked about this place. But nearby I found more than sixty pits. They may look like latrines but they're not. The Russians did not dig pits with that in mind. They peed

wherever they were. Now could these shapes have been something else? We know the direction of the shadow - it must always be towards you - so we can try to approximate the angle of the sun by holding the light in that direction. I mean, we have to be objective. Maybe these were haystacks and they collapsed into the center when they were wet. But when we study the shadows we see that these were not haystacks. These are pits. Burial pits. They are on a high rise of the land, a knoll. The NKVD did not plant potatoes here. They buried people.

We were peering into a God-forsaken swamp in northern Russia from thou- sands of feet up and Maliszewski's eyes were piercing that miasma-covered surface and finding graves. He explained that during the *Yezhovschina* killings in the 1930s the Russians used bulldozers when they wanted to excavate large trenches, the kind that were used for mass burials of the Polish and Baltic officers. Since almost every village had a quota of people to be killed, these pits could be found all over Russia.

"It's different from the United States, you know," Maliszewski added with more than a touch of black humor.

Aerial sightings in our country would typically show a Little League park in most communities. In Russia you would find burial pits in even the smallest village. Don't forget that a village of only 200 people could have had 30 percent or more of its population condemned to death. Sometimes these gravesites would be incorporated into an existing cemetery. At Vinnitsa, in the Ukraine, the bodies were at three locations. One was in a forest, another in a Jewish cemetery and one that was eventually converted into an amusement park. Just as in Katyń, an officer building was made into a sanatorium for children. The Russians were not overly imaginative in choosing places for burial. They used whatever location was available. There was a mineral-processing plant near Suchoje and so they had some pits already available. I could show you a number of gravel pits that became ideal places for burial. The Germans, on the other hand, preferred to use existing cemeteries, though they also used anti-tank ditches and ravines in Russia. They were better organized in Poland where their death factories made burials less necessary.

Maliszewski amplified on the difference between the German and Russian disposal of bodies. "The Germans," he said, "dug graves with care. They usually squared them off, measuring the same number of meters each time. I don't want to suggest that they always did that. At Krasnodar they

also put bodies in anti-tank positions and just bulldozed them over. The same thing happened at Kharkov. But most of the time the Germans dug pits with precision, as was the case when there were mass executions of Jews at the Dzierżyński ravine about twelve kilometers from Kharkov. At Kiev, the explosions at the Babi Yar ravine were symmetrical to hide the many thousands of Jewish victims."

His quiet voice was that of a bard reciting an epic. He placed a number of otherprints of Luftwaffe films under the stereoscopic viewer.

> Here is a photograph of Warsaw taken by a German pilot on August 5, 1944, right after the uprising that led to the destruction of the entire city and the deportation of most of its inhabitants. You can see that the houses are gutted, but clearly the railroad facilities are intact. There are several thousands of such pictures of Warsaw that may provide us with a record of German intentions. Zawodny is working on that topic. Here are photographs of the Łódź ghetto which was liquidated in August 1944.

I looked closely at the city where Schochet and I spent our young years. The outlines of the ghetto walls were clearly visible. My eyes were beginning to swim. He had two more photographs to show. One was a map of Smolensk that was developed for the German intelligence. Published in 1941, it showed the Russian *Schlachtbahnhof* (the train station designated as a place for the slaughter of animals), with its own railroad siding, where apparently many of the Polish officers found at Katyń were first executed. It also showed the Jewish quarter. Another aerial photo taken in 1942 told of the death of its inhabitants in one unmistakable image. The quarter had disappeared.

• • •

We had spent a day in Schochet's apartment looking at maps and photo- graphs. Although we had just met, I had the feeling that even though I was old enough to be his father, we had become friends. Maliszewski's story about his own family was a story of a universal hurt. Schochet's father died when they were in a concentration camp. I lost most of my family and all of my friends in Poland. We were in a timeless zone, survivors in one of the most cataclysmic centuries in human experience. The three of us, filled with mutual trust and goodwill, sat around a table covered with the historical horrors of Katyń. Sally, Schochet's wife, her face in an expression of concern, brought some refreshments. It was now, in a reaction to the scenes

of horror, a time for some banter as we moved to the room overlooking the street. The noises of the Brooklyn neighborhood filtered through the window. The throbbing cafe music, the loud and carefree shouts of young people, the distant wail of a siren, these were part of our world. Schochet's eyes, dark pools of memory, reflected the happiness of the moment. He and his friends, a young Polish Christian and a fellow Polish Jew, were applying balm to the pain.

Chapter 3

Chapter 3

*How I learned from Maliszewski about connections between the
history of a nation and a person. And how I discovered that the
art of an* ébéniste *may be combined with the science of aerial
photography in order to solve a fifty-eight-year-old mystery of
thousands of missing Poles.*

Wacław Godziemba-Maliszewski, an easygoing man with a difficult
name, prefers to be called Wacek (or Wacław) by his close friends, the Pol-
ish "W" sounding like a "V" and the "c" like a "ts." To many others, he
is simply "Willy." Tall and solidly built, a roundish face accented with a
mustache and topped with bushy brownish hair parted old-fashionably in
the middle, his looks combine the restrained strength of an athlete with the
outgoing intensity of an entrepreneur. He is in fact the owner of a respected
studio specializing in conservation and restoration of antique furniture for
customers as demanding as the Vanderbilts and the Du Ponts. But this is
only part of a most unusual life. At fifty-one, when many Americans of his
generation have given the words "me too" an all-too familiar ring, Malisze-
wski has made a commitment of time and money to rectify a historical lie,
to find the truth in one of the most complex deceptions of our times.

• • •

Maliszewski was born in 1948 in Leith, near Edinburgh, the child of
a wartime marriage between a Polish chief petty officer and a Scottish girl
who was his nurse. The couple met in an Edinburgh hospital. Maliszewski's
father had enlisted in the Polish navy at seventeen and was recovering from
injuries suffered on board the Polish destroyer *Błyskawica* [Lightning], a
ship known for its brave forays against the German navy in the early years
of the war. After V-E Day, he joined the Polish Resettlement Corps, an agen-
cy set up by the British for Poles who refused to return to their Commu-
nist-dominated homeland. He had his mind set on an academic career and
was accepted to Oxford, but the demands of a growing family, including
two girls, caused him to try the restaurant business. He entered the London
Culinary Institute and began his professional career as a chef.

The Scottish-Polish connection was a mixed blessing for young Mal-
iszewski. He remembers his maternal grandfather who, like his own father,

hid his true age and began military service at the age of fourteen in such faraway places as India and China. "His survival during World War I in the trenches was miraculous, though he did not escape unscathed," Maliszewski remembers. "His body was a map of battles, a topography of missing fingers and scars." He recalls that when he was five, his grandfather took him to local pubs and encouraged him to sip the foamy head from a glass of *Guinness* stout. The sound of the old man's wartime stories, the sight and smell of his clay pipe, its stem shortened so he could hold it between the stubs of his missing fingers, these are still among Maliszewski's most cherished memories. To this day, he credits his grandfather with "seeding" his imagination. He also recommends that his friends try a bottle of *Guinness* stout as an elixir.

But there was another side to the Scottish experience, one that dogged Maliszewski's childhood and created turmoil in his adult years as well.

I grew up with a feeling of facing a tremendous prejudice. When I was going to school in Edinburgh, and we lined up for the traditional Empire Day ceremonies, a teacher whom I now suspect of pro-Russian feelings always made a to-do about my name. I wanted to be Scottish, but instead I was carrying this tremendous sack on my shoulders, my name. I played a lot of rugby so nobody could give me a rough time. When I tried to talk to my father all I got was tears. My Scottish mother had read many books about Polish history, but she couldn't understand why I was having so many problems with a country I had never seen.

Names were a problem for the father as well, and he used the name "Walter Martin" in his early career as a restaurateur. Whether in spite of the old name, or because of the new one, what had started out as a necessity became a calling. He persevered, took courses in Paris, and was finally accredited as a *Cordon Bleu* chef. His reputation and business grew. But to this day his son is convinced that anti- Polish prejudice fueled by pro-Russian sentiments in Scotland made them feel unwelcome. The father was eager to try his skills elsewhere.

When I was about six, we moved to Canada. My father had secured a managerial position with the Canadian Pacific Hotel Group, but he met with reverses almost as soon as we arrived. The fellow who had interviewed him in Scotland had died. His successor had hired a Frenchman who didn't want a "damned Pole." We lived in a Ukrainian neighborhood, and I soon discov-

ered that Toronto was just as terrible as Edinburgh. The teacher did not seem to like little Polish boys from Scotland. All my schoolmates were allowed to pull the traditional Christmas tree from the field to school, and I was told to follow behind with the girls. I wanted to change my name in the worst way. I thought William would be perfect. In any case, we returned to Scotland after several months.

In 1960, when young Maliszewski turned eleven, the family emigrated to the United States. To this day he remembers the day of his departure. As they boarded the train at Edinburgh's Waverly Station that was to take them to the *Queen Mary*, a bagpipe band happened to be playing on the platform. The wailing sounds and the sight of his grandfather, his face streaming with tears, has remained with Maliszewski.

The move to the United States was crowned with success. The Maliszewski family lived for awhile in Vermont while the father worked in New York, his fame as a chef growing. They moved to Westport, Connecticut, and he eventually purchased the enormous, colonial-style Roger Sherman Inn in New Canaan, one of the finest French and Continental restaurants in the area. Chefs from Europe when in New York came to visit, among them the great Antoine Gilly. The cuisine at the Inn was so superb that guests flew in from Bar Harbor and elsewhere. But as young Maliszewski was growing up he had in mind another business, the personal, unfinished kind. He was desperately trying to make sense of his family's history. While their economic problems were behind them, the arrival in America was only the start of his emotional journey.

For reasons I still don't quite understand this coincided with a renewed determination to find out more about my family. My Polishness, which was to me a deformity that I had to hide when we were in Scotland and Canada, now became a badge of honor. I don't know if any boys my age were interested in genealogy, but for me it became a passion. I knew my father was descended from an aristocratic family. In 1864, after the unsuccessful 1863 uprising against the Russians, his relatives were forbidden the use of their ancient titles. My family name, z Godziemba Maliszewski, [the "z" indicating "from" the Godziemba clan in the region of Maliszewo] was one of the oldest in Poland.

Maliszewski has searched for his family records with the single-mindedness that he later brought to his search for his countrymen's remains.

He found that a Bishop of Płock was a "Godziemba Maliszewski" and the name was found in various "Acts" [records] from the earliest Piast dynasty, Poland's founding family. In a country where titles were and are of great social significance (to this day Poles preface their conversations with *Prosze Pana, Prosze Pani* for which there is no adequate translation except "I beg, dear Sir," or "I beg, dear Madam"), a family lineage distinguished the few from the many.

"Titles were often obtained through foreign entitlements," Maliszewski said, "particularly from the seventeenth to twentieth centuries, becoming almost a kind of business, with pseudo counts and earls all over the place." He tried to find as many family documents as he could and discovered that one of his forbearers, Michal, was a winged hussar. This regiment made up of nobles, served at the famous battle at Vienna's gates in 1683, where the Polish ruler Jan Sobieski lifted the Muslim siege, and where Maliszewski imagines that one of his relatives may have captured one of Mustafa's opulent tents trimmed with cheetah skins and jewels. To Maliszewski, his family fortunes and misfortunes were a reminder of Poland's glories and tragedies, particularly after the Partitions of the eighteenth century and the aborted rebellions against Russia in 1830 and 1863. After 1864, a few of his family were deported and the remainder lived in penury. Some of them had to work for the first time in their lives and a few went on to acquire university degrees. Most of what he found out about his family came from the study of family correspondence. Many of these records were destroyed during the London blitz, but he was soon busy deciphering the ones that remained and struggled with the French and Latin documents that belonged to his ancestors, discovering that a Vito Maliszewski was a student of Rimsky-Korsakov and became first the Director of the Odessa Conservatory, and in 1935, the Director of the Warsaw Conservatory.

> When I was about fourteen, I became very interested in the story of the Katyń massacre. I had heard about it first from my father. This subject was particularly painful to us since a cousin of his, Lieutenant Bolesław Maliszewski, was imprisoned at Kozielsk, one of the three camps set up by the Russians for the Polish officers in 1939. There was also a Dr. Maliszewski who as a member of the Polish Red Cross was assigned to go to Katyń with the German Commission in 1943 to research the names of the slain but could not go due to illness. In 1962, Notre Dame Press published the first scholarly work in English on Katyń by a Polish *emigre* professor, Janusz Zawodny. It was called *Death in the Forest* and was the first scholarly work in English on that topic.

I read it right away and it made an enormous impression on me.

His favorite subjects in high school were American and English literature, art and history, but he suffered from a case of severe stuttering. Maliszewski believes that this handicap enhanced his love for the English language. Hesitant and shy in school, he immersed himself in literature, especially poetry, and began to write poems. After graduation from high school, he continued his strong interest in art and enrolled in the Phoenix School of Design in New York. This institution was known for graduates who had become illustrators at magazines such as the *New Yorker.* He remembers going with his fellow students to the Metropolitan Museum and being asked to observe for a six-hour-period one particular object in the medieval armor collection. He chose a knight on horseback and had to draw this from memory the next day in class. A day later, the students returned to the museum and drew the object again *in situ* to prove how well they remembered the details. After a year at the Phoenix School, Maliszewski transferred his credits to the Silvermine College of Art in Norwalk. There the instruction was quite different. This was an experimental school, much like Antioch and other such campuses in the 1960s. As he recalled it, the place was filled with "renegade professors." It was the time of Andy Warhol, Roy Lichtenstein and Hans Arp. One of his professors, William Woody, had been dismissed from Yale for suggesting that his students "drop acid" while watching his famous slide presentation on Western Art. At Silvermine pot was the drug of choice. It could be smelled everywhere. Maliszewski, directed to "stare" at a 2' x 2' area of paving until he could see "everything," took up photography and discovered that he was more of a precisionist than an experimenter. Today he is convinced that the skills he acquired at Phoenix and Silvermine became the foundation of his work as a conservator of antiques and as an aerial photography specialist.

It was also at Silvermine that he met an academician who would have an enormous influence on his intellectual development. Professor Barca Tartaro provided the spark that rekindled his earlier interests in American, English and Irish literature. He persuaded the Dean to allow Maliszewski to change his major to literature and he was the only student to get a degree in fine arts with a major in literature. The sixties were a heady time for him as they were for many others. He was even permitted to teach a class in poetry at Silvermine and under Tartaro's guidance immersed himself in the writings of Ezra Pound, T. S. Eliot and James Joyce. He credits Tartaro with helping him to overcome his stuttering. The teacher suggested that Maliszewski read Allen Ginsberg, especially the poems *Howl* and *Kaddish*, aloud to himself. The poems were based on the Hebraic Bardic Breath, that is, the length and stroke of each line were related to the amount of air available in

the lungs. Maliszewski is certain that these exercises and growing self-confidence helped him to eliminate his stutter by the time he was twenty.

It was also Tartaro who influenced him to apply to Cambridge, where he was admitted as a seminar student in 1971. There he devoted himself exclusively to the study of modern poetry, particularly Pound. After a stay at Cambridge, he moved to Dublin to be near Tartaro and his wife Celine. For the next few years, he shuttled back and forth between New York, London and Dublin in order to be near his favorite teacher. Tartaro was a link with the past. Many years earlier, he had been the editor of a little-known magazine, *The Connecticut American,* a publication that was the first to feature the writings of Ernest Hemingway. From him and from his wife, a Joycean scholar, Maliszewski acquired a love of learning that has shaped his intellectual life. To this day he can easily quote from memory passages from *Ulysses.*

The decade from 1965 to 1975 affected him as it did countless other young Americans for whom the opposition to war in Viet Nam was connected with other rebellions and fulfillments. It was, as he put it, his period of "hippie life." His stay at Cambridge also coincided with a renewed interest in woodworking and ancient artifacts and he spent many hours studying the wood carvings in the King's College Chapel. But even before Cambridge, while at Phoenix and Silvermine, Maliszewski had worked part-time for the area cabinetmakers. He was also employed at an oceanographic company that specialized in research instruments for oil exploration and seismology. There he learned tool-and-die skills which later on gave him the edge in decorative inlay work. He traveled all over Europe from 1969 to 1979, visiting close to thirty countries, "from Portofino to the docks of Malmo." While "shuttling" between Ireland and America, he worked in Liskeard, near Plymouth, for Harold Marr, a "splendid old man of eighty," who taught him the fundamentals of English cabinetmaking. "He didn't hesitate to use a dowel on the back of my legs. He told me that this was how he learned." Maliszewski managed to visit Marr several times, learning everything from "cabriole legs to scotch-glue veneering, from carcass construction to lathe turning." Marr also did conservation and restoration work and Maliszewski learned to detect false wood, or "Dutchman," in the original piece of furniture.

But he soon realized that in order to learn the ancient crafts he would have to go to the home of the woodworking and marquetry artisans—that is, to France and Italy. In 1976, he settled for a while in Florence, awe-struck by Florentine architecture and art. One night in a bar he met Carlo Piatelli, a member of a family of ébénistes and conservators. Maliszewski then and there decided to take up residence in the artisans' quarter and studied under

Piatelli's guidance for three months.

> I learned of the great secrecy among those artisans' families, some of whom for generations had handed down their skills to members of their own family. Windows were barred and shuttered. Even families that knew each other socially would never dream of sharing their secrets in woodworking and particularly in the decorative processes. Italian polishing was an art that I dearly wanted to master, but Carlo would not share it with me.

He recalled one "lesson" when Carlo Piatelli pointed to a pile of tiny stones and asked him to separate them according to color. When Maliszewski told him that they were all the same, Carlo laughed at him. After staring at them for a day Maliszewski realized that indeed these polished pieces of agate were not of the same color, the variations being extremely subtle. "That's when I discovered what Carlo meant by 'learning to see,'" he said, "an essential quality for the craft of an ébéniste." It was Piatelli's son, Lorenzo, who seeing Maliszewski's work fifteen years later declared him to be an ébéniste.

I had never heard the term ébéniste before. Maliszewski explained that in a process of marquetry, or wood inlay, (sometimes called painting-in-wood), different species of woods were cut and tinted to create a picture. Chemicals such as acids or aniline dyes were also utilized. Materials as varied as ivory, tortoise shell, marine coral, horn, mother-of-pearl, and gold were used decoratively, in addition to such unusual woods as ebony, amaranth and mahogany. The ébéniste, he explained, worked out of a deep-frying pan filled with a very fine sand. The pan was heated constantly and then tweezers were used to place pieces of wood in the sand to create shadings through the application of heat. The process originated in Italy as early as the fifteenth century and made its way to France and Flanders. By the late sixteenth century, in addition to such centers as Florence, inlay work of very high quality came to be associated with the courts of the Grand Duke of Tuscany and the German Emperor Rudolf II. A century later the art of the ébéniste reached a high point in the reign of Louis XIV, the Sun King. His chief minister, Colbert, determined to make French products into standards of excellence, organized in 1697 the Manufacture Royale des Gobbelins, which included cabinet making. French colonies provided a variety of exotic woods. Colbert appointed as his chief ébéniste, Andre-Charles Boulle whose name was given to a technique of inlay utilizing shell and metal. But it was the period of Louis XV that came to represent the most elegant and elaborate marquetry, employing more artificial colorings to produce subtle shadings and perfecting new methods in cutting veneer. Apprentices had to

pass stringent tests for their masters, many years being required to produce a "masterpiece" for the approval of the guild. The famous desk presented to Louis XV by the craftsmen Jean-Francois Oeben and Jean-Henri Riesener took nine years to construct.

Maliszewski, following the traditions of apprentices in this demanding craft, spent one summer in Paris trying to find work in an atelier, but found the conditions there even more daunting than in Florence. He spent a great deal of time in the Louvre staring for hours at the work of such prominent craftsmen as Boulle, and the late eighteenth century ébéniste, Bernard Molitor. Maliszewski has also praised the creative talents of a twentieth century French ébéniste Jacques Rhulmann, who was the artist known for turning Art Nouveau into Art Deco and who designed the furnishings on the famous liner *Normandie*.

Considering his fulsome comments on the skills of the European craftsmen, it was surprising to hear Maliszewski's tribute to early American workmanship. Having worked in many of the finest private collections in Newport, Rhode Island, and Winterthur, Delaware, he had an opportunity to see the handiwork of the best American designers, such as the Goddards, the Townsends of Newport and William Seymour of Boston. "The reason the Americans became so good," he said, "was that England's taxation laws forbade the use of native ironmongers, except in the making of horseshoes. Because of these restrictions, ship and yacht designers developed ways of construction using better wooden joints. This had an important impact on furniture design as well, and with the exception of such English designer-craftsmen as Thomas Chippendale, Robert Adams, and Thomas Sheraton, the Americans were far superior to England's cabinetmakers."

In 1975, at the ripe age of 26, Maliszewski established his own company for furniture restoration and conservation, London Joiners of Pound Ridge, as well as a business Abbingdon Antiques. He was now called upon by the New Canaan Historical Museum and other institutions to advise on restoration of rare furniture pieces and appeared as an expert witness in New York and London courts to authenticate antiques. His clients eventually included not only the most affluent families, such as the DuPonts of Delaware and the Frelinghuysen's of New Jersey, but celebrities such as Bette Davis. Andy Rooney of *60 Minutes* stopped in often to see a shop that Rooney has referred to as the "Walt Disney World" of old tools.

• • •

Maliszewski's father was killed in an auto accident in 1979. "He had survived everything," the son said, "the naval battles of North Atlantic, Nar-

vik and Gibraltar, only to die as a passenger in a car crash. A couple of years before he died, my father was finally able to tell me things about his background without tears. Now I had to find out on my own." He began to search for family records and particularly for maps that would show the location of his ancestral estates in eastern Poland. One of his friends, a Mormon and a genealogist, told him of the location of family names in an underground archive in Utah. There, members of the Church of the Latter-Day Saints assembled a computerized data bank recording the names of millions of people (many from Eastern Europe and Russia) in the belief that all those whose names were known would rise on Judgment Day. One day his friend came up with another idea: "Why don't you look at the Luftwaffe photographs?" It was the first time that anyone had mentioned this particular source to Maliszewski, although he had spent many hours looking at maps of Eastern Europe in the New York Public Library and the Library of Congress. The reference was to seven million images, referred to as the GX series, that were made by low-flying German aircraft over Eastern Europe and Russia. The Germans, who photographed Russian territory long before the invasion and had flown 200 photographic missions deep inside Russia between January and June 1941, had assembled high-resolution pictures of potential battlefields and areas of strategic interests. The hoard of films included wartime photography not only of military targets, but also ghettos and concentration camps, and, as it turned out, evidence of Stalin's crimes as well. These German films were finally declassified in 1979, although historians largely ignored them. Maliszewski began to use them in the mid-1980s to search for his family estate, and in the meantime immersed himself in the work of Poirier and Gino Brugioni, expert CIA photo interpreters, who had also analyzed the films made by both American and German fliers of the Auschwitz-Birkenau death camps. It seemed to Maliszewski that finding his ancestral estates would be a relatively simple matter compared to the discovery of crematoria.

His first look at the German films was an epiphany. It was one thing to locate the ancient landholdings on maps, and another to see them on film. The moment he spotted the area of his family's nineteenth century estate between Łomża and Białystok on a high-altitude German aerial photograph, with the twin properties of Maliszewo Lynki and Maliszewo Perkusy and the meandering river Narew clearly visible, he felt he had arrived home.

> You have no idea how excited I was. There was Lake Maliszewski next to the villages of Maliszewo-Lynki and Maliszewo-Perkusy, an area settled by the two sons of Godziemba [the family name before "Maliszewski" was added to it] in the fourteenth century.

They did not like each other so they built separate for- tresses two kilometers apart. The castles, along the Narew were now only ruins. These two villages became associated with my family's name. Now it's mostly marshland, with some boxwoods and other hardwoods. After the 1863 uprising, the Russians expelled my ancestors from their estates and my family moved to Łomża and Białystok. My father was born in Białystok where he inherited some property from my grandmother, Urszula Jarmołowska, who owned land in Kamianka, near the Russian border. The Germans destroyed much of the Łomża archives during the war and I have not been able to find any documentation here.

But suddenly, as I was looking at the German aerial films, an idea hit me. It was as if a tremendous light bulb in my head had lit up. My God, it was incredible! All the things I had read about Katyń seemed to point me in that direction. If Maliszewo is there, what about Katyń? Could something new be discovered from these photographs about Kozielsk, Starobielsk, Ostaszkov and the sites of burial of the thousands of "missing" officers? I was especially interested in the northern railway routes because I knew about the stories of Polish prisoners being transported to the White Sea. Following the railroad lines would be crucial, because the Russians used them to transport their prisoners just as the Germans did.

He decided then and there to study aerial photography. It was to become an avocation and an obsession that would include knowledge not only of photography, cartography, hydrology and geomorphology but also of botany, military science, arboreal science, studies of the sun's angle at different times of the year, searches through old Baedekers, city maps and archival evidence finally coming out of Polish and Russian sources. His work as an ébéniste stood him in good stead. He recalled the assignments from art school, and he would stare at various areas of the cement floor in his studio and concentrate on a square foot patch for hours. Eventually he was able to detect a great variety of detail unseen at first glance - a photo interpreter's unique skill.

Maliszewski's work in photo interpretation brought him into contact with the specialists who were members of the American Society for Photogrammetry and Remote Sensing, an organization of a few thousand members which published the journal Photogrammetric and Engineering Sensing, and many texts on the subject. While trying to maintain himself in the business world of antiques and restoration, Maliszewski continued to

study aerial photography, and established contact with Zawodny, the man whom he has come describe as his "ex-academy professor for seven years." He had in the meantime spent a small personal fortune on photo- graphing maps and printing Luftwaffe negatives in laboratories employing a state-of-the art computerized enhancement.

But the search for the graves of the Polish officers brought on another discovery, one that belonged outside the geographical limits of normal human experience. In the process of sifting through the maps and films at the National Archives, Maliszewski found that the Germans had made horrific use of Stare Maliszewo and Wielkie Maliszewo, his family's ancestral estates. They built there the Treblinka death camp.

Chapter 4

How 1990–1991 proved to be a decisive year in Maliszewski's efforts to solve the mystery of the missing Polish officers. In spite of the questionable behavior of some Polish officials, he always believed that his eyes were "a gift from God" and the study of aerial photographs was to be proof of this.

The year 1990 was a critical one in the Katyń calendar. On April 13, at 2:30 in the after- noon, the TASS news agency announced that "materials obtained from the archives have established beyond any doubt that NKVD chief Lavrenti Beria, Merkulovv and their helpers were responsible for the crimes in Katyń forest." After a half century of lies, the Soviet leaders finally, albeit reluctantly, admitted responsibility for the Katyń murders.[1]

That confrontation with an historical truth had begun a few years earlier. In 1987, Warsaw and Moscow appointed a joint commission to clarify "blank spots," Gorbachev's expression for slow and controlled revelations of bloody deeds, all of them done in the name of an ideology to which he had committed most of his adult life.[2]

Within the crenelated walls of the Kremlin, unlike Bluebeard's castle, every locked door concealed horrors. Imprisoning Raoul Wallenberg, ly-

[1]TASS, April 13, 1990. Moscow News Weekly, No. 18 and 20, 1990. Also, Paul, ix, xix. Lech Wałęsa, *The Struggle and the Triumph: An Autobiography*, (New York, 1992), pp. 264–265. Cf. Simon Schochet, "Polish-Jewish Officers Who Were Killed in Katyń: An Ongoing Investigation in Light of Documents Recently Released by the USSR," in *The Holocaust in the Soviet Union: Studies and Sources on the Destruction of the Jews in Nazi-Occupied Territories of the USSR, 1941–1945*, eds. Lucjan Dobroszycki et al., (M. E. Sharpe, 1993) 237 ff.

[2]Elizabeth Kridl Valkenier, "'Glasnost' and Filling in the 'Blank Spots' in the History of Polish-Soviet Relations, 1987–1990," *The Polish Review*, XXXVI, No. 3, pp. 247–268. Russia's record for filling in "blank spots" may be gauged by the fact that her archives maintained as secret for a century documents of the Polish uprising of 1863 (!), Tadeusz Pieńkowski, in "Studia z Dziejów Rosji i Europy Środkowo-wschodniej, Materiały i Dokumenty," *Polska Akademia Nauk* (Warszawa, 1997) XXXII, p. 149.

ing about the evidence in the downing of the Korean Airlines Flight 007, countless purges at home and assassinations abroad, forced starvations of millions in a system of slave labor rivaling that of any Pharaoh—all this was done in the name of universal brotherhood. One had to conclude that for three quarters of a century the Soviet state was run like a criminal enterprise. Machiavelli counseled leaders to lie if necessary, but he also suggested that they could choose the truth, an even more potent weapon being less expected. He certainly did not envisage a society where leaders would deceive others not as a matter of state policy, but as an undiscriminating, automatic response.

As Gorbachev began to tack with the winds of change loosened in Eastern Europe, he seemed to be obsessed with the advice he gave to East Germany's leader, Ernst Honecker. Widely and variously quoted, it counseled that "he who does not learn from life is punished by it." It was a strange aphorism from a leader whose society was governed by rules of glacial orthodoxy. Still, the fall of the Berlin Wall in 1989 was an historic opportunity for not only a clever man, but one about whom the indestructible Soviet Foreign Minister Andrei Gromyko said that he had "steel teeth." Dialectics, the enshrinement of life's contradictions in a Marxist system, was a most cherished concept. If time was running out for the Soviet leadership, it was also an ally whose reliability had been tested throughout Russia's millennium-long history. Gorbachev assumed that there would be enough time to allow the still powerful KGB, the successor of NKVD, to maintain control of archives that had the potential not only of condemning past leaders, but of incriminating those still alive. The concern was understandable, if somewhat unwarranted. Western leaders, having failed for decades to sound alarms about Soviet crimes, would soon urge forgiveness for those atrocities in the spirit of reconciliation and future partnership. In our therapeutic times, the past had become worse than an embarrassment; it was an impediment.

Still, Katyń was *sui generis*. Americans may be guided by sentiment that smoothed the sharp edges of history, but for Poles the Katyń forest and the secrets it held had been a never-ending re-creation of suffering. The trickle of revelations about the massacre (which could never be discussed publicly) had pressed on the brain of the Polish nation like an abscess. In the meantime, Solidarity, helped enormously by Papal visits, accelerated change throughout Eastern Europe and in Russia itself. A political movement marched beneath religious banners. Even Jaruzelski sensed it was time to assume the mantle of reform. Significantly, he first acted to obtain changes in the way Polish history was treated in official Russian accounts and textbooks; he was still not ready to mention Katyń in spite of the fact

that he himself had been deported to the interior of Russia as a forced labor-er in 1939. But he was clearly unwilling to have history remember him, as former Defense Secretary Caspar Weinberger once described him, "a Rus-sian officer in a Polish uniform."

There was no time to lose. Already in October 1987 the Polish Commu-nist Party paper *Polityka*, carried an interview with Iurii Afanasev, a direc-tor of the State Institute of Historical Research in Moscow, who was the first to break the taboo by suggesting that Katyń must be discussed along with other "blank spots." In the Sejm, the Polish Parliament, Ryszard Bender, a professor at the Catholic University in Lublin, argued that future relations between Russia and Poland depended on the way Katyń was handled. In February 1988, fifty-nine outstanding Polish public figures sent an open let-ter to their counterparts in the Soviet Union, asking for a dialogue on Katyń. Most significantly, appeals for investigation appeared in the prestigious *Wo-jskowy Przegląd Historyczny* [Military Historical Review], a journal loyal to the government. Significantly, permission was granted to the Polish Cath-olic Church to erect a cross at Katyń, although the Poles who were now able to visit were not allowed to engrave the year of the killings on a memorial plaque. This was a crucial point because the year "1940" if allowed, would point an accusing finger at the Soviets.[3]

Still, Gorbachev could not be moved to talk about Katyń, let alone acknowledge the crime. Then, on March 7, 1989, Jerzy Urban, the Polish government's most unlikely spokesman for change went on record as say-ing that the crime of Katyń was committed by the Stalinist NKVD. TASS did not carry that portion of his remarks. Shortly thereafter, the Polish side of the Joint Commission established in 1987 refuted in detail the Burdenko report. Still the Kremlin continued its silence. Events moved more rapidly in 1990. A Polish military expert, Colonel Marek Tarczyński, wrote about Russia's role in the killings in *Wojskowy* Przegląd *Historyczny.* The Polish Prosecutor-General petitioned his counterpart in the Soviet Union to bring charges of murder against those responsible for Katy. The Russians could not ignore the issue much longer. In February 1990 they finally found archi-val copies of the Ribbentrop-Molotov pact, which anyway had been avail-able from German sources since the end of the war, but which the Russians denied existed. *Memorial,* a Russian group organized to commemorate the victims of Communism, sensed that they could proceed more actively and held a conference on Katyń in conjunction with an exhibit in Kraków. The

[3]Franz Kardell, *Die Katyn Lüge: Geschichte Einer Manipulation-Fakten, Doku-mente und Zeugen*, (Munchen, 1991) 283 ff. Gabriel Superfin and Vera Tolz, "So-viet Reaction to Official Polish Revelations about Katyń Massacre," *Radio Free Europe-Radio Liberty*, Report on the USSR (March 10, 1989) 9–12.

historian Liebiedieva, a member of *Memorial* and a scholar working for the Moscow State Historical Society, scheduled a news conference to reveal Soviet responsibility in the Katyń atrocity. In a remark whose significance was not apparent to many at the time, she noted "rumors of air photos." She also found references of cooperation between Germans and Russians in the movement of the Polish prisoners in December 1939. It had been known that there was an understanding between the NKVD and the Gestapo in handing over human cargoes at border crossings, but Liebiedieva now found references to collaboration between Russian and German rail specialists in the interior. Gorbachev could not maintain silence any longer. On April 13, 1990, he handed to Jaruzelski the so-called "Blue Files," documents that contained lists of Polish prisoners compiled by the NKVD. He called Katyń "one of the most serious of Stalin's crimes." Now Jaruzelski, who of course knew all along who was guilty, said that but for Gorbachev, the Katyń issue would have lain dormant for another fifty years.[4]

For Gorbachev, the process of gradually revealing only what he absolutely had to, while maintaining control and preventing an even greater disaster, had become a breathtaking tightrope act. Secure in the knowledge that the West would not take an advantage of his moribund empire, he had unaccountably confused his system with that of Britain's and assumed that it could somehow evolve into a commonwealth. The attention lavished on him by Prime Minister Margaret Thatcher and President Ronald Reagan strengthened his belief that he was indispensable to the changes that were sweeping Eastern Europe. But the piecemeal release of information about Katyń was to become a paradigm for his failures. Still, it would be two more years before another leader would pry more admissions on Katyń from the reluctant *apparatchiks*, an act designed to both reveal the truth and to embarrass Gorbachev.

In November 1990, as a result of a visit to Russia by the Polish foreign minister, additional pressure was placed on Gorbachev to make progress on the Katyń investigation. In a secret note to his cabinet he again referred to the need to resolve the "blank spots," (which some have translated as "white spots"), an expression that seemed to be used mainly in connection with Katyń. He instructed his prosecutor general to hasten the investigation into the fate of the Poles held at the Ostaszkov, Kozielsk and Staro-

[4]Jack F. Matlack, *Autopsy of an Empire: The American Ambassador's Account of the Collapse of the Soviet Union*, (New York, 1995) p. 284 ff. *Biuletyn Katyński,* (Kraków, 1992) p. 3 ff. Zdzisław Rurarz, "Nieznane Zdjęcia Cmentarza Katyńskiego," *Kontakt* No. 7–8 Paris 1988), pp. 74–85. Tadeusz Pieńkowski, "Doły Śmierci i Cmentarze Polskich Oficerów w Lesie Katyńskim," *Wojskowy Przegląd Historyczny,* No. 4 (Warsaw, 1989) pp. 214–233.

bielsk and to search the archives for other materials on the "repression" of Polish people in the territory of USSR in 1939.[5]

By 1990 no one who had studied Katy had the slightest doubt what the "fate" of those thousands of Poles was. The only question was what had become of the remains. Maliszewski had been busy looking at Luftwaffe aerial photographs at the National Archives for almost a year and had made his startling discoveries and conveyed his discoveries to Polish officials in the United States. In April 1990, an article in the *New York Times* announced that the Russians had identified a mass burial of the Polish officers imprisoned at Ostashkov in the region of Miednoje. Zawodny informed Maliszewski that information had surfaced pointing to the burial of Poles from the Starobielsk camp in the woods near Kharkov, and that children there had found Polish uniform buttons, decorations and coins. Polish workers constructing a hotel near Kharkov had seen at a bazaar the Polish *Virtuti Militari* medals and buttons. In July 1990, Maliszewski was the first one to locate and interpret photographs showing the likelihood of mass graves of prisoners from Starobielsk in the area of Alexeyevka, Piatachatka, and Sokolniki, all near Kharkov. The fact that these locations were near Jewish cemeteries and forests that contained hundreds of mass graves added to the difficulty of pinpointing burial sites. Maliszewski had earlier examined Luftwaffe films of that region and noted that while the German photo-interpreter singled out Alexeyevka, it was still not possible to find the precise location where the medals and buttons were found. He studied more intensively the areas where mass graves may have been dug, keeping in mind the statement of Brugioni's that "it takes 140 years for earth disturbances to disappear."

• • •

In February 1990, before Gorbachev's half-hearted admissions on Katyń and prior to the revelations of the discoveries in the Miednoje-Kharkov region, Maliszewski wrote to the Polish prosecutor-general, Aleksander Hercog, detailing his findings in the Luftwaffe photographs. The Polish government responded by sending a representative, prosecutor Blazej Sobierajski to New York to meet with Maliszewski at their Consulate. Maliszewski showed the Polish representatives the various photographs of Miednoje-Jamok, Kharkov, and other imagery bearing on the Katyń massacre. He also showed them the confidential Poirier report

[5]"O rezultatach wizyty w Zwińzku Sowieckim Ministra Spraw Zagranicznych Republiki Polski," K. Skubiszewski, in *Katyń: Dokumenty ludobojstwa, Instytut Studiów Politycznych Polskiej Akademii Nauk*, (Warszawa, 1992), pp. 127–131.

(which the CIA was still reluctant to make public) that proved how the Russians attempted to cover the traces of the massacre by bulldozing existing gravesites andremoving the remains. It took Sobierajski a few months to convince his colleaguesthat the materials were of great value.

In January 1991, Maliszewski, having received an official invitation from the deputy prosecutor-general Stefan Śnieżko, arrived in Warsaw with his impressive Katyń collection of 3,000 pages of documents and maps. He brought with him copies of the original German aerial photographs of Kharkov, of the northern region near Kalinin (Tver), and the area around Smolensk. He was deposed as an expert witness by prosecutor Zbigniew Mielecki. His presentation was meticulous. He drew attention of the Polish authorities to an unusual spot, whitish and kidney-shaped, inside the forest complex of Kharkov, and also to earth-disturbances near Piatachatka. In his opinion, this was a "thinning," an area where large-scale tree-cutting had taken place. Within the "thinning" there were white lines. He concluded that these were really roads leading to military installations. The ground disturbance in this area was regular in shape and obviously man-made. Maliszewski was of the opinion that this was where the remains of the Polish officers from the Starobielsk camp were located. He noted the importance of the Piatachatka area and Czarna Droga. These discoveries corresponded to reminiscences of General Anders that prisoners from that camp were shipped in the direction of Kharkov in early 1940. Poirier agreed with Maliszewski's findings and suggested that further corroboration could be found in the Luftwaffe photographs taken before and after 1941. Indeed, the wooded area around the city of Kharkov showed many such possible whitish spots. According to Zawodny, witnesses had testified that there were remains of Polish officers fourteen kilometers south of Kharkov, near a place called Bezludovka. Maliszewski investigated this area as well and found more potential gravesites, yet no exhumations had taken place there.

The materials that Maliszewski provided the Polish officials included not only rare items from the National Archives and the Library of Congress, but also the multi-volume transcript of the 1951–52 Congressional Hearings into Katyń, including complete documentation. He also offered suggestions for further research in the Wiener Library in London and the Bundesarchiv in Bonn. He informed the officials that the National Archives had the Smolensk NKVD files, and that other NKVD records touching on Katyń may be found in Germany. He made them aware that in the recently published book by Hedrick Smith, *The New Russians*, the author described at length how a burial place at Kuropaty in Belarus was found to contain

human remains and pieces of Polish uniforms.[6]

Soon after his arrival in Poland, Maliszewski was invited by Professor Kazimierz Godłowski, an archaeologist at the Jagiellonian University in Kraków to address the combined archaeology and geography faculties. Godłowski confirmed that the disturbances in the region of Miednoje were very likely mass graves. This was the area where the aerial photos indicated bulldozer striations and other disturbances. Professor Bronisław Kortus of the Jagiellonian University Institute of Geography also agreed that the ground disturbances at Suchoje were most likely graves. The nearly fifty photographs that Maliszewski gave to the Polish government contained notations that indicated gravesites, "hunches" that turned out to be correct when subsequent exhumations were made by joint Polish-Russian teams. Maliszewski also met with the officials at the Army Historical Institute in Warsaw and was interviewed on Polish radio. He was gratified that one of the experts in Katyń research, Tadeusz Pieńkowski, a civil engineer and an experienced cartographer, agreed to serve as his representative. Pieńkowski, who was imprisoned in Kharkov in 1940, was of invaluable help to Maliszewski. He represented him in various stages of discussions with government officials, with the faculties of Warsaw University and the *Instytut Katyński* in Kraków.

In the spring of 1991, prosecutor Śnieżko, in an effort to obtain cooperation from the Russians, gave information to the German press based on the imagery information provided by Maliszewski. On May 12, the German paper *Tagesspiegel* reported: "The graves are in Katyń and in the woods near Kharkov and Miednoje, though the latter two locations have not been confirmed. In order to do so Poland wants to provide the Soviet Union Luftwaffe aerial photographs of these regions." Cooperation from the Soviet side soon followed.[7]

But it was one thing to discuss research with specialists and another to persuade Polish government officials. Maliszewski tried to tell them that the time had come to apply a multi-disciplinary approach to the search for remains. He wanted them to involve geologists, botanists, archaeologists and others and to compare their findings with those in the 1951–52 Congressio-

[6]Hedrick Smith, *The New Russians*, (New York, 1990), pp. 121–125, pp. 127, pp. 128–130, p. 132, p. 142. See also, Louis Fitz-Gibbon, "Les Crimes de Katyń et de Vinnytsia," in *L'Est Europeen*, No. 211 (1988) pp. 41–61; David R. Marples, "Kuropaty: The Investigation of a Stalinist Historical Controversy," *Slavic Review* 53, No. 1 (Summer, 1994).

[7]*Tagesspiegel*, (May 12, 1991) When Prokurator Mielecki landed in Kharkov armed with the imagery and analysis provided by Maliszewski he was taken directly to the "Czarna Droga" site near Piatachatki, Kharkov.

nal investigation into the Katyń Massacre. He assumed that the Polish officials in the Ministry of Justice would quickly follow up on this freely given information, much of it completely new to them and their countrymen. Eventually the Poles did seek an inter-disciplinary analysis, though they did not release any of their findings to the press. According to Maliszewski, those who worked at the criminal justice laboratory did an outstanding job. There were twenty volumes of medical testimony alone. It was in the satellite interpretation and in cartography that the Poles lacked expertise. The lack of information helped to spawn lurid stories about Katyń in the Polish media. There was no need to sensationalize. The truth about Katyń was horrible enough.

• • •

Two exhumations were conducted by Polish teams in the fall of 1991, but Maliszewski was not invited to either of them. This rankled since he had been instrumental not only in providing the Polish authorities with enormous amounts of material but had pinpointed some of the soil disturbances that suggested the existence of mass graves. At times he has referred to those officials whose conduct he questioned as a "gang of six." When in 1990 Maliszewski first approached those in Poland who were interested in Katyń, he felt that his primary responsibility was to contact government officials. He soon found out that he was somewhat naive. Without his knowledge or permission, the documentation he provided those officials was given to Cesare Chlebowski, a member of an Independent Katyń Committee, who later published articles on aerial photography without reference to Maliszewski's work. The latter had assumed that this Committee was an official body but soon discovered that he was supporting a small army of scriveners who were using his information and publishing his findings without attribution. None of the members of that Committee ever responded to any of Maliszewski's letters or acknowledged his cartographic documents and analyses of photography - materials that no responsible scholar would use without attribution or permission. There was one especially egregious example of this. When Maliszewski was in Poland in January 1991, Tarczyński of the *Wojskowy Przegląd Historyczny* him at Śnieżko office and asked for microcopies of the materials that Maliszewski had sent, including the imagery of Katyń, Kharkov, Miednoje and several other sites. Maliszewski agreed to that and sent him fifty images. These were never acknowledged. Subsequently he saw numerous articles that made use of his materials without any attribution. Postal services are notoriously poor in Eastern Europe, yet that alone would not account for the fact that while all of Maliszewski's letters and materials seemed to reach their destination, none of their replies

ever reached him. Maliszewski eventually realized that the Independent Katyń Committee had excluded from their circle the foremost authorities on Katyń. "It was a closed society," he said. He was especially pained by their failure to take note of the pioneering work of Zawodny. Maliszewski came to the reluctant conclusion that the men of the Committee were part of the old academic *nomenklatura*, whose careers and publications had formerly adhered to rules of dialectical materialism. The *Review* had been an organ of the Institute of History, headed by a late Stalin supporter and writer Wanda Wasilewska, who accepted the Soviet version of the massacres at Katyń. "She wanted to convert the Polish eagle into a chicken," Maliszewski said. There were important exceptions. In addition to Pieńkowski and Mielecki, Maliszewski spoke glowingly about the work of the late Jerzy Smorawiński, the son of one of the generals killed at Katyń, as well as Professors Kostrzewski and Godłowski of Jagiellonian University.

• • •

A diary kept by engineer Jędrzej Tucholski, published in the volume Zbrodnia Katyńska: Droga do Prawdy [Katyń Murders: The Path to Truth] published in Warsaw in 1992, provides a graphic account of the exhumations and the difficulties connected with such research in the former Soviet Union.[8]

According to Tucholski, a team of Polish experts led by Śnieżko and made up of criminologists, archaeologists, specialists in weapons and uniforms and including clergy, filmmakers and reporters, went to Kharkov from late July to early August 1991 to conduct exhumations. This trip followed a visit to Poland by a delegation of military representatives in charge of Case No. 159, a Soviet designation for Katyń murders. The Polish side arrived without the necessary equipment, prompting even the KGB officials at the site to inquire why they had not asked for more favorable conditions! Members of the local *Memorial* groups attended as well. Another two weeks were allotted subsequently to Miednoje, in the vicinity of Kalinin (Tver).

The terrain to be exhumed was not far from the Kharkov-Belgorod highway. A wooded area, full of telltale depressions crisscrossed by trails, it was guarded by the military. When the Polish expedition arrived in Kharkov they still did not know the exact location of gravesites. Mielecki showed the Russians the CIA maps and aerial photos that Brzezinski and Maliszewski had produced, focusing on Sokolniki, Piatachatka and Alexeyevka areas. According to Mielecki, the Russians knew about Maliszewski's work and

[8]Jędrzej Tucholski, "Diariusz Ekshumacji w Charkhowie i Miednoje," in *Zbrodnia Katyńska: Droga do Prawdy.*

about the CIA maps provided by Brzezinski. "They knew they had to co-operate or face further humiliation by wider disclosure of our sources and materials," Mielecki confided to Maliszewski subsequently. The Polish del-egation found itself in the midst of a large contingent of KGB personnel, Russian journalists and some members of the *Memorial*. According to one of the KGB officers (who had brought with them a dowsing expert!), grave robbers came to this area in the 1970s. Instead of gold they found Polish in-signia and currency. The forests on the outskirts of Kharkov had been used since 1938 for the burial of Ukrainians, Russians, Poles and "God knows who else," according to one of the Russian army officers - victims whose identities have not been revealed to this day by the Russian government.

The Russian and Ukrainian KGB militia who were doing the digging soon found Polish uniform buttons, hat peak, binocular case and many bones. At first no skulls were located. The Russian general in charge, eager to terminate the search as quickly as possible, said to the Polish delega-tion: "Well, you've found some Polish things. What's the point of digging anymore?" The young soldiers quickly tired of the assignments haphazard-ly ordered by their superiors were unable or unwilling to comprehend the importance of the digging. The general was opposed to any search beyond August 8 in spite of the expectations of the Polish team that they would surely find a mass grave.

In the days that followed, often guided by the Luftwaffe photography provided by Maliszewski (Polish papers referred to a "certain American of Polish origins who provided Luftwaffe aerial photographs for our experts …"), the young soldiers, sweating profusely, came across some skulls and many remains of Polish officers. There was nervous banter as skulls and parts of jaws were taken to be cleaned in the criminal laboratory set up in the field. Parts of bodies were misidentified, and the Polish specialists were exasperated at a Russia that could not properly care for its living or its dead. In a number of the excavated graves the bodies were found in disarray, with some in a vertical position, the heads down. The digging revealed shoes, buttons, fragments of uniforms, officers' insignia, calendars, currency, a comb and mirror with the photograph of the famous Polish tenor Jan Kie-pura, and a canteen still filled with wine. More and more skulls were found, the gold and white tooth inlays glistening in the gray soil. The Russian soldiers could not comprehend why this awful detritus was inspected by the Polish team with as much care as might be lavished on Schliemann's Troy treasures. It was clear from the appearance of the bodies and the location of the bullets that some had been shot in the fields, while others were shot elsewhere.

The excavations were interrupted when the Polish experts went to Kharkov itself, to visit the NKVD headquarters on Dziernyński Street where the Polish officers from Starobielsk were said to have been murdered. The KGB chief informed them that the killings had taken place daily, about 100–120 men put to death in a sound- proof cell. From a series of interviews held with Mitrofan Syromiatnikov, one of the NKVD officers involved in the killings, the Polish team learned precisely what happened. The Polish officers were brought to the NKVD headquarters and their suitcases were promptly taken from them. They were then sent to the basement where coats and belts were removed. With hands tied behind their backs, they sat quietly and awaited their turn. After an official in civilian clothes verified each name, they were taken one by one to a soundproof cell and immediately killed with a shot to the back of the head. Upon hearing the shout of "allo," soldiers entered the execution chamber and removed the body, covering the bloody head with the soldier's overcoat. It is possible that those awaiting their turn could hear the muffled shots. The executions started in the evening and continued into mid- night. Two trucks were used to transport twenty to thirty bodies each, the victims arranged alternately head to foot. Syromiatnikov went with the first truckloads but eventually came down with hepatitis. He remembered that there was one enormous grave in the woods holding 500 bodies. The suitcases with personal belongings were also thrown into the common grave.

A year after the executions, another NKVD killer, Kuprij, dynamited the execution site. Syromiatnikov returned in 1943–44 with the NKVD chief to make sure that the ground was level at the place of burial. He remembered that among the victims was a woman. He had personally escorted her to the execution chamber. When her hands were being tied, a gold ring fell out of her coat. He retrieved it and gave it to the executioner. Midway through the exhumation period at Kharkov, members of the Polish expedition visited the Starobielsk camp where the officers were held prior to execution. The dilapidated buildings were locked and old people who lived in the neighborhood where the group of Polish generals was quartered were sought out.

The weather continued to be good. For those present it was difficult to imagine that people had been led to slaughter on just such a sunny day.

As the soldiers and the Polish team returned to the exhumation sites, their digging revealed many more personal objects. At site No. 30 these included belt buck- les, locks from suitcases, haversacks, scissors, officers' whistles, pieces of epaulets, watches, broken crucifixes, bent spoons, shaving paraphernalia, parts of eye-glasses, cuff links, medallions, paper money - the varied accumulations of men who held on to these objects with the single-mindedness of children. Mass was celebrated, attended by some of the KGB officers and Russian soldiers. Soil from Katyń was deposited in

some of the gravesites that held remains of Poles and Ukrainians. When a request was made for one of the skulls to be taken to the Church of St. Anne in Warsaw, a quick decision was made that such uses of remains would not be allowed. Still, "souvenirs" disappeared.

After several days, as the digging accelerated, more and more remains were found with items nearby that identified the dead as being from the list of officers compiled by Polish historians. The remains were cataloged, including thousands of unidentified bone fragments. A list of hundreds of prisoners was found with one of the remains, enabling researchers to match these names with other evidence. The Polish expedition was particularly moved when they came across the remains and the personal possessions of the two women officers executed by the NKVD. Somehow the sight of women's shoes, hair combs and blouse buttons provoked a greater shock than he sight of actual remains. By August 9, forty-nine sites had been explored, and seventy-four remains, including skulls, of Polish officers were located. The Poles and Russians, reaching the end of their joint effort, exchanged commemorative medals, a plaque was affixed noting, much to the annoyance of some local Russian officials, that the NKVD were responsible for the killing. Finally, flowers were laid at a cross, and coffins for the remains and the personal possessions found in mass graves were readied for a return trip to Poland. The team carried back hundreds of pages of materials garnered at the site. Additional studies were to be made by specialists in weapons, medals, uniforms and various insignia, shoes, buttons, belts, religious objects, and crafts produced in confinement.

On August 15, exhumations began at Miednoje, near Kalinin (Tver). Śnieżko was suddenly recalled to Warsaw (no one was told why) and Mielecki took his place. Polish newspapers printed stories that Śnieżko was recalled for drunkenness with a "Soviet General." The expedition was warned that the Miednoje region where they proposed to dig was a hazardous site. It seemed that from 1940 to 1948, a Siberian animal disease had afflicted cattle in the region and the remains of animals were buried there posing a deadly risk of infection to anyone from the bacteria still present in the animal parts. It was not clear whether this was true or just a clumsy attempt to frighten the search team. A general nervousness overtook the expedition. As Mielecki lifted up a "bone," those around him howled: "That's a pig, a pig's foot." An expert was summoned who informed them that it was only a root. There was strained laughter.

Soon more serious discoveries were made. The area had been used by the NKVD from 1937 to 1953 to bury Stalin's victims, but it now became clear that this was another mass grave for Poles. Pieces of dark blue uniforms, typical of the Polish border police officers who had been imprisoned

at Ostaszkov, were recovered. The smell that had accompanied the team throughout the excavations at Kharkov, permeated clothing and accompanied them to their hotel rooms, was now notice- ably stronger. They had hit upon a mass grave with human debris spilling out everywhere. Remains had to be separated with crowbars. Parts of bodies were still intact, mummified, the decomposition seemingly arrested.

In two days of exhuming, the soldiers found thirty-five skulls. Some of them were taken out of the ground with hair and mustaches still intact. The sight of the remains fully dressed in uniforms was macabre. Members of the Polish expedition could not get used to the sight of death and sought out each other for solace. A Russian officer, specialist in hygiene, removed some of the Russian soldiers from the job, claiming that they had headaches and were vomiting. Śnieżko, who now had returned from Warsaw, complained: "We have come here for an exhumation, not for games. They knew this would not be an easy job." Most of the Russian soldiers went on with their work and some sat under a nearby tree, told jokes and smiled openly. The Poles suspected that the KGB officials at Kalinin, displeased with the exhumation, were doing all they could to disrupt it. Indeed, on September 3, Gorbachev had received a message from the military at the site that the NKVD officials had interfered in the exhumations.

The Polish team took time to visit the monastery on Lake Seliger where the Ostaszkov camp was located. Before the war, the buildings had been used for children orphaned during the purges of the late 1930s who somehow "disappeared." After the Polish soldiers were killed in 1940, the site was turned into a camp for juvenile delinquents and was now a retreat for the aged. The team also visited a nearby cemetery where some of the Polish officers were buried. While at a nearby motel they heard that Gorbachev had just been overthrown in a *putsch* and that an Extraordinary Committee had taken over. Some expected a civil war to break out at any moment.

Unable to contact Warsaw or leave the country, the Polish team continued to exhume what were now three large burial sites. Around hundred skulls had been collected. While Yeltsin was fighting for his political life in Moscow and barricades were being set up, the Poles who had been digging up the remains of their compatriots were invited by their military hosts to a fine goulash dinner. The young Russian soldiers looking for any diversion wandered off, found and adopted five newly born, motherless kittens. The diarist Tucholski recalled how he and his colleagues went for a walk along the riverbank. It was peaceful. Tiny fish splashed in the water.

The Polish team had neared the end of the exhumation efforts. They had found close to 250 skulls and a large quantity of personal effects. Father Peszkowski who had escaped execution in wartime Russia, mixed the

soil from Katyń with that of the graves at Miednoje and decided to build a church at Katyń so as to spend the rest of his life praying for the dead. To conclude the expedition, the Polish team visited the NKVD headquarters on Sovietska Street. Approximately 6,300 Polish officers had been killed in the soundproof room of that building. The Poles and Russians held joint services there in their respective languages. Crosses were raised. A candle found among the remains in the mass grave was lit. Those assembled prayed and sang: "Sleep my friend, in a darkened grave."

On the return trip, the group made a brief stop at Katyń They went to the Gnezdovo station where the officers were presumed to have disembarked prior to being executed in the woods. While the old sign that blamed the massacre on the Germans was gone, the Russians had not yet seen fit to erect a truthful version. The area of the cemetery was neglected, overgrown with weeds. In place of the NKVD villa at the edge of the Dnieper River there was a children's sanatorium. The team now hurried back to Warsaw. They had been away for six weeks.

• • •

On November 19, 1991, Pieńkowski, Maliszewski's associate, was called in to Śnieżko office. Present, in addition to Pieńkowski, were Tarczyński, Mielecki, Stawryłło, and Hercog. Armed with Maliszewski's cartographic research as well as the interpretation of Luftwaffe photographs, Pieńkowski proposed the digging up of twenty-ones sites in the area of Katyń. Śnieżko informed Pieńkowski that the Russian *prokurator* had already notified him that preliminary digging was to begin in Katyń but that only two days would be allowed on November 21 and 22. Śnieżko had delegated Stawryłło to represent the Polish authorities and said that Father Peszkowski would go as well. Pieńkowski who represented Maliszewski at these discussions was taken aback at the short notice given by the Russians and the ready acceptance of the restrictions by Śnieżko. He spent two hours giving Stawryłło a crash course on what he must look for on the basis of Maliszewski's photographs and his sketches. These showed the results of the exhumations conducted on October 27 and 28, 1990. Of the twenty sites, twelve had not yielded any- thing and in the remaining eleven were found some partial bones, shoes, a canteen, parts of uniforms, buttons with eagles, belts and two skulls with the telltale signs of execution. Pieńkowski told those assembled that he did not understand the haste in accepting the Russian proposal, since exhumation in Katyń had been planned for April 1992. Śnieżko replied that he too could not understand why the Russians were in such haste and that was why he was only sending an observer. It was clear to Pieńkowski from the remarks made by Śnieżko at that meeting that

the Polish officials had little interest in acknowledging the help rendered by Maliszewski.

On November 20, 1991, the day after that conference and almost a year after Maliszewski's visit, the Polish authorities sent a delegation of their "experts" consisting of two lawyers and a priest to Katyń to fully document the results of the various exhumations and to see if further sites needed to be explored. The maps made of the site over the years (many of them drawn to improper scale), the efforts of the NKVD to exhume and scatter corpses and relocate the graves, the effects of time on the vegetation, the changes in road building since 1940 - all these were cogent reasons for a further investigation. It was clear that the area now dedicated as the cemetery was some distance from the original site, and that such distinguishing landmarks as the monument that identified that cemetery had been moved. The planting of pine trees had also helped to hide the original site. The Russians stipulated that no digging would be allowed in the northern and southern trenches, the very areas that Maliszewski had designated as likely to yield results, based on the Poirier report.

Pieńkowski letter of November 21 confirmed Maliszewski's suspicions about the "gang of six." He noted that Chlebowski had published an article, *Luftwaffe nad Katyniem*, [Luftwaffe over Katyń] without citing Maliszewski's work. As for his own research, Pieńkowski wrote that specialists at the University of Warsaw had been helping him in photo-interpretation work on Maliszewski's Luftwaffe photo- graphs, but that he did not have too much hope of publication. Two articles he had submitted to the *Military Historical Review* in the past year and a half had not yet seen the light of day. He thought that the editor, Tarczyński, was not really interested in them and that he preferred to feature materials submitted from the "gang of six." "It's all very sad," he wrote to Maliszewski, "but that's the situation. As long as there is any strength left in me [Pieńkowski had suffered a heart attack recently] I will do all that is possible to complete some decent research on these murders." He concluded by saying that Kraków's Katyń Institute had decided to award Maliszewski their medal.

On September 10, 1992, the Polish authorities finally took note of Maliszewski's concerns. Mielecki in most diplomatic language thanked him effusively for his "gift" of photographs and asked to be forgiven for the long silence. He had been on vacation abroad. He assured Maliszewski that his concerns about his materials being used by the Independent Committee without authorization were unwarranted, since that group is "connected" with the present government. He pleaded with Maliszewski that he should not assume anything was being done to put him at a disadvantage. "The Prosecutors in the Ministry of Justice in Warsaw who have any connection

with the crimes at Katyń have behaved towards you with all goodwill, and none of us has any intention of doing you the slightest unpleasantness." He noted that the Polish authorities expected to present the results of their investigation to the Russian government by the end of October and concluded his letter by asking Maliszewski to help him publish the Madden Report in Polish.

Even though Maliszewski was not able to see the exhumation process in per- son he had the satisfaction of knowing that he had discovered the sites at Sokolniki, Alexeyevka and Piatachatka. The process of finding additional sites has continued since only Piatachatka was partially excavated. Maliszewski is convinced that the remains of the officers are at the other sites as well.

Since the 1991 exhumations, Maliszewski has identified twice as many images of sites than had Poirier. One particular photo, hitherto unexamined and annotated by the Germans, shows the area Waldlager, just outside of the Gnezdovo station, the last stopping place for the Poles before they were forced into the "Black Marias" (trucks especially fitted to hold a maximum number of prisoners)[9] and taken to be executed. Waldlager contains mass graves contemporary to those found at Goats' Hills, just a few hundred feet west of Katyń woods. Prof. Stanisław Swianiewicz who was at Gnezdovo, but who at the last moment was ordered off the transport has written that the "Black Marias" backed up to the train, loaded the officers and then returned in a half hour for more. However, this timing does not correlate with the distance to Goats' Hills. "There are two Katyńs at Katyń," Maliszewski told me recently.

Maliszewski had learned through painful experiences that he could not trust some of the officials. He added that it will take a new generation of Polish historians to undo "the opportunistic mischief of the *nomenklatura* surrounding the corpse of Katyń."

• • •

By 1992 both Gorbachev and the Soviet Union he represented were gone. The new republics, whose territories contained thousands, if not millions of unmarked gravesites, were more preoccupied with feeding the living than counting the dead. A few of the officers of the former NKVD who have given chilling interviews about their role in the Katyń killings and other massacres had been pensioned off. In the vast cemetery of Communist misrule, the layered strata of bodies form a still uncharted archaeologi-

[9]For a full account of these conveyances and their history, see Jacques Rossi, *The Gulag Handbook: An Encyclopedia Dictionary of Soviet Penitentiary Institutions and Terms Related to the Forced Labor Camps*, (New York, 1989), pp. 56–57.

cal record of Russia's countless victims. Some of these sites surely contain remains of the Polish officers. Exhumations conducted in 1991 and 1992 jointly by Polish and Russian teams have revealed in places such as Kharkov and Miednoje the remains of more Polish officers, in addition to some 4,000 that were found in 1943 when the Germans first discovered the burial pits in Katyń forest. Many more sites remain to be found. Maliszewski has been searching for them from the skies.

Chapter 5

*How Maliszewski met with the Russian "Memorial" represen-
tatives in Warsaw in April 1992, discovered kindred spirits who
made him aware that suffering may ennoble rather than embit-
ter, and how I discovered the possible sources for his mission in
Katyń forest.*

On April 6, 1992, Warsaw began observing a Week of Conscience,
a commemoration started in 1987 by the Russian group *Memorial,* a four-
teen-thousand-strong organization of mostly young people whose purpose
was to establish memorial sites to victims of Stalinism. Our concerns ex-
tended to other lands of socialist misrule. On April 24, 1990, the Memorial
staged a vigil when the Chinese leader, Li Peng, who was responsible for
the massacre of students in Tiananmen Square, came to lay a wreath at the
Tomb of the Unknown Soldier near the Kremlin Wall. Though dispersed
by the Special Purpose Militia Unit and reprimanded at a court hearing the
group was not deterred. By late 1990, the Memorial, prodded the con- sci-
ence of the Russian people by placing a memorial to honor victims of Soviet
terror in front of the KGB building in Moscow, the infamous Lubyanka.
It was a piece of granite brought from the Solovki Islands where so many
Russians were sent to die. The stark simplicity of this monument sent a
powerful message. There was not much time left for the leaders of Russia
to reveal the truth about the decades of terror. Weeks of Conscience were
occasions for elderly victims and their families to assemble and exhibit ma-
terials on the Gulag. An important feature of those meetings was a Wall of
Remembrance, where they displayed photographs, documents and inquiries
about missing people. The late Andrei Sakharov, who referred to it as "the
conscience of the nation," supported this grassroots association from the
start. In spite of the fact that the peaceful activities of the Memorial took
place during the period of *Perestroika* and *Glasnost,* its gatherings were at
first forbidden by the Gorbachev-led government.

The meeting in Warsaw was held at the Independence Museum, a
Prince Radziwill Palace renamed for Lenin. The funding that was promised
by various institutions never materialized, but when it seemed that the meet-
ing would have to be canceled, private donations and offers of accommo-

dations enabled the participants to come. This historic assembly was made up of fifty-four delegates from the new Republics of Russia, Belarus, Kazakhstan, Ukraine, and from over twenty towns of the former Soviet Union. Localities such as Alma Ata, Kharkov, Irkutsk, Krasnoyarsk, Lvov, Moscow, Omsk, St. Petersburg, Kalinin, Vorkuta and Solovki Islands sent their representatives to Poland. A few of these names had a terribly familiar ring. They were associated with notorious prison camps and sites of mass burial. In recent years, Poles had established contact with the Moscow office of *Memorial*, and began collecting materials on their fellow citizens who had suffered repression in the former Soviet Union. Katyń was foremost on their list of concerns. The Warsaw meeting was sponsored by the Polish organization, *Archiwum Wschodnie* [Archives of the East] and its publication *Karta*. The opening day included art of the Gulag and photographic exhibits, such as the remarkable images by Tomasz Kizny of a mindless construction by prisoners of a rail line in the Siberian tundra, and a documentary showing the prisoners released from the Vorkuta labor camp in the 1950s. The veneration of photographs can only be understood as an affirmation of truth in an era when the very existence of suffering and sufferers was denied. Of the many items shown on the Wall of Remembrance, few made a greater impression than the torn patches of a dress, the sole garment of a woman imprisoned at Butyrki, the largest prison in Moscow, where 70–80 people were kept in rooms that measured 20 by 36 feet.

The *Memorial* meeting in Warsaw was a reminder that many in Russia who have never given up the struggle to oppose tyranny and continue, in spite of many obstacles, to remember the countless victims of Communism. A measure of their task may be gauged from an announcement that appeared in a St. Petersburg paper during the conference stating that it would be publishing a daily list of victims of terror for the next several years. Next to the conference hall, a computer bank was surrounded by people anxious to find names of friends and relatives who disappeared in the *Gulag*. In one week, there were close to ten thousand inquiries. Occasionally there were tearful reunions. Poles and Russians, their lives set apart by official enmity, found understanding in the commonality of suffering.

There was a moment of unease when Lev Kopelev, an eighty-year old survivor of Stalin's repressions, rose to speak unexpectedly. An expert linguist, he had been sentenced in 1947 to a ten-year term for speaking out against the excesses of the Soviet forces in occupied Germany. He was confined in a *Sharashka*, a term used to designate a relatively comfortable (by Soviet standards) confinement for scientific work on secret projects, a place made famous by Solzhenitsyn's *The First Circle*. Both Kopelev and Solzhenitsyn worked there for a time, and the character of Lev Rubin in the

novel is that of the scientist Kopelev. In 1976, when Kopelev published his volume of memoirs abroad, the Soviet government charged him with "bourgeois humanism," stripped him of his citizenship and expelled him to Germany. Kopelev who wrote how he cried when Stalin died in 1953, believed in the "benefit and greatness of the October Revolution," and the "righteous Lenin," even as he condemned the excesses of Stalin. In the introduction to his memoirs in 1983, he wrote that the Soviet system "is bad not because it is ruled by bad people, but because it lets good people do bad things."

As he rose to speak in Warsaw, Kopelev returned to that theme. "All of us were guilty," he said. "The most terrible aspect of the communist system was not that it was created by sadists and criminals ... but that good and honest people were forced to take part in the criminality." The audience looked at one another in an embarrassed silence. There was no applause.[1]

• • •

Maliszewski had been invited by Zbigniew Gluza, the Director of the *Archiwum Wschodnie*, to address the *Memorial* meeting sponsored by *Karta* and to share his research with various historical and scientific institutes. The Polish government also invited him to present a protocol on his work and he was once again deposed by Procurator Mielecki. Pieńkowski, his representative in Poland, arranged a series of technical lectures on geography and photo-interpretation at Warsaw University, the Łomńa Historical Society and the Katyń Institute in Kraków. As he had on a previous trip in 1990, Maliszewski brought with him a veritable cornucopia of documents from his personal archives and delivered to Polish authorities over 10,000 pages of materials. All this he transported at his own expense to Warsaw, hoping that the Polish authorities would make their own Katyń records available to him. He had sent money ahead for just such a purpose only to find out that there was no accounting for the disbursement of these funds. He received no materials from the Polish side. This was just one of many disappointments for a man who had to cast aside his earlier notions of "Polishness," characterized by old-fashioned courtesies. Indeed, Eastern Europe had now come to resemble a society for which the American-Sicilian word "Mafia" might be more appropriate. Maliszewski could accept as a normal occurrence being robbed by a band of gypsies. This happened while he was shopping in a store soon after his arrival in Warsaw and Maliszewski, with some help of other customers, trapped the youngsters in a *cul-de-sac* and

[1]Katarzyna Madon-Mitzner, "Tydzień Sumienia," *Karta*, No. 8, pp. 139–143 (Warszawa, 1992).

retrieved his passport and money. What upset him more was a request by an official that Maliszewski sponsor visas to send two beautiful young women for a trip to the United States as experts on Katyń, the official suggesting that there was money to be made in such a transfer of skills. Maliszewski found out subsequently that this "official" was an agent of the Polish Military Intelligence who had served under Jaruzelski.

The trip was memorable for the extraordinary survivors whose strength and nobility of character was to become a lasting remembrance of the Warsaw meeting. One of the individuals Maliszewski met at the conference was the octogenarian Jacques Rossi, who had spent thirty-seven years in the various camps of the Gulag and who had recently published *A Guide to the Gulag,* a compendium of terms, many of them scatological, used by the Gulag prisoners.[2] The Russian language is particularly rich in obscenities, and Rossi, a talented philologist, was an ideal author for this encyclopedia. Maliszewski, who had telephoned Rossi in Paris before his own trip to Poland and arranged for Rossi's arrival in Warsaw, found the Gulag survivor (he was scheduled to address the conference the evening following Maliszewski's talk) seemingly unaffected by the horrors he had witnessed and experienced.

"He was unbelievably animated," Maliszewski told me, when I spoke to him shortly after his return from Warsaw. "Rossi has the elongated fingers and the mannerisms of a Leonard Bernstein. I asked him how he managed to remain so buoyant after almost four decades in captivity and he replied that being confined in Siberia had the effect of preserving him in deep freeze. He was irrepressible. I was sure that his sense of the ridiculous must have been a factor in his survival."

Another philologist from Russia made a considerable impression on Maliszewski. He had noticed this man sitting in on the sessions of the *Memorial* and eventually they talked. Maliszewski discovered that he came from Rostov and had an advanced degree in both English and Russian philology. The man's manner and accent resembled those of an Oxford don rather than a survivor of the Gulag. After Maliszewski's lecture they met in front of the shabbily-prestigious *Hotel Europejski,* a well-known prewar Warsaw landmark that miraculously survived the almost total destruction of the city in World War II. Considering that he spent nights on park benches in Warsaw, the man's manner was almost elegant. He told Maliszewski that he had left Russia with just the clothes on his back. For over twenty years he had been confined in various psychiatric facilities, where he was medicated by KGB staff with drugs that were intended for use in veterinary schools. The drugs were so noxious, he said, that flowers wilted quickly after being

[2]See note 9, Chapter 4.

brought inside the facility. He was finally released in the mid–1980s but was told that he had to report to a KGB agent assigned to his apartment building. Maliszewski thought he was talking with someone in his sixties, but it turned out that he was in his late forties, a man almost his own age. After much persuasion, the philologist agreed to let Maliszewski take him to dinner, although he insisted that they get a pizza rather than go to the elegant dining room in the Hotel. When they finished eating, there was some food left on the plate, and the philologist, with some embarrassment, asked if he might take the remainder with him. He unbuttoned his jacket and shirt and revealed a plastic pouch that was fastened around his neck like a horse's feedbag. He carefully inserted into it the unfinished pizza pieces.

• • •

Maliszewski's slide lecture on April 9 created a sensation at the Warsaw conference. This presentation was meant to inform the delegates of the former Soviet Union of what had been learned from the overflights of their Republics by the wartime German aerial photographers. For those assembled, men and women who had spent their lifetimes viewing official photographs that were designed to deceive them, this was a very emotional experience.

Maliszewski began with a series of photographs that included images of other massacres such as My Lai in Viet Nam, Timisoara in Rumania, the graves of the massacred victims in Augusto Pinochet's Chile, images of the killing fields of Pol Pot's Cambodia, the World War II photographs of German concentration camps and the ravine in Babi Yar. Included in these initial images were wartime photographs of Stalin, which, being unretouched, were never seen by people in Russia or its former satellites. They also never saw the original photographs from which the executors of Stalin's policies (and later themselves victims of Stalin's terror), were removed, as in one memorable slide that showed Yezhov, the head of the NKVD during the height of the terror, first photographed with Stalin and then air- brushed out. Another unusual photograph, which illustrated Soviet skills at concealment was one showing the camouflaging of the entire Red Square done in order to confuse wartime German photo-interpreters.

Maliszewski's slides were meant to illustrate the technique of aerial photo analysis, particularly the study of shadows cast which gives clues both to time and position of the object. He demonstrated the importance of stereoscopic viewing, a technique I had seen for myself the previous year in Schochet's apartment. The audience was able to see how photographs taken before and after a disturbance of the soil surface offered clues as to what had transpired and the reasons for the disturbance. The group was fascinated

to hear Maliszewski explain his own contribution in detecting clues from the striations produced by the bulldozers used by the NKVD to hide the bodies of their victims. He also explained the limitations of aerial photography by showing that a particular earth disturbance could not be observed in early spring, when new grass appeared and that it was only when the grass died that the effect of the bulldozers could be observed. Another limitation was dealing with fourth-generation images, where some 30 percent of the original sharpness may have been lost. (The first generation was the actual film in the cam- era, the second, the Luftwaffe print that was developed, the third, the negative in the National Archives, and the fourth, the print that Maliszewski obtained from that negative). He emphasized to his listeners that his observations had been based on the study of the original generation in the National Archives.

The Polish audience was especially interested in German photographs of the Warsaw uprising of 1944. There were also photographs released by the American government in 1979 that showed Auschwitz-Birkenau - the people lined up to go into gas chambers and the deceptions used by the Germans to conceal the crematoria. The audience gasped when they saw in the aerial photographs that the guards at the extermination camp had their own swimming pool.

But it was the photographs of the Katyń exhumation in April 1943 - a massacre that Gorbachev acknowledged only two years earlier was committed by his predecessors, that held the audience spellbound. Maliszewski first showed them some of the slides that he had shown me earlier, particularly those of Suchoje, with many pits whose outlines could be clearly seen from the air, and where Maliszewski believed initially that the Polish officers from Ostaszkov were buried. He illustrated for the audience how he analyzed the transportation of the Polish officers from Ostashkov. It was not easy to establish the location of the camp, since the few who were interred and freed before their friends were massacred drew understandably different sketches of the place. Maliszewski integrated those accounts with aerial photographs and showed how the men first arrived by train at Ostashkov, were then taken by icy roads that skirted the city, and finally transported to the islands that made up the actual camp. He first located the right island through aerial photo analysis, then followed the road to Kalinin (Tver) and Miednoje with his red-lighted laser point. Shining a dot of light on a spot he said: "This is where they were killed, right here." The place had been verified by people who lived in the vicinity.

Maliszewski also showed slides from the Kharkov area where remains of Polish soldiers were found recently, some of this made possible by his interpretation of aerial photographs and augmented by CIA's drawings

of satellite photographs done at Brzezinski's behest. Much had changed in those areas since 1940. Maliszewski gave his Warsaw audience a lesson in many disciplines by going back to Russian pre-war photography of that region using a Dutch edition, the only one that carried photographs of the Kharkov Forest area. In this historical whodunit, Maliszewski was able to find first the burial sites of victims of earlier purges and then those of the Katyń era. I had seen some of those photographs in Schochet's apartment when I first met Maliszewski and remembered looking for the first time at Piatachatka, Czarna Droga and the changed topography of that area. An untrained eye would not notice that the pine trees of an earlier period were replaced by broadleaf ones, but Maliszewski could clearly see in the aerial photos what a trained detective would see at the scene of the crime and in the crime laboratory - signs that evidence had been altered.

Maliszewski shared with his audience material that was taken from both Solzhenitsyn's *Gulag Archipelago* and Rossi's *The Gulag Handbook,* of the Solovki Islands and the hundreds of camps and mass graves that remained to be documented. The photographs he showed revealed the equipment supposedly used for crushing shellfish at Solovki Islands, but which Rossi said was really used to grind up human bones to be scattered at sea - equipment similar to that used by the Nazis to obliterate all traces of their victims in Chełmno, one of the first death camps in Poland.

But to this day no one knows where all the bodies lie. Less than five percent of remains have been found. Maliszewski is convinced that he will get better results from the *Memorial* group search of the Miednoje area than had been obtained from the Polish search teams, since the former are also interested in examining this burial site for Russian victims since the 1920s. It is worth noting that areas that Maliszewski marked as "suspicious" when he first began to microscopically examine the Luftwaffe films have turned out to be those where remains were found.

• • •

The grim and gruesome subject of the conference took its toll. While the four lectures (including one at the Warsaw University Geography Department) gave Maliszewski immense satisfaction, he now looked forward to some of the side trips, particularly those related to the search for his family estate, the subject that first made him aware of the uses of aerial photography. One of the first places he visited east of Warsaw was Białystok, an important textile center before the war.

"I wasn't enamored of Białystok at all," Maliszewski said to me the week of his return. "It was a very seedy city, a terrible place. It was like the heart of darkness. I only went there to meet my relatives, who, as it turned

out were really not my relatives but made false use of my family connec-
tions. I thought I was going to see my impoverished kinsmen, and instead I
was invited into a palatial house with parquet floors and expensive carpets.
I found out that they had been part of the Communist hierarchy. But the
worst was yet to come. I wanted to go and see my grandfather's grave in
the Białystok cemetery and when I got there, I discovered that the plaque
which displayed my family name was gone and that my so-called relatives
had substituted the lettering of their own family branch. There was nothing
for me to say. I just wanted to escape."

An experience in a church in Białystok had made up somewhat for
the others. "I am not a regular church-goer. I am a Catholic, though not a
dogmatic one," Maliszewski said quietly.

> I wanted to go to a Mass while I was seeing my so-called rela-
> tives, so I went to theCathedral where I spent two hours. It hap-
> pened to be Good Friday, and there were several hundred people
> there, the crowd spilling out into the street where they listened
> to loudspeakers. I had the good fortune to get inside. I had nev-
> er been to a Polish Mass before. Hearing the chant, I literally
> felt my soul grow lighter. "Jezu, Jezu, Jezu," the massed voices
> that somehow symbolized Poland were chanted up and down
> the scale, a chant that had endured centuries of suffering, per-
> haps the same chant sung by men at Katyń as they went to their
> deaths.And the strange thing was that it reminded me of Allen
> Ginsberg's *Kaddish,* a poem dedicated to his mother, Naomi,
> where years ago I read those mantra sounds "caw, caw, caw," the
> crows rising in Van Gogh's wheatfields. It was uncanny, because
> there was a man standing next to me who really resembled Allen
> Ginsberg! I realized how those simple people all around me in the
> darknessof their lives drew comfort from their own mantras.

I did know of Maliszewski's great love for Ginsberg's poetry, but I
did not expect him to find echoes of the "beat generation" writers at a Mass
in a God-forsaken Białystok.

Maliszewski went once more to nearby Łomńa where he had given
a lecture to the Historical Society and where he had first spotted the family
estates of Maliszewo-Lynki and Maliszewo-Perkusy. Members of the Soci-
ety took him on a tour of those estates, now mostly agricultural settlements
along the banks of the Narew. The remaining ruins of the ancestral forts
were long gone. Maliszewski could see for the first time the area that he
had seen only on Luftwaffe photographs in Alexandria, Virginia, the estate
circled in the 1944 photos with anti-tank defenses and bunkers built by the

Germans. Now the scene was peaceful. There were storks, a meadow lark called *Pirkusy* as well as a duck called *Lynki*, bird names originally given the estates. Pines, boxwood, and alder trees were planted all around. It was the highlight of his journey.

• • •

The lecture and visit in Kraków, the home of the *Rodzina Katyńska* [Katyń Family], a group whose research about Katyń was conducted in secret through the years of Communist repression, was a fitting conclusion to Maliszewski's trip. Here he found officials who were eager to benefit from his research and offered to work on joint projects. One such example was a public prosecutor who met Maliszewski after his lecture and told him of her investigations into the execution in 1944 by the advancing Red Army of 150 members of the *Armia Krajowa* (AK), the Polish underground force. The massacres occurred at a place called Trzebuska, north of Rzeszów, in south-eastern Poland. The story about this first surfaced in 1980 during the heady days of Solidarity, but the imposition of martial law in December 1981 made further investigations impossible, although reports about it circulated in the underground press. She was astounded to learn that Maliszewski could deduce the place of execution from an article that had been written about that event. As Maliszewski explained it to her, these men were taken for a *pro forma* trial to an old brick factory and were then shot. What Maliszewski had done was to look at a very detailed American army map showing the brick factory and then had based his conclusions on a careful examination of the available roads that could have been taken by the NKVD executioners. The prosecutor intended to use a sonar device to locate some of the graves in the area indicated by Maliszewski and was hoping to obtain aerial photographs in the future to examine the remaining sites.

At the conclusion of his lecture, Maliszewski was invited to dinner by two academicians involved in Katyń research, Godłowski and Kostrzewski. They sat together in the *Dom Polski* [Polish Home], a medieval building with carved beams and old paintings. It was, as Maliszewski referred to it, a "sublime setting," and he described these men as "the stars that light up the dark night of Poland." He felt that this was the "Old Poland," a society maligned and misunderstood, whose virtues were symbolized by his hosts who devoted their lives to righting the wrongs of Katyń. Maliszewski told his hosts how the graves were "cannibalized," and he handed over to them the grim souvenir that the "grave digger from New Jersey" had stolen from Piatachatka. The academicians were appalled. Godłowski , an authority on the archaeology of the Bronze Age, confirmed that these were indeed finger

and bone particles and promised that the bag would be placed in a Katyń memorial that would be dedicated to all faiths. At a dinner when Maliszewski was honored with the Katy Medal by his Jagiellonian University hosts, he was asked to write about the behavior of men such as Lichnowski. "How could Śnieżko allow this to happen?" his hosts said angrily.

• • •

Half a year after Maliszewski's visit to Warsaw, two themes continued to reverberate through the weary Russian society. These are human dilemmas - what to remember and what to forget, but they carry a special meaning for a people whose leaders were involved in more killings than any other in history, no more monstrous than those committed by other leaders in this century but different because they were designed to kill their own countrymen.

In the Arctic region, the Solovki islands are mute testimony to the question of remembrance. There are those in the region who want to make it a tourist attraction. By 1990 the number of tourists grew to 32,000 annually and entrepreneurs have planned more hotels. The area is after all important for the centuries-old monasteries that dot the archipelago. Just ninety miles from the Arctic Circle, it is full of beautiful, clear lakes and a climate that is surprisingly mild, at least for a people used to a harsh climate. But it was also a place of exile during the Tsarist period and in 1923 one of the first labor camps was started there by Communists. It is the icy circle of Solzhenitsyn's *Gulag Archipelago,* that searing indictment of the barbaric imprisonment and deaths of many thousands. In an unforgettable pas- sage in his work, Solzhenitsyn has described a visit to the Solovki prison by the famous writer, Maxim Gorky. The officials, like the Nazis of Theresienstadt, attempted to show him the camp as a place of rehabilitation and cultural improvement. As Gorky was leaving a teenage prisoner ran up to him and proclaimed the place to be one of torture. Gorky ignoring these inscribed words of praise for the administration in the visitor book. The youngster was put to death as soon as Gorky left.

There were examples of exceptional bravery in the midst of the carnage. Professor Liebiedieva of the *Memorial* was present at the Warsaw meeting and in a recent article she took note of the ordinary Russian people, about cooks and nurses who not only brought food to the camps where the Poles were kept prior to executions but also smuggled out letters. Soprunenko, head of the NKVD department for prisoners of war reported to his superiors that twenty documents (probably letters from Polish officers to their loved ones) were intercepted) taken out of the camp by the interpret-

er Chekholsky. There was also a Tatarenko, commander of the prisoners' guard battalion, who a month after the Kozielsk camp empties left for his native village and killed himself. He left a note saying that he "could no longer stand the anguish."[3]

• • •

It was a brilliant spring day when I took the train from Philadelphia to Stamford to see Maliszewski's cabinet-making, antiques and conservation business about which I had heard so much. He had just returned from his trip to Poland. The peaceful and prosperous Connecticut countryside, with its boat-filled estuaries, reminded me of rustic Oxfordshire and the Thames. He met me at the station and drove me to Pound Ridge, where his studio, London Joiners, was located. Maliszewski had converted a nineteenth century carriage house into a spacious work- place. His antique shop, Abbingdon Antiques, was located on the second floor. A downturn in the economy had forced him to close it in 1991, but a year later he decided to reopen it.

Whatever expectations I had (and I was ready to see a craftsman's *atelier*, more European than American), nothing prepared me for the extraordinary mix of a working museum, a relic of bygone days with state-of-the-art technology to recreate the past and an artist's studio where creativity was wedded to a modern business enterprise. The large room looked as if a wave from a remote time had deposited intact the continental workroom of a Renaissance ébéniste. I recalled that Maliszewski described his shop as an American might have imagined it, the past recreated for effect, rather than for use. But the truth was that all the tools were there to be used.

When discussing the traditions of his art, Maliszewski spoke of "an invisible hand of art that passes through the ages," one that had enabled furniture designers from the Egyptians to the Renaissance to use veneers and other inlays. There was also, he said, a carry-over from one discipline to another. The process could be illustrated in techniques that linked dyeing textiles (as developed by the artisans in the Low Countries who had settled in Paris in the eighteenth century), to the coloring of wood. There was, I learned, considerable difference between a stain used in wood coloring when it is applied to the surface, and the kind of chemical process that is needed to permeate the veneer, where lavorate, an extract from Brazil, is applied to the wood to create a totally different coloring process and effect.

Maliszewski was a fountain of facts on woods and colors available to people in ages past when they had to rely on household ingredients. For instance, cream of tartar, present in most kitchens, is also a mordant, and

[3]*Moscow News*, 1990, No. 18.

such common vegetation as seaweed or carrots may be used for coloring. Lichens, a gray green fungus growing on rocks and tree trunks, was dried and ground for dyeing in times past.

But perhaps the most important element in Maliszewski's work were the tools of his art, a collection of which was visible on many of the shelves. I had heard him say that in repairing the old pieces of furniture it was often crucial to find the type of tool that was used contemporaneously to build or make repairs. His collection is not only of museum quality but is used for day-to-day work. Indeed, he some- times has to create his own tool for a special job. But even the high-tech tools in his shop, including a reciprocating fret saw that can vary its action from 40 strokes per minute to 2,000, depending on the material being sawn, is not crucial to his work. According to Maliszewski, most of the work is done by hand. Only five per cent is done by machines.

I saw pairs of old right and left-handed planes, used when the grain of the wood necessitated a change in direction ("just as it happens when you shave," Maliszewski advised). There was a mid-eighteenth-century chariot plane of English manufacture, though its design had not changed since Roman times. In many of the tools, the parts were often named for natural objects or parts of the human body, so that one has the "heel" of the plane, or the "throat," where the blade is placed, one thin blade referred to as a "witch's tooth." The tool was not just an extension of the human be- ing wielding it, but at times the naming suggested a social claim, as when a plasterer would refer to his wooden flat tray with a handle as a "hawk," comparing the shape of the tool and his use of it to that of a noble falconer holding his bird of prey.

• • •

It was late afternoon and the trees outside the studio cast longer shadows. I wanted to get Maliszewski's thoughts on possible connections between his skills as an ébéniste and those of an interpreter of aerial photo- graphs. "I have educated eyes," he said. "I can see what other people can't." In his approach to art, Maliszewski is an universalist. He always refers to the Greeks and their traditions. "They took things on the span of the handle - seven and a half inches - the same proportion that you find in the Parthe- non you will find in Chippendale and Hepplewhite. That and the golden tri- angle. It all comes from the Greeks. Even the proportion in Art Deco comes from the Greeks. The system does not change. Only the product changes."

There was a cubicle in back of the studio where I saw Maliszews- ki's Katyń archives. He had parted a curtain and invited me into different

"woods." On the wall were photographs of his grandfather and his father, the latter in a naval uniform. A dress sword and framed military decorations hung opposite Maliszewski's desk. The shelves were filled with books on Katyń in both Polish and English and the many volumes of the Congressional Report on the Katyń massacre lined another wall. Boxes and folders with aerial photographs and documents were stacked in every corner. It is probably the largest such collection in private hands in the United States.

The cabinet-making studio and the Katyń cubicle seemed to represent Maliszewski's two worlds. He has very strong convictions about that which is natural in our environment and that which disrupts it and destroys its harmony. He believes that it is impossible that a history of such evils as were committed in our century would not leave its traces in both the physical world as well as on our con- sciences. His study of aerial photography, his efforts to find the remains of victims, are not just an exercise in detective work and retribution but seem designed to complete the natural links of our existence that were severed in a world gone amok. Maliszewski's cabinet-making tools should not have to co-exist in our world with instruments that destroy life.

It occurred to me that only a person with Maliszewski's love of tradition and reverence for nature would devote so much of his life's resources to righting the wrongs of Katyń Only someone whose hands seek to reveal the hidden wood grain, who shapes the miraculous creation that a tree represents would not rest until he had exposed a hideous misuse of the earth and its gifts.[4]

[4]An interesting interview on the subject of Maliszewski's work as an *ébéniste* was conducted by Judy A. Juracek in *Surfaces: Visual Research for Artists, Architects and Designers* (New York, 1996) pp. 284–287.

Chapter 6

How Maliszewski, encouraged in his work by Zawodny, dean of Katyń studies, and Brzezinski, former National Security Advisor, obtained valuable CIA satellite imagery which has enabled him to search for additional burial sites, a cooperative attitude not reflected in the actions of Polish officialdom.

"A great Polish-American historian who has devoted his life to Katyń, who was forced out of some universities, who selflessly through all those years raised an enormous amount of capital from expatriate Poles and donated funds to buy computers, software, hardware, this man never even received a thank you from his compatriots."

Maliszewski was talking about Zawodny, the "father of Katyń studies," who had waged a lonely fight in the 1950s against a political establishment in Poland and abroad that sought to put the massacre in the forest down that Orwellian "memory hole." Zawodny was and is a fighter. He fought against the Germans in the underground Polish army. Afterwards, he used his pen in a valiant struggle to tell the truth about Katyń. Maliszewski has a scholarly temperament and observes all the requirements of the profession with the fierce dedication of a parent protecting his young. He is punctilious about his sources and is not forgiving of anyone who appropriates someone else's work, His sense of ethical conduct is as solid as the wood he works with. Maliszewski has been especially outraged by those in Poland who have pirated Zawodny's research. He could not understand why the Polish investigators failed to maintain contact with Zawodny, especially when they had received such an enormous amount of help from him, including archival material. "All they had to do was to install a fax line for him," he said incredulously.

Maliszewski's contacts with a number of Polish officials, people he has referred to as a "gang of six," or "confederacy of dunces," seemed to be an echo of Zawodny's experiences. Maliszewski has at times attributed the behavior of these Poles to years of communist indoctrination. "It's a genetic fact by now," he complained, "they have eliminated most of the good people."

But the support rendered Maliszewski by Brzezinski restored to a certain extent his faith in Polish scholarship, though Brzezinski is as far from a Polish identity as Henry Kissinger is from a German one. Brzezinski's skills as a political scientist, his experience as a National Security Advisor and his access to the intelligence community have made him an invaluable asset to Maliszewski. Now a member of the Center for Strategic and International Studies, Brzezinski worked in the 1950s under Merle Fainsod, the Harvard specialist on the Soviet Union, whose examination of the Smolensk Communist Party archives captured by the Germans established a new standard for research on the operations of the Communist Party bureaucracy. In 1990, Maliszewski wrote to Brzezinski and explained his research. When he returned from his visit to Poland in 1991, he contacted him again and raised the point that since each of those exhumed at Katyń were killed by a single bullet, this suggested that many of the officers were killed elsewhere and then brought to Katyń forest for burial. Brzezinski who went to Katyń in 1990 now began to show interest in Maliszewski's work. He provided Maliszewski with CIA intelligence culled from modern satellite images of the Kharkov area where Maliszewski was searching for possible gravesites.

When I visited Maliszewski in the spring of 1992, the table in his studio was covered with CIA maps provided through Brzezinski's good offices. We were soon looking at a map of Katyń generated from recent American satellite intelligence. This was the latest of many maps of Katyń that have both aided and confused researchers since the graves were uncovered by the Germans in 1943. One of the earliest maps was smuggled out by Polish Red Cross workers who came to the German exhumation. Some of these crudely drawn maps were part of the Polish underground archives, protected as if they were a national treasure, which they sadly were. The maps that were in the 1951 Congressional investigation of Katyń were similar to those used in a book published by General Anders in 1948. Those maps distorted the terrain and made it difficult to localize the phenomena of interest to historians.

We bent over the satellite map provided by Brzezinski. "The reason this map is so important," Maliszewski said, "is that without it the Poles had to rely on photogrammetry produced by the Luftwaffe in World War II. For example, trying to analyze the twenty-one holes that were dug in November 20–21, 1991, we can now point to this area with greater precision and know exactly where the exhumations were."

Maliszewski had put certain questions to Brzezinski relative to Katyń, which generated the pictures he had obtained from the CIA. As Maliszewski went over these images with me, his voice again had that singsong

quality that had become familiar to me by now. It was his requiem. He was again trodding the familiar trails in the forest, the Golgotha of his imagination, the terrifying "stations" on the forest's dappled ground where lifetimes were counted by footsteps.

"Both primary and secondary areas of interest are still heavily forested," Maliszewski said. "The roads located in the imagery in 1944 are still visible, though not as pronounced. They seem more like trails. The NKVD *dacha* is no longer visible, and two new structures, probably a house and a barn, are located to the east and west of the site of the *dacha*. A new trail leads from the main highway to the easternmost structure." Maliszewski was still angry that Śnieżko was willing to accede to the terms set forth by the Russians the previous November. Nonetheless, the results of the probes in the twenty-one holes, though meager, did provide a *prima facia* case for the existence of remains there in 1944. The satellite map sent to Maliszewski by Brzezinski would have made possible a more determined effort to find remains.

Some of Maliszewski's recent questions to Brzezinski had not yet been answered, and Maliszewski was particularly curious whether the Russians had gone into the area visited by the Polish team on November 20–21, 1991, once the twenty-one holes had been dug. That could have only been revealed through sub- sequent satellite photography. More recent satellite photography could also help in tracing the meandering of the Dnieper River, a natural phenomenon that over the years resulted in portions of land being closed off as the river cut into new channels and created islands and contours.

In July 1992, Maliszewski addressed a lengthy memorandum to Brzezinski. He referred to the holes dug in Katyń by a joint Polish-Russian team on November 20– 21, 1991, and requested an improved map that would include the area of the original graves as discovered by the Germans in 1943, the sites of the graves following the Russian exhumation in 1944, and the holes dug by the Polish-Russian team in 1991. If there existed an image of the site taken in November 1991, then obviously a comparison could be made between the Luftwaffe photographs and the recent satellite map.

Maliszewski wrote that the location of the original No. 8 grave was still "conjectural," and that it was probably in the southern trench pointed out earlier by Poirier, an area that revealed a cluster of pit-like diggings. The Poles were not allowed to explore this area in November 1991, and Maliszewski thought it would be useful to have a photograph showing whether the Russians had made any probes themselves after the departure of the Polish team. The area of the northern trench was also out of bounds to the

Polish team and Maliszewski wanted to investigate that more intensively. He also posed questions to Brzezinski in connection with Kharkov, a largely unexplored area and, to judge by the authorities' reluctance to grant full access to Polish investigators, one of potentially great embarrassment to the former Russian and present Ukrainian leaders. Changes in vegetation (*Czarna Droga* is now forested with broadleaf trees, whereas before the war they were pines) and the disappearance of some of the trails that could still be seen in the Luftwaffe 1943 photographs presented problems for investigators. The Polish commission there had been confined to certain areas, and the attempted coup against Gorbachev, which coincided with that Polish visit, made conditions even more difficult. Maliszewski suggested to Brzezinski that this area, particularly that which was examined on July 25, 1991, should also be mapped, the limited exhumations made the accounting of the officers from the Starobielsk camp difficult.

Maliszewski also raised with Brzezinski questions about Alexejevka, Piatachatka and Sokolniki, particularly since some of the possible burial sites were now under high-rise apartments, under *dachas* or were parts of existing cemeteries. "Only a shovel can prove what is there," Maliszewski told me when I was in his studio. He suspected that areas where the great battle of Kharkov took place and that showed the presence of scars in Luftwaffe photographs taken in 1944 may have been places of mass burial, particularly since those scars did not appear to have been made by bombs. Large sections of the forest around Kharkov area were cleared by General Timoshenko in connection with the important 1942 battle. "Anyone who knows anything about military affairs knows that when you are around a wooded area, your injuries are going to be much higher than if you cut down the trees." He added that in World War I, the French in the battle of Belleau Wood suffered many casualties from exploding wood particles, particularly the sap pockets in pines. "My microanalysis shows that this was where the graves were exhumed," he said in reference to the cleared area in the former woods. He added that the nearby collective farms most likely provided the tractors used in exhumations.

The 1944 Luftwaffe photographs showed massive and selective destruction of the forest, The Russians sought to explain the disturbances at Piatachatka by saying that Ukrainian children found Polish eagle buttons and medals at play near an enormous apartment complex, and that these items found their way to a Kharkov bazaar in 1971. But, as Maliszewski has insisted, surely in 1944 the children were not capable of leveling trees over these graves. More detective work followed. He discovered a German propaganda film of 1942 that showed the battle of Kharkov. He was able to stop the film at a precise frame and found that 22 minutes and 50 seconds into

it German bombers were seen over the Kharkov forest where the Russian troops advanced into Piatachatka. By noting what area was being bombed Maliszewski was able to establish which portions of the forest were destroyed through enemy fire and which were either cut down by Timoshenko's troops to avoid injuries from the exploding timber or for the purpose of mass burial.

The Miednoje site was another one that Maliszewski wanted to investigate more intensively. The Polish-Russian team that was there in August 1991 had not been allowed to explore it fully, particularly the grounds on which the KGB *dacha* stood. The Russians had made a habit of building Communist Party retreats and erecting apartment houses on the grounds of mass burials. Well-constructed government buildings and numerous *dachas* were conveniently erected over gravesites at both Miednoje and Piatachatka. The CIA maps provided by Brzezinski, when compared to contemporaneous Luftwaffe films, rendered a vivid account of how the Soviet secret police masked mass graves by erecting houses, radio stations, as well as building roads on those sites. It was possible, Maliszewski concluded, that after the German discovery of the bodies at Katyń, the Russians began to frantically scatter remains from other mass graves, such as Vinnitsa, Kuropaty, and the Solovki Islands. It was certainly proven that they did this after they recaptured Katyń in 1944.

Maliszewski did not think that the Polish government lacking funds and the Russians, lacking inclination, would conduct thorough exhumations. Perhaps symbolical cemeteries would be established at each of the gravesites and a few bodies would be interred and memorialized. "This is not the way it would have been done in America," he concluded.

• • •

Part of Maliszewski's lengthy letter to Brzezinski in July 1992 was devoted to an analysis of the "politics of Katyń," a subject both painful and important to him. Painful because it raised question about the honesty of the Polish officials in general, and important because it bore on his own research and need for future cooperation, particularly with such important sources as Brzezinski. Maliszewski wanted to explain why he had not turned over the maps he had received from him to the Katyń Commission of the Polish Justice Ministry. He argued that he was not a native-born Pole or a trained political scientist, and that he had serious misgivings about the attitudes and actions of the Polish officials, an impression he had from very start of their contacts in New York in 1990. Some officials, he noted, had been connected with the intelligence services of the Jaruzelski government

and not considered trustworthy. He criticized the choice of Śnieżko, who reminded him of Jackie Gleason's character Ralph, the truck driver from the *Honeymooners,* whose eyes were always darting. "Like the double swishing of a horse's tail," Maliszewski said, "he never looked me in the eye." The choice of Śnieżko, since then a member of the Polish Senate to head the investigation, was in his opinion unwise and could lead to politicizing the work at Katyń. "Śnieżko," Maliszewski said with considerable feeling, "never asked Zawodny to serve in any official capacity - instead he was advised by an electrician, Tucholski."

Except for Mielecki, Maliszewski had little good to say about those around Śnieżko. Sobierajski, sent over by the Katyń Commission to interview Maliszewski early in 1990, had claimed when in New York that he did not speak English. Yet, three-and-a-half months later, when Maliszewski formally presented his protocol in Warsaw, Sobierajski spoke to him in perfect English. When Maliszewski visited his luxurious apartment, he was shown "documents" with Jaruzelski's signature secreted behind picture frames and was told by Sobierajski that he was once in the Polish secret service. These contacts had their comical aspects. Maliszewski, whose Polish is rather limited, was suspected by Sobierajski and colleagues of being a CIA agent who only pretended that he did not know Polish!

"They found it hard to believe that an American citizen, who is an antique furniture expert, and a conservationist could also be a photo-interpreter and specialize in the imagery of the former Soviet Union," Maliszewski said more with bemusement than resentment. As for the Warsaw group, Maliszewski quoted William Butler Yeats: "Was there ever a dog that praised its fleas?" He more or less agreed with Zawodny that "Katyń had become a political football."

Maliszewski concluded his long letter to Brzezinski by suggesting that the release of these important documents to the Polish authorities might also complicate relations with Italy, Hungary, the Baltic states, as well as Russia and the Ukraine, since it was possible that their nationals were also buried in those areas. He was convinced that the Russians have been slow to follow up on exhumations in the areas of Kharkov and Miednoje because these contained the remains of other nationals.

Brzezinski was not exactly happy with Maliszewski's reluctance to forward all his materials to Warsaw. His long service in government and academia had taught him just how injurious politics could be, especially to those who do not know how to use them to advantage. He may have sympathized and even agreed with most of Maliszewski's complaints, but he had a larger picture of the unfolding events before him and believed that one must do what is right and let the other side make all the mistakes. A seasoned dip-

lomat, old enough to be Maliszewski's father, he insisted that Maliszewski send all his research promptly to Warsaw. "It must be sent," Maliszewski quoted him, "but retain copies for future use." He had his secretary write a short message to Maliszewski restating that opinion and indicating that he was not ready "for the moment" to honor further requests. Maliszewski decided to abide by Brzezinski's suggestion. Within days, Brzezinski's secretary sent a message that if Maliszewski would provide "a very specific, narrow request, he will be glad to pass it along to the CIA." Certainly Brzezinski must have realized that if it were not for the materials that Maliszewski had been sending to the Polish authorities since 1990, they would not have succeeded in finding many of the gravesites.

Maliszewski's contacts with Brzezinski were complicated by a story written for a Kraków newspaper by the journalist Stanisław Jankowski, with a banner headline proclaiming Maliszewski's use of "super-secret CIA maps." The American Consulate in Kraków alerted Brzezinski to this and relations with Maliszewski were strained for a short time. In any case, Maliszewski was once again able to get the all-important maps from Brzezinski who now writes him personal letters with "warm regards." For time being, peace has been restored among the truth-seekers. It had not been easy for those involved in the affairs of state to find an individual such as Maliszewski, a man without a political agenda who pursues truth for its own sake.

The Russian government has now offered to sell its satellite imagery, some of it of exceptional quality, to anyone who can afford it, including a Soviet satellite photograph of the Pentagon. The passion for secrecy may be cooling, but it is one thing for the Russians to release photographs of the Pentagon and the White House, and another to reveal the shameful topography of wartime killings. The truth about Katyń has emerged not because the Russians have been forthcoming with information, but because dedicated individuals, such as Zawodny and Brzezinski, have provided crucial bits of information to researchers like Maliszewski. The truth-seekers are not many, but they are effective.

Chapter 7

How a document by a mysterious "Georgy Novgorod-Sever-sky," an alleged eye- witness to the exhumation in 1943, as well as testimonies by eyewitnesses, Dr. Marian Wodziński, Ivan Krivozercov and others call for caution in considering "wit-ness" testimony, and how Maliszewski resolved this contradic-tory evidence and pinpointed places of execution and burial in Katyń forest.

When Maliszewski began to organize his research, it became clear to him that the Katyń story had been manipulated by friend and foe alike, and that in order to find the truth it was crucial to return to original sources, particularly eyewitness testimony. A half century of lies had made it difficult to separate wheat from chaff. According to him, a Russian proverb, "he lies like an eyewitness," which may have been in use during the purges of the 1930s, was particularly appropriate. Lies and misleading statements had made Katyń one of the most perplexing problems of wartime histo-riography. The task that Maliszewski faced was to find the truth buried by friend and foe alike in a forest of lies.

Facts and Documents was edited by Professor Wiktor Sukiennicki and published by the Polish Government-in-Exile in London in February 1946.[1] Restricted and marked "most secret," it was a key document, one of the most trustworthy early sources, and yet it was an example of how docu-ments could be and had been manipulated. Several editions of *Facts and Documents* were published, each version less reliable than the original. By the time the Select Committee Hearings of the U.S. Congress on Katyń were held in 1951–52, many of the "facts" in *Facts and Documents* were altered to suit the parties concerned. Professor Jan T. Gross, author of *Revolution from Abroad*, found that the questionnaires handed in by contemporaneous witnesses to the Katyń massacre were altered and tampered with by the Bu-reau of Documents to suit the political agenda of the Polish Government-in-Exile. Both Sukiennicki and Anders, the leader of the Polish armed forces who was instrumental in urging that the information be collected while the

[1]"The Mass Murder of Polish Prisoners of War in Katyń," *Facts and Documents Concerning Polish Prisoners of War Captured by the U.S.S.R. in the 1939* Cam-paign, (March 1946), pp.1–31.

events were fresh in the minds of those who had been imprisoned in Russia, were not party to those changes and "obfuscations." For Maliszewski, whose devotion to Poland's cause was rooted in filial faith, this research and its fruits were to become a source of bitter disappointment.

Palo Alto, a town known for the prestigious Stanford University, is also home to the important Hoover Institution on War, Revolution and Peace. When Gorbachev visited the United States, he was invited to see some Bolshevik artifacts (such as the first issue of *Pravda*) that were no longer available in his own country. Hoover is known for its Boris Nicolayevsky Collection, named for the Menshevik leader who was able to smuggle from Paris exile priceless archives, particularly those touching on Leon Trotsky and his friends and enemies. This has made Palo Alto a mecca for Kremlinologists and collectors. Jerzy Szwede, a Polish book dealer in Palo Alto specializing in Polish and Russian materials sent Maliszewski a manuscript by an "eyewitness" to the German exhumation in 1943.[2] The thirty-page Russian language document, entitled: "Monstrous Bolshevik Crimes in Katyń forest near Smolensk, and in the town of Vinnitsa: Execution of 12,000 Polish Officers," was published in 1947 by a Reverend "Georgy Novgorod-Seversky." The original work was discovered by Szwede in the Library of Congress.

It was Maliszewski who found documents that revealed the identity of the mysterious pastor in a box of Congressional materials declassified after forty-three years. Dated January 21, 1951, and addressed to John J. Mitchell, Counsel for the Investigating Committee by Congressman Roman Pucinski, they identified "Georgy Novgorod Seversky" as Pastor Sergeyenkov. Congressional investigators located the sixty-six-year-old Sergeyenkov, who did not speak English, at St. Joseph's Hospital in Iowa. Admitted to the United States as a Displaced Person in December 1950, Sergeyenkov was a Greek Orthodox pastor who had lived near Smolensk in 1916 and returned to Poland in 1920. He resided in a community near Białystok for over twenty years, was taken prisoner by the Germans in 1944 and kept in a concentration camp near the city of Brest. According to the deposition made to Congressman Pucinski, the Pastor met Kazimierz Gorczakowski, an old friend, in this camp. Gorczakowski, who was a railroad worker at Smolensk until 1943 when he was captured by the Russians, informed Sergeyenkov that he witnessed the transfer of Polish prisoners from Smolensk at the Gnezdovo rail station in early spring of 1940 when they were detrained and

[2]"Georgii Novgorod-Severskii," (Rev. J. Sergeyenkov) "Chudovishchnye bol'shevitskiye zlodeiania v Katynskom lesu pod Smolenskom i v gorode Vinitze," [Monstrous Bolshevik Crimes in Katyń Woods near Smolensk and in the Town of Vinnitsa] Typescript, 1947, *Library of Congress*, pp. 1–30.

placed on trucks. According to Gorczakowski this happened at a siding just north of Katyń forest, a siding not shown on maps that Poles made of this area. Gorczakowski was also clearly the witness to some of the exhumation as related by "Novgorod-Seversky."

Maliszewski saw that the map drawn originally by Gorczakowski and mentioned by Sergeyenkov has not been found, but that it was presumably the same as in the "Novgorod Seversky" 1947 publication. According to Maliszewski, the 1947 map while distorted was still the work of someone who knew the terrain. More importantly, Maliszewski's own research indicated that the siding was about 500 meters north of the Gnezdovo station, and it was there that Maliszewski placed the building where a majority of the prisoners had been detrained and executed.

"Novgorod-Seversky" dedicated his typescript manuscript to "Fighters for Mother Russia's Freedom from Bolshevism." He wrote about the Katyń massacre with a passion and in language characteristic of one who had fought against Communism for many years. His account of the exhumation was based on what his friend Gorczakowski had witnessed. "Novgorod-Seversky" reviewed the history of the murders, the transport of Polish officers at Gnezdovo station which was also testified to by witnesses interviewed by the German Commission. He obviously did not see the completion of the exhumation since he noted that 2,500 corpses were exhumed in seven graves as of the end of April 1943, whereas the Germans continued to search for remains until June of that year.

Some of the conclusions reached by "Novgorod-Seversky" have been con- firmed by later research. He noted for example that the arrangement of corpses proved that the murders took place elsewhere and that the bodies were trans- ported to Katyń and buried in prepared pits. While there is still no accounting for most of the officers who were in the Starobielsk and Ostashkov camps, it is probable that the majority of the bodies were brought from the slaughterhouse at the NKVD headquarters in Smolensk. It was possible, according to Maliszewski, that the first mass shootings took place in the forest, but that the NKVD decided that this presented a problem in terms of witnesses from nearby villages, not to mention the possibility of sounds and sights of a desperate struggle with the condemned men. After all, many of them must have known of their impending fate.

"Novgorod-Seversky's" account suggested that he either left with the German forces or accompanied the Slovakian medical expert, Dr. Shubik Kharkov (referred to as "Subic" in other accounts) as the German forces retreated. He described a speech made by Dr. Kharkov before a large audience in Hlinka House in Bratislava, on May 9 "of this year," which must refer to 1947, the year that he wrote his reminiscences. "Novgorod-Sev-

ersky" quoted Kharkov as stating that the mass murder had alerted him to the danger that would face Europe in the event that communism was victorious, and he appealed to public figures in Slovakia (which in 1943 was a puppet state of Germany) not to close their eyes to that frightful prospect. "Novgorod-Seversky" cited Kharkov's comments about some fellow Slovaks…" who choose to stay in our country for personal gain. It is easy to be a "salon-Bolshevik," and at the same time to live in an affluent society in safety and enjoy all the privileges."

"Novgorod-Seversky" referred to the Soviet Union as *Sovdepiya*, an acronym for "Soviet Deputies," a derogatory term used by those of the 1917 White Russian emigration. "I think it is a horrible blasphemy to call her 'Russia,' because she is still in a coffin," he wrote. He noted that long before the German invasion, local people near Katyń forest talked about large transports that brought military and civilian prisoners from Soviet-occupied Poland, Lithuania, Latvia and Estonia to the Smolensk area. The victims were taken to Goats' Hills, where executions took place at night. Railroad workers at Smolensk said that judging by the clothing, the trains brought people from all walks of life, from well-to-do families to peasants. Sometimes entire families were shot, including house pets. The military men who were condemned, arrived at the Gnezdovo station in separate trains.

Goats' Hills, "Novgorod-Seversky" wrote, was an isolated spot, which before the Revolution had belonged to the Borok estate, owned by a Moscow lawyer Wacław Lednitsky. Situated near the Dnieper River, its surface showed mounds and cavities that were part of a settlement and stronghold of an ancient Slavic tribe. The area was covered with trees and brushwood. The soil was sandy and could be easily excavated, even during winter. He said that the location, the nature of the soil, the two rail lines and the single highway that connected it with Smolensk all must have been taken into account by the Bolsheviks when seeking a place for mass burials. The entire area had been a favorite place for executions since the beginning of the Russian Revolution. He told the story of a Bishop Makary from Smolensk, a saintly character, who was shot in the forest in 1920, and quoted a woman physician who treated a member of the firing squad that executed him. Suffering from tuberculosis and nightmares and showing signs of severe emotional trauma, the soldier told the physician of shooting a holy man who had blessed his executioners even as they were pointing their guns at him.

"Novgorod-Seversky" described the area where the executions took place as an uneven square, 2 by 2.5 km, surrounded by an impenetrable wall of three rows of barbed wire. It was guarded by sentries with dogs. The local people only came near it while using the highway and did not dare even to look at the forest. Women and children did not go near there without

being accompanied by men. The area of execution was approximately half a kilometer from the highway. A rest home that predated the war stood on the beautiful, steep bank of the Dnieper and provided a deceptively serene setting for this place of horror. It had become headquarters for the secret police. "Novgorod-Seversky" described this *dacha* as a place of "orgy and debauch."

In his proposal for a course of action to save "Mother Russia" he called on the people of the world to support the United Nations and urged that they work together with leaders such as President Harry S. Truman, Generals George C. Marshall, Dwight D. Eisenhower, Douglas MacArthur, and Charles De Gaulle, former Prime Minister Winston Churchill, Eleanor Roosevelt, Generalissimo Francisco Franco and Archbishop Griffin - a rather unusual roster. In what was surely a prescient warning, since no one talked publicly about Russian plans for developing an atomic weapon, "Novgorod-Seversky" warned that the Bolsheviks could manufacture an atomic bomb and dominate Europe.

He concluded the portion of his manuscript about Katyń by saying that, since 1917, the Communists had annihilated sixty million people by executions, war, starvation, imprisonment, and forced labor. The building of canals and the work in mines and in Siberian exile had resulted in enormous casualties, numbers that did not include people injured physically and emotionally during the brutal years of repression. "Let the people of the world know what is in store for them if they continue to be indifferent to Russia's fate," he warned, and asked that Russian and foreign publishers print his work based as it was on twenty-five years of personal experience that included physical and mental torture in various prisons. This he wrote, was still the lot of some twenty million Russians.

Maliszewski, who knows the Katyń area better than most people know their neighborhoods, was amazed at the map hand-drawn by "Novgorod-Seversky" even if it was a second-hand version created from the earlier sketch by Gorczakowski. He says that it was a better map than that drawn by Wehrmacht Lieutenant Voss, who was the first German officer to visit the site in 1943, and superior to the one made by Polish intelligence for Anders. What has troubled Maliszewski (who inspected most of the cartographic materials on Katyń at the Library of Congress), was that this particular map did not have a number assigned to it and was not included in the documentation for the 1951 Congressional hearings on Katyń. He was surprised that the Polish authorities showed no interest in it and urged him not to publish it until their investigation into Katyń was adjudicated. "Why?" Maliszewski exclaimed when he talked to me about this. "What is their agenda?"

• • •

"Novgorod-Seversky's" account of the "Bolshevik crimes" also included the massacres at Vinnitsa, in the Ukraine, a companion to the horrors of Katyń. The Germans discovered mass graves in Vinnitsa in 1943. These were examined by an international commission in a manner similar to that employed at Katyń. Over 9,000 bodies were found, many bearing the telltale signs of a NKVD execution, i.e. a shot to the back of the head, the victims' hands tied behind their backs with either rope or wire. The massacres apparently took place in 1938, and the victims were executed in the cellars of the NKVD, their bodies buried in three long trenches within the city limits. Parks, orchards, summer houses, cinemas and playgrounds were built over the mass graves and the entire area was designated as a "Garden of Culture and Recreation." As in Katyń, the graves were also filled with the possessions of the dead: handbags, notebooks, photographs, and religious objects. According to "Novgorod-Seversky," the victims' clothes showed that they were mostly impoverished peasants and workers, ranging in age from teenage children to old people, and that they included members of the Russian Orthodox, Catholic, Protestant and Jewish clergy. "Novgorod-Seversky" also noted the horror of executions in Ekaterinodar where an "assembly line system" used "a crusher with automatic ejection into the sewerage" to place bodies in the river bottom as feed for fish and crabs. Alexander Contract, who claims to have been Stalin's bodyguard, wrote in his *Back Room: My Life with Khrushchev and Stalin* that there was special room within a secret service headquarters near the Dnieper River where a sewer line extended from the room to the river, allowing a body to be flushed. "Predatory fish would swiftly destroy the evidence," wrote Contract.[3] The account of Vinnitsa was obviously written later than the account on Katyń, the date 1949 used in reference to an emigre publication *Posev*. "Novgorod- Seversky's" former appeals to world leaders were replaced by angry references to Eleanor Roosevelt and the United Nations. He condemned Secretary of State Dean Acheson for shaking hands with Gromyko on April 5, 1949, the opening day of the United Nations Assembly. He saw all this as "humiliation and cringing before the Bolsheviks, the Kremlin bandits," and thundered that the people of the world should not confuse the people of Russia with the USSR and the Bolsheviks, the "deadly enemy."

• • •

[3]Alexander Contract, *Back Room: My Life with Khrushchev and Stalin* (Vantage Press, N.D. p. 30).

Another lengthy report deposited after the war in the Sikorski Institute in London and included with the 1948 3rd edition of *Facts and Documents,* has provided an important account of the German exhumation.[4] It was written by a Polish forensic expert, Dr. Marian Wodziński, who was the only doctor to accompany the Polish Red Cross group to Katyń. Wodziński, who before the war had worked at the highly respected Jagiellonian University in Kraków, was forced by the Germans to go to Katyń. Like other Poles, he had been worried about the fate of the Polish officers since all correspondence with them ceased in the spring of 1940. Before leaving, he had a talk with a colleague, Dr. Pragłowski, who had been to Katyń before most of the exhumation was begun and was shocked to see among the corpses one of his students, a Captain. Pragłowski said that the young pines were clearly three to four years old, showing that the graves dated from 1940 when the area was in Russian hands. Wodziński's account of five week's work at Katyń in 1943 with the German appointed commission remains to this day a most authoritative record, remarkable for its scientific detachment, although unfortunately he did not "orient" himself in describing the graves in relation to one another.

Upon his arrival at Katyń forest, an area of gentle hills and grass-covered marshland alongside the Dnieper River, Wodziński found that the bodies of several hundred officers had already been exhumed and buried in new graves. From April until June, he worked with the other members of the Commission disinter- ring many more bodies (they lay, he said "like herrings in a cask") from their original graves, searching and numbering them, identifying them, where possible, from objects found with them, and reburying them in a common grave. Examining on the average ten bodies a day or 800 in all, Wodziński recognized two of his physician colleagues by their personal effects. He noted that the bullets used in the executions were of German manufacture, "Geco." Although it was clear that this ammunition was available to the Russians at the time of the massacres, it tended at first to raise questions about the German version of the executions.

Wodziński described other delegations that arrived at the site as the Germans sought to capitalize on the propaganda windfall. The bodies were reinterred at a slow pace, in order to allow visitors, absorb the horror of the scene. The Germans were particularly anxious to show a grave in which the bodies were placed face down, hands tied behind victims' backs, a position suggesting that the officers had been thrust into the grave while still

[4]"My Five Weeks Work at Katyń," (Report by Marian Wodziński, M. D. Expert in Forensic Medicine of the Technical Commission of the Polish Red Cross at Katyń) in *Crime of Katyń: Facts & Documents*. 3rd Edition (London, 1965) op. cit. pp. 191–228.

alive and shot while lying there. Among the numerous delegations was a group of some ten Allied war prisoners, including an English surgeon, a colonel from South Africa, a New Zealander, a Canadian, an Australian and two American officers, Colonel John Van Vliet Jr. and Captain D. B. Stewart. The Germans treated these men with considerable ceremony, arranging photographs and interviews. Wodziński was also able to spend some time in private conversation with the English officer who spoke some German and Russian, and who conveyed to Wodziński quietly his opinion that the Soviets had been responsible for the massacre.

By the end of May, the Germans had disinterred 4,150 bodies. A frantic search ensued for more victims since the Germans had announced that they totaled more than 10,000. In the course of further digging, some small graves were uncovered with Russian dead in both civilian clothing and uniforms. They had also been executed and were judged to have been buried five to ten years earlier.

The remains were identified with metal tags, while tags with the same number were attached to pouches with personal belongings. The bodies were interred in six "fraternal" graves. Eventually, eight graves were dug, including two individual graves for Generals Mieczysław Smorawiński and Bronisław Bohatyrewicz. The graves were covered with turf and topped with crosses while members of the Polish delegation placed red and white flowers on them. Great care was taken with reinterring the bodies in the belief that the remains would one day be transferred to Poland. On the last day, members of the Polish delegation placed a metal wreath with a crown of thorns fashioned of barbed wire over the tombs. An eagle taken from an officer's hat was affixed in the center.

Wodziński left the Katyń area on June 3, 1943, spurred by growing disenchantment with his German supervisor as well as a realization that a Russian recapture of the area was likely in the near future. Before he left, the Germans discovered a grave which much to their disappointment held only 200 more Polish officers. Many had been shot in a different manner from the previously discovered victims. Possibly because the officers offered resistance, the executioners wrapped the victims' coats around their heads, tied these around the necks, and then connected the rope to the hands in the back, raising them to the level of the shoulder blades. Any attempt by the prisoner to free himself only made the knot around the neck tighter, in effect choking him.

In his final report, Wodziński noted that since he had found inoculation certificates from the Kozielsk on the bodies these must have been the officers missing from Kozielsk in 1939. Most of them, he concluded, were shot in back of the head; the absence of a struggle before death suggested

that the victims were held by assistants. The presence of *apelówki*, wooden soles attached by straps to shoes for winter wear in one mass grave, and lighter clothing found in another, meant that the killings were spread over a considerable period of time. Wodziński paid tribute to those Russians who testified that they saw Polish prisoners taken to the Katyń forest. Some of these villagers lived close enough to hear shots. No one had any doubt what the Russians would do to them if they captured them.

Maliszewski questioned one important aspect of the Wodziński report suggesting that the executions took place near the burial site in Katyń forest. This was a reference to bullet scarring on the trees near the burial site. Wodziński in his 1947 report, stated that Dr. Francois Naville, the Swiss member of the Red Cross Com-mission, looked for traces of bullet scars, although Naville's own report does not mention it. Wodziński went on to say that he had seen a large number of cartridge cases and bullets in the vicinity of the graves and in the graves themselves, leading him to "suppose" that the executions took place close to the graves. He found one pine tree with bullet scarring, and he assumed that some executions took place at that tree. Maliszewski considers this as too speculative and thinks it is more likely that a drunken NKVD soldier used the tree for target practice.

Maliszewski has cited other witnesses on the subject of cartridges and bullet scarring at the burial site. Professor Gerhardt Buhtz, the forensic specialist who was with the German team stated in his report that the victims were not shot near or at the graves. Józef Mackiewicz, a Polish journalist who had spent some time with Buhtz at Katyń, also reported that the latter did not tell him of any bullets at the site.

• • •

The third and the most controversial of the eyewitnesses was Ivan Krivozercov.[5] The account he gave first to the Germans, then to Polish authorities rang with simplicity and honesty. He was twenty-five when the war broke out and lived with his peasant family not far from Smolensk. In the late 1920s, the family, now declared to be *kulaks*, was forced to join a *Kolhoz*, and the father, who first tried to run away, returned, and after imprisonment was executed in 1937. The young Krivozercov knew Katyń forest and Goats' Hills (also known by such names as "Robbers' Well" and "Black Swamp"), where he and his family went to gather mushrooms, berries and kindling wood. Because of poor eyesight he was declared unfit for

[5] "A Russian Witness of 1940," Ibid 229–240. Cf. Jacek Trznadel, "Rosyjscy Świadkowie Katynia," in *Zbrodnia Katyńska: Droga do Prawdy*, op. cit., pp. 77–111, passim.

active duty and worked at a collective farm near the Katyń forest. In March 1940, he noticed prisoners from Smolensk coming to the forest with shovels and pickaxes and was told that these men were digging foundations for buildings. It was the section of the forest reserved for the Secret Police. He recalled a local saying: "Keep your mouth shut or else they will take you to Goats' Hills." Krivozercov said that "fear crept into your bones," but he also remembered his father's fate, and his determination to right a wrong grew.

One day, while working near the rail line, he saw cars, vehicles commonly called *Voronki* [Black Marias]. These trucks removed men from trains that came from Smolensk to a siding near Gnezdovo. A friend of his recognized Polish uniforms worn by the men. In the days that followed, Krivozercov and others found out that these men were taken to be executed. It was clear from conversations he had with others that these prisoners were brought to Gnezdovo from Smolensk and from there were trucked to Goats' Hills. The routine did not vary, and the number of prisoners was constant. The transports arrived only in daylight hours to eliminate the possibility of escape. Care had to be taken that those brought to Goats' Hills would never be seen by the new arrivals. Krivozercov, who referred to the NKVD as *Cheka* [Extraordinary Commission, predecessor of the NKVD], observed these transports for almost a month and a half. By the end of April, he saw one more convoy, which carried only personal belongings of the condemned men. Then silence descended on the forest and the area was guarded by soldiers and vicious dogs.

The Germans invaded on June 22, 1941, and took Smolensk by July 19. Krivozercov collected wood for the German Field Police unit stationed nearby. In the spring of 1942, according to him, some Poles working for the Todt Corps who apparently dug up remains of Polish officers at Goats' Hills, recovered some objects and left two wooden crosses. An older villager, Kissilev, whom Krivozercov knew, told him about this. He went there himself and saw the crosses. In January 1943, with the German advance into Russia halted, Krivozercov read in a German-sponsored Russian paper that a Polish army was being organized on Russian soil and that General Sikorski could not find Polish officers who had been imprisoned by the Russians. Krivozercov, remembering what he had seen at the railroad siding in 1940, went to the Germans and said to an interpreter: "Sikorski is looking for his officers in Siberia, and they lie here, shot at Goats' Hills." The crime of Katyń was about to unravel.

Krivozercov and the Germans came to an area where there was a depression. It was covered by large, toppled trees and recently planted pines. Kissilev, upon being summoned to help in the digging, exclaimed: "It should have been done long ago, this weighs like a sin on our souls." They

began to dig and soon, amidst an unbearable stench, they found a corpse in an overcoat. On it was a button with a Polish eagle, which Krivozercov wrapped in paper and put in his pocket. They left and returned with another German officer and proceeded to find more corpses with the help of other local inhabitants.

Following more excavations, Krivozercov reported the arrival of the foreign commission. When the members of the Polish Red Cross arrived, he heard them mention the name "Piłsudski." Apparently, one of the corpses was identified as Dr. Kaliciński, Piłsudski's physician. Krivozercov was at the site until the last pit was opened in Easter, 1943. His testimony was voice-recorded and he was also brought before a German judge to whom he made an additional statement under oath. There was not much time to lose. The German retreat from the area was about to begin.

Members of the local Communist Party now reasserted their authority and told Krivozercov that the government would not harm him. But he was not persuaded. He said to another friend who encouraged him to trust the partisans: "Are you crazy? They will shoot us like dogs." On September 24, he took some food, and with his mother and a six-year-old niece, persuaded the Germans to take him together with his sister. Eventually they went by rail to Warsaw. He worked briefly in Minsk, Belorussia, and by spring was near Łódź. From there he joined a labor group working in a Berlin suburb. As the war was ending, and not wanting to fall into the hands of the Russian forces, Krivozercov went to Bremen and tried to speak to the American authorities about Katyń forest. He claimed that they laughed at him and advised him to seek out Russian authorities. Krivozercov eventually contacted some Polish soldiers who directed him to their headquarters in Ancona, Italy. His dearest wish was "to vouch for the murder of Polish officers at Goats' Hills ... and to live long enough to be brought before a court as an eye- witness in the case."

As 1946 came to a close, Krivozercov under the assumed name of Michal Loboda came to Great Britain as a Displaced Person. It was probably there that he was interviewed by the Polish journalist Józef Mackiewicz who was also present at the German exhumation and wrote about this in an extraordinary book, *The Katyń Wood Murders*, published in London in 1951.[6] Krivozercov disappeared after Christmas 1947 from his camp near Bristol. A local farmer reported that he found the body of a man hanged in his tool shed. It was Krivozercov. Those who knew him refused to believe that he would take his own life.

Krivozercov's testimony was important because it touched on one of the crucial aspects of Maliszewski's reconstruction of the Katyń crime, his

[6]Joseph Mackiewicz, *The Katyń Wood Murders* (London, 1951)

conviction that the killings took place some distance from the burial site and his assertion that the Gnezdovo station, described in Katyń literature as a small rail spur, where the Polish officers debarked prior to being killed, was part of an important railway complex well known to the Russians. According to Maliszewski it was at the Gnezdovo station, twelve kilometers west of Smolensk, that the Dnieper front was organized by General Timoshenko and his political officer Khrushchev at the outbreak of the war in June 1941.

Maliszewski found it curious that Khrushchev (who failed to mention Katyń in his famous secret speech on Stalin's crimes in 1956, at the 20th Communist Party Congress), made his headquarters at Gnezdowo, a command structure "located about 2,500 meters from one of the largest secret police burials grounds in western Russia." About 500 meters outside of the Gnezdowo station was a rail siding that Maliszewski has referred to as *lesopolosa*, a wood-clearing. In his opinion, this spot provides the crucial missing link, an "execution chamber," and the one feature of Krivozercov testimony that withstood later "doctoring." It was particularly important to compare the Krivozercov testimony with that of a surviving eyewitness, Stanisław Swaniewicz, who at the last moment was separated from the other prisoners, but was able to observe the debarkation surreptitiously.

Maliszewski, in a work he recently published in *Fotointerpretacja w Geografii* [Photo-Interpretation in Geography], tells of a document just declassified by the U.S. government that supports his earlier hypothesis that a "probable execution building" existed in a wood clearing on the border of a hidden railway siding northwest of the Gnezdovo station. This document, kept secret for forty-three years, states that "according to Gorczakowski there is a railroad siding just north of Katyń forest ... to which many of the railroad cars were brought directly, and the Polish soldiers were unloaded right in the forest. This siding cannot be located on maps of the immediate area which we have on file from the Polish government, but the 'Novgorod-Seversky' insisted that the map which he and Gorczakowski drew is a correct representation of that area."[7]

In order to buttress his conclusions regarding the execution site, Maliszewski examined not only accounts of survivors (some of whom scribbled messages on the walls of the railway carriages prior to their debarking), but also maps, aerial photographs and testimonies of other witnesses, particularly that of Swianiewicz.[8] Various versions of Swianiewicz account appeared

[7]Wacław Godziemba-Maliszewski, "Katyń: An Interpretation of Aerial Photographs Combined with Facts and Documents," in *Fotointerpetecja w Geografii: Problemy Telegeoinformacji*, (Warsaw, 1996) p. 121 ff.
[8]Stanisław Swianiewicz, *W Cieniu Katynia* [In the Shadow of Katyń] (Warsaw, 1990), p. 108ff.

between 1942 and 1965. In one published account he said that he was de-trained about 200 meters outside the Gnezdovo station, in another "beyond the station," and elsewhere "somewhere behind the station." Maliszewski's examination of Luftwaffe imagery makes it clear that Swianiewicz was de-trained northeast of the station and that as he was escorted back to the sta-tion house he could see to the west of his position "a fairly desolate open space covered with grass." This statement was more in conformity with a report that Krivozercov made to Mackiewicz in 1945 in which he men-tioned seeing a siding to the north of the station where "there was a storage building opposite the little square." In a statement that Krivozercov made to the Polish military at Ancona in 1946 he asserted that trains were driven to a siding north of the Gnezdovo station and thus hidden from view. It is there that Maliszewski's analysis has placed the "execution chamber" for many of the officers from the Kozielsk camp, a structure that may also have served as a command post for General Timoshenko.

Chapter 8

How the Russian President Boris Yeltsin finally delivered to Lech Wałęsa *in 1992, the President of Poland, documents dating to 1940, materials that incriminated Stalin and the Politburo in the killing of thousands of Poles in the* Katyń Forest.

On October 14, 1992, Rudolf Pikhoya, Chairman of Russia's Archives Commission and a personal envoy of Boris Yeltsin, delivered to the Polish President, Lech Wałęsa, the rarest of parcels.[1] These were forty-two documents on the Katyń massacre. This was not the first time that a Soviet leader had made a confession of his system's sins. In 1956 Khrushchev in a secret speech shocked his Communist comrades by revealing some of Stalin's crimes. It says something about the lingering ghosts of Stalinism that thirty-five more years passed before another Russian leader, Gorbachev, renewed the strategy of piecemeal confession. For five years after being appointed general secretary of the Communist Party, he could not con- front the shame identified with the word "Katyń." Even though he had signed an agreement with Jaruzelski in 1987 to have a joint historical commission investigate "blank spots," he avoided mentioning Katyń on a state visit to Warsaw a year later. Not until 1990, a year before he was forced out of office, did Gorbachev point an accusing finger at Stalin and Beria, and even then, at a Kremlin ceremony, he failed to produce the most important documents. This continued reluctance is not hard to understand. For more than half a century a curtain of silence descended over an event unique in the annals of state crimes. Without any formal charges, contrary to all solemn covenants enshrined in Geneva, and avoided even in time of war by the bitterest of enemies, the leadership of the Soviet Union ordered the death of approximately one-half of the officer corps of its Polish neighbor with whom it was not officially at war. The secret of this unprecedented horror was bequeathed to successive generations of Party leaders. It bound them in complicity and shame. Of all their lies - and there were many - this was the most enduring.

The dramatic release of the documents was preceded by unmistakable prodding from Russian media. In 1989, articles in the *Moscow News* point-

[1]*The New York Times*, (October 15, 1992), p. 1, p. 8.

ed to a "new line" on Katyń. In late October of that year, Brzezinski asked for permission to visit the site of the Katyń massacre. The trip was approved by the Soviet Foreign Ministry. During that visit, some of the Poles covered "Gestapo" and "1941," a sign that stood for the lie and substituted hand-lettered signs with "NKVD" and "1940," alterations that significantly were not disturbed by authorities. A month after Brzezinski's visit, the Soviet government decided on another Katyń memorial, one that commemorated both Polish officers and Russian prisoners who were killed in 1943 as the Russian army approached Smolensk. It was a new version of an old lie and it showed how difficult (and inevitable) was the decision facing Gorbachev. Even so, it took almost two more years for the documents admitting the Soviet crime to be transmitted to Polish authorities.

Before the documents arrived in Warsaw a public quarrel erupted between Yeltsin and Gorbachev, the latter refusing to testify before the Constitutional Court charged with judging the legality of the Communist Party. From June to October, in a series of public scolding and retributions, Yeltsin temporarily prevented his predecessor from leaving the country, stripped him of buildings and facilities, including a country retreat that had become part of the Gorbachev Foundation, and replaced his predecessor's armored limousine with a more modest sedan. In a country where possession of property was considered a mortal sin and outlawed as the first act of the Bolshevik Revolution, the fervid acquisition by Communist leaders of property that was not supposed to exist was an activity bordering on the miraculous.

As the Yeltsin government released the documents, it accused Gorbachev of having concealed them. A spokesman, Vyacheslav Kostikov, said on the day the documents were made public that Gorbachev had known for a long time about "the real organizers and instigators of the tragedy," because the documents were in the Sixth Division of the Central Committee archives which had become Gorbachev's personal records. Gorbachev, he said, kept silent and "helped delude public opinion." As proof, Kostikov quoted an ordinance of the Soviet President of March 3, 1990, in which Gorbachev instructed the Procurator General's office and the KGB to continue investigations, although, according to Kostikov, "he knew where all the archival documents were kept and what was in them." Gorbachev defended himself angrily and argued that the Katyń files had turned up only in the waning days of the Soviet regime. He revealed that both he and Yeltsin read them together in the Kremlin on December 23, 1991, two days before he resigned as President. It was a scene worthy of Sergei Eisenstein's guilt-ridden Ivan the Terrible. "I said to Boris Nikolayevich," protested Gorbachev, "it is your time now." He remembered that he told Yeltsin to

study the file and that both agreed the Polish people must be informed.[2] But Yeltsin had the last word. In an interview on Russian television he said that Gorbachev refused to testify before the Constitutional Court because he knew he would be asked about the Katyń documents and of his refusal to make them public while he was in office. What was it about the forty-two documents that made Gorbachev so reluctant to release them?

• • •

The Polish Academy of Sciences published facsimiles of the documents and a Polish translation in a matter of weeks. It is a record of a bureaucracy as an accessory to state murder. A volume titled: *Dokumenty Ludobójstwa* [Documents of Genocide], showed why it was so difficult for Gorbachev to release the records.[3] He had been willing finally to assign blame to Beria and Stalin (after all, Beria was shot as a traitor soon after Stalin died) but the documents made clear that leading members of the Politburo, the men who were mentors and models for Gorbachev's generation, appended their signatures to the death sentences of the Polish soldiers and civilians. If Gorbachev still thought that he could salvage some shred of legality for Communism as a theory and for the Communist Party as an instrument to implement it, the documents shattered that hope. Gorbachev's strategy, alternately audacious and cautious, had been to use and control the explosive elements in his society. But the partial opening of the archives, particularly the Katyń documents, were the start of a meltdown, as devastating a symbol for his political future as Chernobyl was for the system as a whole. Moreover, if released, this was a record of his own shameful conduct, for the documents that he now shared with Yeltsin clearly proved Gorbachev's own role in the cover-up. Even without a coup to depose him, his stewardship was over.

The Russians matched the Germans in a morbid devotion to keeping records of their misdeeds. In the Soviet state where paper was at times the rarest of commodities, the files were bursting with incriminating evidence. The Katyń documents released on October 14 were only a partial record, but they offered a rare glimpse into a bureaucratic mind for which the word "banal" is hardly accurate or adequate. In the midst of extracts dealing with arrangements for trade in munitions with Nazi Germany, production of binoculars, and preparations for a new sarcophagus for Lenin complete with an up-to-date lighting system, one could read the "strictly secret" Katyń documents, a ledger where lives soon to be extinguished were carefully arranged

[2]Ibid., (October 16, 1992), p. 6.
[3]*Katyń: Dokumenty Ludobójstwa, Instytut Studiów Politycznych Polskiej Akademii Nauk*, (Warszawa, 1992).

in rows of figures.

Central among the documents that Gorbachev could not bring himself to reveal was an excerpt from the minutes of the Politburo dated March 5, 1940.[4] This was a lengthy memorandum from Beria, head of the NKVD, addressed to "Comrade Stalin." Scrawled boldly across the first page were the approving signatures of Stalin, Voroshilov, Molotov, Mikoyan as well as those of Kalinin and Kaganovich. In the opening sentences, Beria set forth the reasons why the Polish officers could not be freed. They were "counter-revolutionary" elements, engaged in anti- Soviet agitation in their camps, "each one of them awaiting liberation" only in order to wage a struggle against Soviet power. He referred to them as "bitter enemies," filled with hatred for the system. His letter enumerated the ranks and categories of 14,736 officers (among those 295 with the rank of general, colonel and lieutenant colonel), and included such "enemies" as factory owners, landowners and clergymen, as well as those considered spies, partisans, and deserters. What Beria did not mention was that the Polish prisoners included over 800 physicians, hundreds of educators, clergy of all faiths, and members of many professions. There was another shocking revelation. Beria added to this list 11,000 mostly civilians kept in prisons in Western Ukraine and Belorussia making a total of 27,000. At the end of the letter, he disclosed the alternative to letting the Poles "go free." All of them were to be condemned to death by "supreme punishment," that is, by shooting. The sentences were to be carried out without summoning the condemned to a hearing and without presenting them with any indictments. A troika of NKVD officials, Merkulov, Kabulov and Basztakov, was assigned the task of carrying out the order. Obviously if the sentences were to be effective, the Poles would have to be kept unaware of their fate until the very last moment.

The "elitocide" at Katyń (a term coined recently by an English journalist for the slaughter of professionals in Bosnia-Herzegovina), would seem to have held little advantage for the Soviet state. Russia had already partitioned Poland with Nazi Germany and the prisoners she held represented no threat to those gains. What motivated Stalin, a most cautious and cunning leader, whose own people were condemned if only after sham judicial proceedings, to exterminate without any legal pretense an officer corps of a neighboring state in time of peace? The killing of the Polish prisoners had to be based not only on Stalin's conviction that Hitler's hegemony was assured, but more importantly on his determination that the act was a requirement for their joint brutal partnership. Stalin must have also concluded that even if Hitler, in spite of all craven concessions, chose to attack him, the Polish officers would not help him and were certain to fight against him.

[4]Ibid., pp. 34 - 41.

He and they remembered the 1920 campaign when the Poles succeeded in keeping the Red Army out of central Europe. Stalin would make only one calculation. Were the Poles worth more dead than alive? Clearly, if he was to be Hitler's partner, they would have to die. The spring of 1940 was a time of Germany's stunning military victories and the start of Hitler's own plans for the extermination of the Polish elite at Auschwitz. The Nazi system was based on the politics of murder. Stalin found his blood brother.

• • •

The documents sent by Yeltsin to Wałęsa presented a fifty-year record of cruelty, lies and concealment. On March 9, 1959, six years after Stalin's death, and almost twenty years after the killings, Alexander Shelepin, Stalin last appointee to head the Komsomol, Communist Party's youth organization, subsequently head of the KGB and member of the Politburo, summarized Beria's memorandum of March 5, 1940, and confirmed that a total of 21,857 had been shot. Specific figures were given for those shot in Katyń forest, in Starobielsk, near Kharkov, and in Ostashkov, near Kalinin (Tver), two of the three camps where the Polish soldiers were interned. Shelepin worried that the sheer volume of evidence might be cause for some "unforeseen indiscretion," and urged that all the records concerning those who were shot be destroyed. He argued that these materials had no historical value and added that "it is doubtful if they have any value for our Polish friends." In any case, he concluded, a Russian commission of inquiry had already declared that the Poles were liquidated by "German Fascists," a version circulated by Russia and accepted by most Western media. Shelepin advised that only the records kept by the troika, which were few in number, should be retained in a special folder. His recommendations were accepted by the Presidium.[5]

There was an unaccountable gap from 1959 to 1971 in the documents delivered to the Polish authorities. 1971 was the *annus horribilis* for the aging Soviet leaders. They had hoped to die peacefully before the truth about Katyń, (and many other truths), became known. The unmarked mass graves of the Polish soldiers were now covered by children's sanatoria, rest homes, latrines for the KGB, high-rise complexes, radio towers, and newly planted forests, but like ghosts in a Shakespearean drama they continued to haunt the Soviet leadership.

Zawodny, was in London in 1971 as adviser on a BBC documentary, *The Issue Should be Avoided*, which revived the question of Soviet guilt in the killings at Katyń. On January 28, Zawodny's new edition of his 1962

[5]Ibid., pp. 42 - 45.

book, *Death in the Forest,* appeared in London bookstores.[6] With the BBC scheduling the Katyń film for mid- April and the book by Louis C. FitzGibbon, *Katyń: A Crime Without Parallel* due to appear at about the same time, the signs multiplied that something was afoot.[7] To the Soviet government, whose own conduct was always a carefully orchestrated propaganda campaign, these events bore all the hallmarks of a conspiracy.

On April 15, 1971, the Politburo, whose members now included Brezhnev, Kosygin, Suslov, Andropov, and Gromyko, instructed the Soviet ambassador to London to take note of an "anti-Soviet" campaign in England on Katyń. He was to protest plans by the BBC to show a film that would very likely be followed by "slanderous" books about the "tragedy." A protest note from the Kremlin referred to Katyń as a "Hitlerite" crime, and asserted the oft-stated falsehood that the Nuremberg Tribunal had found the Germans guilty. According to the Soviet note, those who questioned their innocence were repeating Goebbels' lies and trying to "blacken" the Soviet Union "whose people had shed its blood to save Europe from Fascist slavery."[8]

On April 22, Airey Neave, a Member of Parliament, tabled a motion for a new investigation and condemnation of the culprits in the Katyń murders. He was joined by 224 of his colleagues. The issue was also debated in the House of Lords. Katyń was again newsworthy, but the government spokesman stated for the record that "Britain has no standing on this issue." In spite of, or perhaps because of England's, craven attitude, more complaints followed from the Soviet side. A "strictly secret" Politburo circular on September 8, 1972, considered a protest to the British ambassador in Moscow on plans to erect a "monument to the victims of Katyń," in London, this obelisk to be placed in the Kensington-Chelsea district. The circular asked that "Polish friends" join in the protest. The note, which was delivered to the British ambassador in Moscow on September 13, reviewed what were by now standard arguments on the history of the Katyń massacre. As was so often the case with Soviet representations, the phrase "as is well known" was used to describe what was not well known at all. The British government was warned about those whose "provocative acts" could harm relations with the Soviet Union. The Soviet leaders whose propaganda skills were not inferior to those of Goebbels, understood well the danger that monuments and other symbols posed to their version of history. With the

[6]Janusz K. Zawodny, *Death in the Forest: The Story of the Katyń Forest Massacre,* (Notre Dame, 1962).

[7]Louis C. FitzGibbon, *Katyń: A Crime Without Parallel,* London, 1971 and *The Katyń Cover-Up,* compiled by Louis C. FitzGibbon, (London, 1972).

[8]*Katyń: Dokumenty,* op.cit.,pp. 54–55

35th anniversary of Katyń approaching, and in the face of new challenges, the language of their concerns grew shriller. On April 5, 1976, a note from the Politburo to the officials in Smolensk, within whose jurisdiction Katyń was located, not only spoke of efforts in the West to worsen Polish- Soviet relations but warned that such "provocations" could lead to the deterioration of the international situation. The Smolensk officials were instructed to take proper care of the monument to the Polish officers, and the Politburo once again importuned their "Polish friends" to join in affirming the Soviet account of events.[9]

Document No. 24 titled "The Katyń Affair" (abbreviated version), a handwritten item marked "secret," (1976 ?), was an effort to summarize the history of the Katyń massacre. In no other document dealing with Katyń up to that time had Soviet writers cited at such length the opinions of those who challenged the official line. It began with the standard account that the 11,000 Polish "prisoners of war" who were employed in road building in the vicinity of Smolensk and could not be evacuated at the start of the "Great Patriotic War" were made prisoners by the Germans and executed by them in 1941. This was followed, however, by an unusual concoction of previous Soviet assertions and denials, mixed with accusations made against the Soviets. The writer noted that in 1943, an "international medical commission" was assembled by the Germans and that the resultant official report placed the blame for the atrocity on the Russians. In an odd passage, he wrote that the monument in Katyń forest has been visited by Polish delegations but that other foreign visitors did not come since that part of the forest was not really of interest to tourists. It was hardly a secret, at least to those who read the report, that the area of Katyń was strictly controlled by the secret police, surrounded by fences, and guarded by armed men and dogs - hardly a place where tourists, native or foreign, could roam freely! The memorialist then summarized the growing chorus challenging the Soviet version of Katyń. He described hearings on Katyń held by the United States Congress in 1951–52, followed a year later a State Department request that the Soviet government provide additional evidence. He did not note that the Congressional investigation found the Soviet Union guilty. He simply concluded that the Soviet government rejected that request for additional evidence as an insult and that raising this matter eight years after the fact was a calumny designed to rehabilitate the "Hitlerite perpetrators."

The writer of this memorandum, interestingly enough, listed several other instances that challenged the official Soviet version. He noted that in July 1972 a BBC broadcast claimed the British government was in possession of documents establishing Soviet guilt in the matter of Katyń, and

[9]Ibid., pp. 70–73.

that in June 1975 a press conference was held at the Parliament building
by a group that calling for an investigation by the International Court of
Justice at the Hague. He also referenced a document in possession of the
Daily Telegraph which revealed that more than 10,000 Poles were killed
by Russian secret police; this probably a declassified report by Sir Owen
O'Malley, wartime ambassador to the Polish government-in- exile, who had
written in 1943 that the British authorities knew the Russians were respon-
sible. Radio Free Europe had beamed these developments to Poland where
clergy in their sermons referred to "tens of thousands executed innocents
who were the best representatives of the Polish society." The Soviet embas-
sy in Poland reported that there was no shortage of people in Poland who
believed such anti- Soviet inventions. Finally, the report referred to another
monument bearing anti- Soviet inscriptions, erected in November 1975 in
Stockholm by Polish emigrants to honor the victims of Katyń. This and the
erection of a similar monument in a London cemetery were examples, ac-
cording to the author, of a growing anti-Soviet campaign.

Document No. 24 was an extraordinary example of a statement that
challenged the orthodoxy but whose text still mouthed the "Party line."
Those Party officials whose ears were finely tuned to the nuances of the
Communist lexicon could not fail to sense that a change of the "official
line" was in the offing. Like Peter Abelard's *Sic et Non,* that most unusual
and revolutionary medieval tract in which the ill-fated scholar presented
both sides of an issue in order to undermine the official Church version, the
Soviet memoirist provided the first sign that the lie of a century may have
outlived its usefulness.[10]

There was another gap in the documents between 1976 and 1988.
An extract from the "strictly secret" Politburo protocol of May 5, 1988,
addressed to the officials of the Smolensk Communist Party and sent to
Gorbachev, Gromyko, Ligachev, Chebrikov, Shedvarnadze and other high
officials of the Central Committee, showed that high Party officials were
still interested more with the appearance of the Katyń gravesites than in
uncovering crimes committed by their government. The Ministry of Culture
was advised to prepare a proposal for the erection of a monument at Katyń
for both the Polish officers and for the "Soviet war prisoners put to death by
the Hitlerites." In addition, the National Committee for Tourism was asked
to facilitate visits to the Katyń graves by families of the Polish officers. The
Smolensk officials were directed to put in order the area of the forest in-
volved in the visits, obviously an important decision in view of the fact that
offices of the military and propaganda were to be consulted. An additional
note to the above memorandum signed by Shedvarnadze made clear that the

[10]Ibid., pp. 76 - 81.

Soviet leaders were now trying very hard to coordinate their actions with their Polish "friends." They wanted to link up Katyń with their own dead in a macabre unity of sacrifice by repeating the falsehood that the burial site at Katyń held the bodies of 500 Russian prisoners-of-war, forced by the Germans to exhume the bodies of the Polish officers and subsequently killed by the Germans. The Soviet leadership was hoping to meet the minimum requirements of their Polish colleagues. Much of this activity was clearly designed to ease the arrival of Gorbachev in Poland on July 11, 1988.[11]

It fell to Valentin Falin, who had been the head of the news agency Novosti before being promoted to the Foreign Office, to set the stage for a decisive change. On March 6, 1989, Falin, who was also in charge of providing millions of dollars for terrorists worldwide and who specialized in obtaining fake passports, beards and mustaches for his operatives, wrote an unusually frank memorandum. He stated that the majority of Poles were convinced that Stalin and Beria were guilty of the Katyń massacre, and that in 1988 the joint Polish-Russian commission investigating Katyń had in hand the 1943 report of the Polish Red Cross which showed conclusively that the NKVD was responsible for the atrocity. According to Falin, the Polish press was now asking for explanations regarding 8,000 Polish prisoners interned in Kozielsk, Starobielsk and Ostaszkov whose traces were lost in the vicinity of Kharkov and Bologoje.

For the Soviet leaders, it was still more important to find the right symbol to pacify the Polish people than to speak the plain truth. They responded willingly to a request from their "Polish friends" to bring "symbolic ashes" from Katyń to Warsaw. But a note dated March 22, 1989, and signed by Shedvarnadze, Falin and Kryuchkov, was the clearest sign yet that the Communist leaders worried that the trickle of information about Katyń could become an unmanageable flood. This note broke completely with past versions on Katyń. With the approaching 50th anniversary of the start of World War II there was obviously an opportunity to be seized. The note referred to "blank spots" of 1939 and the growing discussion in Poland on relations with the Soviet state. It warned that prominent Poles were saying the Russians were responsible for Katyń. Most tellingly, Jerzy Urban, the man who had been for years the mouthpiece of the Polish government and who was obviously speaking for Jaruzelski, asserted that it was time to assign blame for Katyń to Stalin's NKVD and not blame the Soviet government. This Polish tactic, as the note explained, was clearly understood. The authorities there were under increasing pressure from their own people and were now using the same tactic against the Soviet government, particularly since joint Polish-Russian commissions of scholars had failed for two years to come up

[11]Ibid., pp. 82 - 89.

with an explanation of the "blank spots" in Polish-Russian relations.

It was no longer a case of citing different version about Katyń. The authors did not even bother to defend the falsehoods that had been the staple of Soviet government for almost half a century. But what was to be done? The bringing of ashes from Katyń to Warsaw and the changing of inscriptions on the 1983 memorial that referred to "victims of Hitlerite Fascism" obviously would not suffice. The memorandum of March 22 quoted from a Polish church brochure stating that Katyń was one of the "most cruel crimes in human history" and that some Poles had even suggested the Soviet Union was no better, and perhaps even worse, than Nazi Ger- many. In language that would have been unthinkable a short time earlier, the authors quoted the Poles as saying that the Soviet Union carried an equal share of blame for the outbreak of World War II and was responsible for the defeat of Poland.

Such statements in a communique at the highest level of the Soviet government were unprecedented and even desperate. According to Falin and his colleagues, Katyń had not only poisoned Polish-Russian relations but was an obstacle to the policy of Glasnost, already proclaimed by Gorbachev in October 1986. "We will probably not be able to avoid explaining to the Polish government and Polish society the tragic events of the past," the note concluded, "time in not on our side." The best thing was to tell how it happened, who was guilty and to close the matter. The cost of such a course would be less than the losses due to delay.[12]

* * *

But now a symbolism of another dimension helped to put an end to the grisly charade performed by Soviet leaders. The Katyń story that began in the blood- soaked soil of Russia was about to end with pictures from her skies. Starting in 1988 reports began to circulate in the West about captured Luftwaffe aerial photo- graphs that showed the process of exhumation as the Russian forces recaptured Smolensk and Katyń, images that proved beyond the shadow of a doubt that not only had the Soviets cruelly put to death thousands of Poles, but that they also scattered the remains in order to hide the crime. There was no time to lose. In April 1989, Falin and other officials who had been trying to help untie what were now referred to as "painful knots" instructed the Procurator's office to undertake a full investigation of the Katyń massacre, to present the results to the Central Commit- tee by August 1, 1989, and to notify all the media that such an investigation was going on. On February 22, 1990, in the first document addressed directly to Gorbachev, Falin revealed that Liebiedieva, a specialist in investigating

[12]Ibid., pp. 108 - 113.

movements of rail transports for prisoners, had uncovered new materials touching on Katyń. Falin referred to Liebiedieva's discovery of the secret lists of condemned men that were sent from Moscow to each of the camps for "action," a euphemism that was analogous to the Nazi use of "special treatment." He wrote that enough documents had been found which together with the German lists compiled at exhumation made possible a reconstruction of what happened at Katyń and the three other camps. Since the Russian historians planned to publish their findings in June-July 1990, a new situation had developed and there was no point any longer "to avoid dotting the 'i.'" With the fiftieth anniversary of Katyń approaching a position had to be formulated that would be least costly. Falin advised that Jaruzelski be contacted and told that while absolute proof had not been found in the archives for the actual order for shooting, the date when it happened or who the guilty parties were, there was enough proof from the NKVD records that the Soviet version of what happened was not correct. Clearly, concluded Falin, the NKVD, Beria and Merkulov were responsible. All that remained was to consult with Jaruzelski how this information should be conveyed to the Polish public so as not to arouse too much emotion. 1990 was to be a climactic year.[13]

On November 3, 1990, Gorbachev, following his meeting with Polish Foreign Minister Skubiszewski, circulated a secret memorandum to his closest advisers. He was anxious to resolve the outstanding issue with the Warsaw government regarding the presence of Russian forces on Polish soil and other economic and financial issues. Gorbachev directed the Procurator's office to search for records of Polish prisoners in the Ostaszkov, Starobielsk and Kozielsk camps. He proposed the date of April 1, 1991, as the deadline for this search and repeated his favorite phrase about "blank spots."[14]

As the Russian documents revealed the pace for the Katyń inquiry increased measurably at the start of 1991. On January 22, Trubin, the Soviet Procurator General, wrote to Gorbachev that there have been further searches of the archives which resulted in more documents from Beria and lists of the Polish officers from the three camps where they were held prior to executions. Gorbachev was informed that between April 3 and May 16, 1940, transports holding between 90 to 125 prisoners each were sent in NKVD transports. Trubin noted that he was now cooperating with the Polish Prosecutors Śnieżko, Stawryłło and Przyjemski and that a conference among them was planned for February. He added that P. K. Soprunenko,

[13]Ibid., pp. 118 - 125
[14]Ibid., pp. 128 - 131

one of the officials involved in implementing Beria's 1940 order, was being interviewed.[15]

On May 17, 1991, Prosecutor Trubin informed Gorbachev of the reports that had been assembled from various archives and indicated that testimony was now available not only from Soprunienko but also from Tokariev, one of the key NKVD officials in the Kalinin area. He concluded that the Poles were shot in April and May 1940, and that burials took place in Katyń forest, in Miednoje, thirty-two kilo- meters from Kalinin, and in a wooded area around Kharkov. Trubin wrote that testimony from the NKVD officers had cited directives from Stalin for the execution of the officers and added that the Polish officials had asked for copies of all pertinent documents as well as for the participation of Polish experts at the exhumations sites as cited in the documents. He concluded that it was very likely that at the end of the investigation the Polish government would ask for material compensation for each victim.[16] The last of the documents released by Yeltsin was dated September 3, 1991. In it the military charged with the exhumations in Miednoje and Kharkov complained to Gorbachev of interference by the secret police. But by this time, the coup had taken place and Gorbachev had lost control not only of the Katyń investigation but of *Glasnost* and *Perestroika* as well, his own versions of Potemkin villages designed to represent "openness and renewal."[17]

In an interview with *Washington Post*, Valery Boldin, Gorbachev's former chief of staff and a participant in the August 1991 *putsch* against his boss, revealed that Gorbachev had known what was in the Katyń file for years. Boldin said that he personally briefed Gorbachev on the original copies of the Nazi-Soviet Pact documents and on Katyń, and that he felt Gorbachev knew about their existence even earlier. It is also clear now that these files were checked out of the Soviet archives by Khrushchev, Chernenko and Andropov. In Boldin's words, when he handed the Katyń file to Gorbachev in April 1989, "He [Gorbachev] unsealed it, read it and resealed the package with Scotch tape." A couple of days later, after Gorbachev returned the file, Boldin placed it back in the archives. "I enclosed it in another package," said Boldin, "since an opened package sealed only with Scotch tape is not quite safe for storage."[18]

• • •

[15]Ibid., pp. 134 - 137.
[16]Ibid., pp. 140 - 145.
[17]Ibid., pp. 148 - 155.
[18]*The Washington Post*, (January 1993), pp. 23 - 24.

The documents released by Yeltsin in October 1992 only confirm what the majority of the Polish people have known for half a century. Numbed by their history, they only wished to find the remains of their countrymen. So far, this search too has been obstructed by delays and evasions. The soil of Russia, like its archives, still holds many secrets. The former Communists are thankful to have survived the devastation of their system, but unlike the characters familiar to us from nineteenth century Russian novels, they are not given to feelings of remorse or soul-searching. The selective scouring of the incriminating archives continues. It is truth-telling as a strategy rather than as a principle. No contrition is expressed for the killings, no punishment contemplated for the guilty or compensation for the surviving families. In a Russia where currency has little value and where food is being bartered for family heirlooms, the hoard of incriminating documents represents a unique treasury of evil deeds, a peculiar storehouse of indulgences that has become at the same time more a source of profit than penance for its owners.

Chapter 9

*How the murdered and their murderers haunt our consciences
and how our century presents us with an awesome task: Con-
fronted by inhumanities unimaginable in their scope, how do we
resolve the urge for revenge and the need for justice?*

On October 27, 1990, the bells of Kraków tolled to mark a date of
symbolic burial as survivors of the Polish officers were now allowed to go
to Katyń. Some came back with handfuls of soil from the Katyń forest to
give to those who were not able to travel there. Many of those who made the
journey could not rest without confronting those who had been witnesses to
the killings or lived in the vicinity of Katyń forest or any of the three camps
where their husbands, fathers, grandfathers or brothers were imprisoned
prior to execution. They wanted to comprehend how it was possible for the
Russian people to remain silent, forgetting that all over Europe millions of
Jews perished in just such circumstances in thou- sands of camps not far
from the homes of their own fellow citizens.

A few of the visiting Poles wanted to find those connected with the
killings, if not the actual executioners. In Smolensk, Pyotr Fyodorovich Kli-
mov, an aged NKVD agent, tried to escape such questioning by a daugh-
ter of a victim of Katyń. He said weakly that he could not speak, that he was
old, that he was sick, that he was sorry. On August 29, 1990, Klimov made
a deposition that was printed in *Moscow News* on September 23, 1990.[1] He
told of a system of conveyor belts used between 1933 and 1939 to take the
bodies from the execution cellars in the Smolensk NKVD building on Dz-
ierżyński Street to trucks, which took the remains to the Goats' Hills burial
site. He estimated that there were more than 10,000 Russian victims. Kli-
mov's job had been to wash out the trucks that were used. He remembered
that the victims were taken to the cellar, their heads placed over the edge of
a sewage hatch in the basement, and a shot fired at the back of the head or at
the temple. He remembered that the Polish officers from Kozielsk were
shot at the Smolensk NKVD headquarters cellars in the same assembly-line
system. The executioners were given grain alcohol to drink. They also used
it to wash their hands. Klimov also told of Polish prisoners shot at Goats'
Hills in 1940. The Poles were brought to the Gnezdovo station, taken by

[1]*Moscow News*, (Sept. 23–30, 1990).

truck to the execution site, shot or bayoneted, and thrown into a ditch. He saw one large ditch, 100 meters long and two to three meters deep, filled with bodies. This confession, according to Klimov, was being written for him to be signed because he could no longer bend his fingers.

• • •

There is a documentary film depicting such a journey of relatives, inspired by the director Andrzej Wajda whose father was one of the officers killed and buried at Katyń. Some of the officers who were unaccountably released before the massacres accompanied the grieving visitors. They visited the monastery at Kozielsk where the officers were held, read letters to each other, touched walls, peered through windows, lit candles and wept. Some of them went to the villagers to ask what they remembered. A daughter pleaded with an old woman to remember what happened in the spring of 1940. "I don't remember," the shabbily dressed peasant woman repeated over and over. "I am going to die soon anyway." But she finally recalled the trucks, "Black Ravens," that made their journeys into the forest. Had she heard anything? She refused to say at first. Finally, she admitted that she heard the sounds: *puk, puk, puk* at night. She knew these were shots. One time when she went with her friends into the forest to gather mushrooms and blueberries, she saw from a distance the figure of an officer in a long black robe. This was probably one of the Polish chaplains who would soon be shot.

Another villager, Mikhail Krivozercov, glowered when the visitor pressed for information. A cap's visor and tinted glasses partly hid his stubble-covered face. The daughter was imploring him to say something. "Daddy, you do know, there isn't much time left in your life. Tell her."

The old man sighed. His words came slowly. "What was cannot be brought back. Nothing can touch them now." But soon the pent-up feelings tumbled out. He told of the nighttime interrogations once the NKVD realized that villagers may have seen something in Katyń forest. His singsong sentences had the quality of folk sayings. "When you are told that white is black, you must say that it is black. And when you are interrogated, what the first one says had better be said by the twentieth as well. It's a wonder they did not shoot us all. They shot Russians, Poles, Latvians and gypsies. But I had to live through it all. Oy, oy," he ended with a moan as his chin sank to his chest.

Another witness to be questioned was Ivan Kisielov. He lived near the Gnezdovo train station, the place where the Polish officers debarked before being put into trucks with whitewashed windows to be taken to the place of execution. "Yes, they all lie on Goats' Hills," he said of the Polish officers." This used to be all our land, but in the 1920s and 1930s when they

accused us of being *kulaks*, they arrested all. Brothers, sisters, parents, all condemned by the troika tribunals. And these people knew nothing about politics. Then graves were dug and they buried them and they drove away."

An old NKVD employee, Ivan Nozdriov, his round face like a smooth stone over which many waves had washed, was in charge of the NKVD archives in Smolensk. He had a habit of laughing quietly as he gave testimony, his large, bald head rolling back and forth on his shoulders.

"Moscow has the archives on the Poles," he insisted. He knew that they had been shot and even now he feels that fear of the nightly knock on the door. All those who worked for the NKVD were afraid. Anyone could be accused of working for the Germans and get sentenced. "And they never gave less than a ten-year sentence. But I managed to get out with my skin intact."

Novoe Russkoe Slovo, a Russian language newspaper in New York, recently carried an article about interviews with the surviving NKVD killers of the Polish officers.[2] One of them was eighty-four-year-old Soprunenko. He handled all the cases regarding prisoners-of-war and signed the lists of men condemned to be shot. He was videotaped by the British journalist, Lord Nicholas Bethell, author of *The Last Secret*, a story of how the allies forcibly repatriated anti-Stalin Russians and members of General Vlasov's army who had supported the German forces. Soprunenko, who resides in a fashionable suburb of Moscow, at first denied that he knew anything about orders to kill the Poles, finally admitted that he did receive such an order from Stalin and that he sent a letter to Beria setting in motion the delivery of the officers to a "Special Commission," a euphemism for death sentences.

Another NKVD executioner who was interviewed was Vladimir Stephanovich Tokarev. Now ninety, he was like Soprunenko a young *apparatchik*, and had been stationed in the region of Kalinin since 1938, thus available to handle matters concerning the prisoners in Ostashkov. Both "experts" have provided a graphic and terrifying account of the killing of Polish officers. Tokarev astonished the interviewer with his calm and remorseless description of the executions: "as though they were cutting wood." The NKVD officer mentioned being summoned to a meeting in Moscow in March 1940, conducted by Kobulov, one of Beria's deputies. It was at that meeting that he was told of a decision to kill the Polish officers. He was shown a document authorizing the executions and warned that "there was to be no witness left alive." This decision probably had already been made in February 1940 when Soprunenko was consulting with Beria. But nothing could be done until April. It was only then that the soil would be sufficiently frost-free for digging graves.

[2]*Novoe Russkoe Slovo*, (October 25, 1991), p. 10.

According to Tokarev, who is blind but whose memory has remained sharp, the executions began on April 1, 1940. German-made revolvers were brought in suitcases because the guns made in Russia overheated quickly during prolonged shooting. The prisoners of the Ostashkov camp were taken by train to Kalinin and then transported in the "Black Marias" to the four-story NKVD headquarters. Crowded mercilessly in holding cells ("Somehow they were accommodated," said Tokarev), the Polish officers were taken to soundproof rooms and killed with a shot to back of the head. There was no trial, no reading of sentence, and there were no witnesses. The prisoners were led into a small room with posters and a plaster bust of Lenin, their names were verified, they were handcuffed, led into a smaller room, made to face the wall and then shot. The bodies were then thrown outside into waiting trucks, covered with tarpaulins which were burned after each trip, and transported to the woods at Miednoje where the bulldozers were waiting. Years later a radio tower was built over the graves. Altogether about thirty people made up the "staff" for the executions. Approximately 250 were shot every day, the numbers increasing as the nights grew shorter, with an execution scheduled every two minutes. The entire operation was a model of efficiency and economy in a country notorious for its chaotic ways. Some of the executioners complained of fatigue. Vodka was given liberally, but only after work was finished. By the end of April approximately 6,000 had been shot.

The NKVD officer in charge of the shootings was Viktor A. Blokhin, who brought from Moscow his own group of executioners, all of whom held officer rank in the NKVD. Tokarev described him calmly and chillingly as outfitted with a leather hat and high leather boots, a leather apron and gloves of elbow length. It was Blokhin who started the first batch of executions by saying: "Well, let's go, let's do it!" When the entire operation was completed, Tokarev said, a banquet was arranged. He was invited but begged off. Tokarev denied that he took part in the killings.

Blokhin died a few years ago. The author Edvard Radzinsky, in his book *The Last Tsar,* cited a letter he had received from Blokhin, who described the murder of the Romanov family as told to him by his friends ("it wasn't terrible, it was ordinary"). Blokhin, while retelling his friend's account of the cruel murders of some naval officers during the Revolution, the condemned men beaten and robbed as their executioners made trips to bordellos, remembered how the drunk assassin made a sign of the cross and muttered "De-e-eath ... de-e-eath ... de-e-eath" as the men were being killed.[3]

[3]Edvard Radzinsky, *The Last Tsar*, (New York, 1992).

Both Tokarev and Soprunenko have confessed that they were upset when told of the plans for execution of the Polish officers. Soprunenko remembered that his knees shook and NKVD officer Kobulov, who carried the official order, remarked how pale Soprunenko was. But when told that he did not have to take part in the actual killings, Soprunenko said that it was as if "a stone fell from my heart." One can imagine the terror among the executioners who were ordered that no witnesses be left. The banalities expressed by Tokarev and Soprunenko half a century later are a testimony to the inadequacy of language to convey human emotion. "How little value human life has," "I feel badly," "I cannot say anything," "I can only regret," "It was like an industrial undertaking." One sees only a snippet of emotion, as a moon's sliver piercing a black night, when Tokarev speaks to a young Polish soldier about to die. "How old are you?" "Eighteen." "How long have you been in service?" "Six months." "What did you do?" "A telegraphist." Tokarev attempts to show his humanitarian character in remembering how he persuaded a hesitant NKVD truck driver Misha to perform his duty and load the remains. "You know, you are a Communist," Tokarev said to him, "you have to fulfill orders." "I accepted the sin on my soul," said Tokarev, "in order to save Misha's life."

Tokarev remembers to this day how the men were killed at his NKVD head- quarters and buried near the villa he occupied at Miednoje. When he found out how other mass killings were done, the cries of the victims, the shots heard by those nearby, he had a professional opinion: "They did it foolishly!"

Jacek Trznadel, who has written about these interviews in the chapter "Rosyjscy Świadkowie Katynia" [Russian witnesses to Katyń] in the volume *Zbrodnia Katyńska*, 1992 [The Crime of Katyń] is reminded of the personality of Rudolf Hoess, the Commandant at Auschwitz, who also lived in a comfortable villa in the midst of the world's largest slaughterhouse. One day, Hoess delayed as long as he could the entrance of two beautiful Jewish children to the gas chambers. Finally, in order not to provide a poor example to the SS men, Hoess himself escorted the youngsters inside.[4]

Major-General Vladimir Kupetz from the Military Prokurator's Office scoffs at the self-serving account of the former NKVD officers. He says that both Soprunenko and Tokarev participated in murders that had no basis even in laws existing at the time. Whatever the case, neither man can be held to account legally since under Russian law there is a fifteen-year statute of limitations for murder.

The Polish periodical *Spotkania* [Encounters] recently printed an interview with an NKVD executioner, former lieutenant Mitrofan Syromi-

[4]Trznadel, "Rosyjscy Swiadkowie ... " in *Zbrodnia Katyńska*

atnikov who had provided an account of the killings of the Polish officers from Starobielsk in Kharkov NKVD headquarters to the Polish exhumation team in the summer of 1991. In his eighties, he lives in a one-room apartment on Rosa Luxemburg Street. He has been blind for several years. The reporter found him in a single-room apartment, sitting on an iron bed. Gray-haired, with a wrinkled face, he expressed no remorse. He has been told that the Polish officers rebelled while in captivity and that therefore the executions were justified. He denied that he was an executionerand named a single NKVD man with the rank of major, Kuprij, as the one who killed all the officers. When asked who had taught Kuprij his "technique," Syromiatnikov replied laughingly. "Maybe he went to a priest. There are instructions on how to kill people. In the NKVD a horse once got ill. One of my friends fired at himfive times to kill but didn't know where to aim. A good marksman has to be moreeconomical. At the front when you shoot, whether you kill or not, you go on. In peacetime, if you get an order, you must carry it out precisely. If you don't do it well, you'll be tried. It's best to know your instructions."[5]

Syromiatnikov's humor had an other-worldly quality, a stand-up comic who could kill his audience. When asked what was done with the bodies of the officers who were shot in the cellars of the headquarters, he replied: "Did you expect us to give them a bath?" The interviewer wondered how it was possible for so few to kill so many, to manage to carry out the remains of several hundred each night. Syromiatnikov spoke with pride about his comrades. "Oy, these were not children, these were men." When the questioner wanted to know about his career since the war, he said: "Do you want to know my biography so you can vote for me for a Deputy?" He remembered the names of most of his NKVD friends and kept track of them after 1945. Kuprij, he remembered, did well. After the war he was made a director of a dairy in Poltava.

In 1955, the KGB showed Syromiatnikov the door and gave him 50 rubles severance pay for a lifetime of loyal work. Bandits killed his only son shortly after- wards. He said that when this happened, his hair turned white overnight. His wife almost went insane with grief and spent most of her time in the Kharkov cemetery at her son's grave. A doctor told him to leave the city to get her away from the grave. There is no word for "executioner" in the Russian language. They use *ispolityel* which suggests "performer," though the performance takes place in a sound- proofed execution chamber rather than the stage. The word "performer" was an NKVD invention. There were no official executioners in a country where millions were condemned to die. There were only people who performed their duty.

[5]"Czy Pan Zabijał?" *Spotkania*, No. 35, 9–10. Cf. Stanisław M. Jankowski, "'Nieludzka Ziemia,' Ujawnia Prawdę", *Przegląd Polski*, August 24, 1991, 14–15.

Chapter 10

1996 - 1997 was notable for two events that became the high-water mark of Maliszewski's personal Katyń history: the publication of his discoveries in Poland, and an extraordinary testimonial from Zawodny - fighter-scholar and dean of Katyń studies - the custodianship of his personal archives. But Maliszewski's attempt to publish the truth about Katyń revealed that some minds had remained captive.

When I interviewed Maliszewski on November 11, 1996, he was going through a painful period in his relationship with the engineer Pieńkowski, his representative in Poland. Pieńkowski was the intermediary with the publishers for Maliszewski's path-breaking manuscript: Katyń: *An Interpretation of Aerial Photographs Considered with Facts and Documents*, a work that eventually appeared in a special issue of *Photo-interpretation in Geography in 1995.* The publication of this work in which Maliszewski had invested so much time and treasure strained relations with Pieńkowski. Maliszewski realized only when the manuscript was ready for printing that it would appear truncated without some of his most important arguments. He felt betrayed.

The history of the Pieńkowski family made it all the more painful. Tadeusz's father, Ludwig, had been imprisoned at Starobielsk and was killed at Kharkov at the same time that his teen-age son was in a prison cell in that city! After the war, Pieńkowski worked in the Katyń underground where he helped in the publication of the journal Biuletyn Katy Katyński and assisted in the founding of Instytut Katyński [The Katyń Institute of Poland], keeping the spark of truth about Katyń alive when such activity was still subject to severe punishment. As Poland regained its independence from Communist rule, Pieńkowski helped to establish *Archiwum Wschodnie* [Archives of the East] and its remarkable publication *Karta.* When Maliszewski arrived in Warsaw in 1991, it was Pieńkowski who accompanied him to meetings with Polish officials and was with Maliszewski when the latter was honored in 1992 with the Katyń Medal of the Instytut Katyński and the Officer's Cross of the Order of Merit of the Republic of Poland, given by order of President Wałęsa in Washington, D.C., in 1992. There were acts of personal kindness as well when Pieńkowski scoured (unsuccessfully!) the country-

side to find for Maliszewski's friend Schochet a bottle of the rare *pesachov-ka*, an exceptional Jewish-style vodka. Later on when Schochet and his two children visited Poland on their pilgrimage to Auschwitz, they were warmly received by Pieńkowski. Schochet for his part procured a much-needed medication for him.

The relationship showed signs of strain at a time when researchers in Poland continued to write about intelligence derived from Katyń photo analysis, relying heavily on Maliszewski's work without the customary attribution. They acted as if they had accidentally stumbled upon a shaft of precious ore and proceeded to mine it with scarcely a thought to its far-away owner. In spite of the evidence that Maliszewski was a serious Katyń researcher these Polish writers seemed to have the impression that he was a creature from a CIA laboratory, a capitalist Frankenstein whose antiques conservation studio was a front for an American intelligence operation. It seemed inconceivable to them that someone outside of academia could appear unannounced with such highly technical revelations. They did not know of his academic apprenticeship. Maliszewski, under a "Don"-like tutelage with Professor Zawodny for close to ten years, was instructed in the analysis of primary documents by the world's foremost authority on Katyń, As far as Maliszewski was concerned, the petty actions by some in the Polish academia demeaned the very profession he held in such high regard. Having never abandoned his love for Poland, the disappointment was almost visceral. These Poles behaved as if they were Russians!

Examples of these "borrowings" abounded. Professor Jan Olędzki, director of the Department of Geography in Warsaw University together with Drs. Mycko-Dominko and Marian Glosek published articles that relied on Maliszewski's original work without a normal scholarly concern that their published work preempted Maliszewski's own plans and thus denied him much-deserved credit when his own publication saw the light of day. It was as if they assumed that "thunder" had not been preceded by "lightning." In addition, both Olędzki and Mycko-Dominko, accompanied by Pieńkowski, took Maliszewski's materials for a lecture tour in the Czech Republic without bothering to consult him. Later, most importantly, Maliszewski blamed Pieńkowski for not objecting strongly to the removal, by Olędzki, of the manuscript portions that Maliszewski considered central to his argument. One issue in particular that Maliszewski raised clearly touched a raw nerve: it was his assertion that the testimony by Dr. Buhtz, employed by the German investigative team was correct. And yet it was clear to Maliszewski that the version which appeared in the German *Amtliches* ... was the correct one. Adding insult to injury, the names of Olędzki and Pieńkowski were added as editors when the now "censored" manuscript was prepared for

publication.

But as Maliszewski now discovered, events in the land where the crime of Katyń was committed may have been a precipitating factor for the removal of some important sections from his manuscript. In January 1996, a book published in Russia by Juri Micha (apparently a pseudonym), under the Katyń auspices of the Russian Parliament, the Duma, once again revived the hoary canard that Katyń was perpetrated by Germans. The book, *Katynska Powiest Krymynalna,* [The Criminal Novel of Katyń], a work whose cover showed Germans executing Poles, argued that Gorbachev's admission of September 17, 1990 that the Soviets were responsible for the massacres was false. It was, at the very least, a sign that the Russians were tiring of "Case 159." The reaction to this astonishing *volte face* in Poland was not what Maliszewski had expected. Now both Olędzki and Pieńkowski made it clear to him that their decision to censor his work was based on what transpired in Russia. They saw Micha's work as a warning that discussion of Katyń was over in Russia. Maliszewski's study criticized Polish "obfuscations," published in 1946 and 1949: Manipulations of eye-witness testimonies. Pieńkowski thought this would arm the Russians. As he explained in a January 17, 1996 letter to Maliszewski: "the decision I have made is unquestionably for the best, both for your work and for the whole affair. One must remember that the Russian prosecutor's office will be glad to hear of a publication that talks about 'falsification' of evidence and 'manipulation of documents' by the Polish government." He added: "In Smolensk District they are writing that the crime was committed by the Germans and that the Poles are writing lies about it. Even some delegates to the Duma are saying that the Burdenko report which has never been officially annulled by the Russia Prosecutor's office was the official Soviet document on the crime of Katyń. These are very important matters, and we must always remember this."

In spite of this "positive spin" that Pieńkowski was putting on this censorship of Maliszewski's manuscript, as far as Maliszewski was concerned these actions resulted in the worst possible outcome for his work and made the scientific con- tent of his research seem subjective. He could not accept the reluctance of the Polish scholars to come to grips with the past. Maliszewski's close reading of witness testimony led him to conclude the obvious. No publication in Poland identified Sukiennicki's primary 1946 source: *Facts and Documents Concerning Polish Prisoners of War Captured by the USSR During the 1939 Campaign.* Instead, *Zbrodnia* Katyńska [The Murders of Katyń] a 1948 secondary source, was used to provide "proof" for the fifteen editions that followed, each of which led to manipulation of evidence. To cite another important example, Maliszewski questioned how

any scholar could accept the five or six versions of the Krivozercov testimony which only by 1953 were brought into agreement with the testimony given by Swianiewicz. It meant that the testimonies were manipulated, or as Maliszewski had put it, there was "obfuscation of the Polish evidence." In this he was following the earlier critiques of Zawodny who in his *Death in the Forest,* introduced a discussion on the German evidence and emphasized that all governments had a political imperative in manipulating the evidence, including the Polish one. The Polish officials never asked the crucial questions: What did Krivozercow see? What did Swianiewicz see? What did John Melby of the Associated Press see? What did Kathleen Harriman see? Eventually the eye of the camera proved to be a more accurate and hon- est witness. It all seemed too obvious to Maliszewski, but he did not take into account the changing political imperatives in both Russia and Poland.

While Pieńkowski objected to suggestions that there were "obfuscations" in the collection of documents he did finally agree that while Maliszewski's conclusions were to remain in the book, the reader was not to see Maliszewski's proof that the testimony had been manipulated. Contrary to accepted publishing procedures galley proofs were not shown to Maliszewski and Pieńkowski substituted his own introduction. The matter was a *fait accompli.* When a year later Pieńkowski's son met with Maliszewski in an effort to mediate he intimated that his ailing father was pressured by higher-ups in academia.

Maliszewski had other important objections to the censorship exercised by Oledzki and Pieńkowski. He questioned the Polish reports on Miednoje-Jamok exhumation sites that claimed that all internees from Ostaszkov were accounted for. His own observations of the terrain and collateral evidence convinced him that additional locations existed. As proof of the inadequate work done by the Polish teams, Maliszewski cited their conclusion that Miednoje was never occupied by Germans. His own research showed that the Lehr Brigade of the 1st Panzer Division fought a protracted battle there with Red Army and NKVD units. Terrain disturbances, differing from acts of war, or the *Yezhovschina*, were not accounted for by Polish archeologists.

The story of Kharkov has been of particular interest to Maliszewski who has studied the photography connected with it intensively. As he had written in his unpublished Kharkov study:

> As to the city that some Germans referred to as "little Paris," it
> may be the hub of the largest killing ground I have so far encountered in my studies of aerial photographs of Soviet terrain.

The imagery reveals "signatures" of concealed mass graves that were created during the Revolution and the Civil War, the Red Terror initiated by Lenin, Stalin's Great Terror, the Purges through 1941, the periods of German occupation and the retribution killings by Stalin on re-occupying the city.

Maliszewski states that he forwarded scientific evidence on Kharkov [with the assistance of Brzezinski] to the officials in Poland that pinpointed not only the mass graves of Polish officers from Starobielsk, murdered and concealed in Kharkov, but also other numerous graves created in the 1930s. There has been no acknowledgment.

The questions Maliszewski was asking were not restricted to the original crime and its aftermath but to the current effort by the Polish and Russian officials to limit the investigative scope. He was like a terrier refusing to let go of officialdom's trouser leg. Why didn't Śnieżko invite Zawodny, the leading expert on Katyń? Why did the electrician Tucholski become the official historian to the commission? Why didn't Śnieżko give to Professor Andrzej Kola who was studying Kharkov, the materials that Maliszewski forwarded years earlier? Why did Śnieżko ignore the materials that were sent by Maliszewski to Mielecki and then fire the latter? Maliszewski saw Śnieżko as an obstacle to an honest and thorough investigation. The representatives of Katyń families have also become disenchanted with Śnieżko and addressed their concerns to him in a long letter. All this was a source of personal sorrow and professional disappointment to Maliszewski. "The honor of the Katyń families should not be sullied with the likes of Śnieżko and his 'gang of five,'" he stated, not even trying to hide his anger.

Maliszewski's only alternative was to withdraw his work from publication, but he finally decided that it would be better if his work would now be seen by experts who would judge the evidence for themselves. He planned to publish a more complete, uncensored version in the United States so that his empirical study of documents, and previous writings on Katyń could be presented as he had intended.

Katyń is the story of multiple burials. First the Russians killed, buried the dead and kept the secret for half a century. Then the Polish investigators "buried" the achievements of honest investigators such as Zawodny and Maliszewski. Śnieżko dismissed Maliszewski as "an American of Polish descent," when the latter had tried to maintain not only the honor of Poland but the standards of academic integrity. He continued to be convinced that much remained to be done to unravel the NKVD-Gestapo cooperation.

• • •

On May 29, 1997, Maliszewski penned a complaint to Heraklius Swi-erełło, the Polish consul general in New York. It detailed discussions held there on January 1, 1996, when Maliszewski, accompanied by Schochet, was invited to meet with Andrzej Przewoźnik of the Rada Ochrony Pamięci Walk i Męczeństwa [a Council for the Preservation of Memory of Struggles and Suffering] and Prof. Andrzej Kola, Chief Archaeologist for the Kharkov exhumations. During the two-hour meeting those present discussed Mal-iszewski's research of Katyń, Miednoje-Jamok and Kharkov sites. Malisze-wski was convinced of the likelihood that remains of some victims from Starobielsk were concealed south of Kharkov, near Bezludovka, west of the Belgorod road near Sokolniki and Alexeyevka, and possibly west of Khar-kov near Dergachi. He had marshaled considerable evidence in support of this. No archaeological study had accounted for the testimony of a German officer who saw bodies blown from the terrain near Kharkov with terrestrial features distinctly different from those of the *Czarna Droga* area near Pia-tachatka. Similar Ukrainian testimony had not been tested. The testimony regarding Bezludovka, south of Kharkov, a hill similar to Katyń and dotted with disturbances that have the characteristic NKVD signature had likewise not been considered. Maliszewski reasoned that reburial took place after the 3rd Battle of Kharkov and availed him- self of American satellite imagery to prove his point.

Przewoźnik implored Maliszewski to send him the results of his re-search even as he confessed that there was tremendous pressure to conclude the terrestrial investigation and establish a military cemetery. He promised that he and Prof. Kola would make all arrangements to assure that Malisze-wski's rights of authorship would be protected. As Maliszewski noted in his bill of particulars, these discussions were in effect held on official Polish "soil" and Przewoźnik therefore acted as a representative of the Polish Re-public.

Przewoźnik made several commitments to Maliszewski which includ-ed an invitation to a special conference on Katyń to be held in Warsaw in the summer of 1996. He promised that Maliszewski would be asked to participate in the terrestrial investigation of the Kharkov terrain and that he would also be allowed to look at the Sokolniki, Alexeyevka, Bezludovka and Piatachatka sites, long suspected by Maliszewski to be burial places of Polish officers. The entire trip and the accommodations in Warsaw were to be underwritten by the Polish authorities. Przewoźnik requested that Mal-iszewski provide both him and Kola with copies of all the mate- rials and advised him that an official letter inviting him to both the conference and the exhumation sites would come from Kola. Reminded by Maliszewski that the documents he was providing included lengthy data obtained from

the CIA. Przewoźnik reiterated that confidentiality and rights of ownership would be strictly adhered to.

Following this meeting, Maliszewski prepared his own map of the Kharkov region as well as Luftwaffe reconnaissance photos and maps based on CIA satellite imagery. He included his own maps of Katyń, those derived from CIA sources and maps of Miednoje-Jamok. Maliszewski also made copies of his correspondence with Brzezinski and sent numerous other documents as well as several copies of his as yet unpublished (and uncensored) work. All these were forwarded to Przewoźnik and Kola. Maliszewski was promised that they would soon be in touch with him.

Nothing more was heard from either official. There was no official invitation to the Katyń conference and no invitation to visit the sites that were discussed at the New York meeting. Seven letters were sent by Maliszewski to Kola but they remained unanswered. Maliszewski accused the Polish officials of misconduct and breach of promises. He concluded his long letter to the Polish consul by demanding that his documents be returned. No reply was tended. Maliszewski concluded that Przewoźnik and other authorities in Poland concluded that all Starobielsk victims were accounted for in Kharkov and that the remainder of the Ostaszkov prisoners were accounted for in Miednoje-Jamok. He disagreed strongly with both conclusions and continued to hold that there was another site at Miednoje as well as several others of interest in Kharkov. Maliszewski sent the evidence to Nikolai Danilov of the Odessa *Memorial* who in turn forwarded these materials to *Memorial* groups in Tver (Miednoje) and in Kharkov. Danilov found out later that the site in Miednoje was cordoned off and that members of the *Memorial* were turned away by militia. What were they concealing? Were there more Polish graves there? Did those numerous "dog bone" shaped graves (the signature of a bulldozer on entering and leaving a trench) contain victims of the Finnish-Russian war or officers from other Baltic states? Polish authorities had not been allowed to explore the numerous sites pinpointed by Maliszewski and eventually gave up on these attempts. Przewoźnik's statement was proof of this. Maliszewski is convinced that the need to curry favor with Western businesses by not fully exposing the *Stalinshchina* and its current successors lies at the bottom of the undisclosed burial places.[1]

Another complaint was sent by Maliszewski to Consul Swierełło on June 1, 1997, this time concerning the conduct of Sobierajski. Ever the precise historian, Maliszewski reviewed contacts since 1992 and reminded the Polish consul that not only were his documents never returned but that this was the second time that promised expenses never materialized and that the above mentioned Sobierajski explained during Maliszewski second trip

[1]Nikolai Danilov to Maliszewski, *Odeskii Memorial*, September 15, 1995.

that the money he was to pay Maliszewski was stolen from his apartment. Maliszewski concluded by noting that he had studied Katyń imagery for twelve years, had made a sacrifice of time and money "that I have borne myself and proudly so."

More than a year ago Maliszewski received a letter from Swierełło informing him that at long last both he and the officials from the Polish Foreign office were looking into his complaints. Maliszewski has not yet heard but, ever the optimist, expects eventual official vindication.

<center>• • •</center>

For Maliszewski 1997 closed on a bittersweet note. A man of generous impulses, animated by a *noblesse oblige* and scholarly respect for sources, he was deeply hurt by the behavior of both Polish officials and some of the academia. Married, with four children, he had sacrificed his personal time and treasure. But there was satisfaction to savor from the remarks addressed to him by men he respected and admired. Robert Conquest, the world's foremost authority on Communist terror, writing about Maliszewski's research on Babi Yar and Katyń, said that he "deserves the world's gratitude." Brzezinski, who had followed Maliszewski's research almost from the start, congratulated him and praised "the meticulous character of (his) photo interpretation." But his greatest moment of personal satisfaction was the receipt of a brief but heartfelt message from Zawodny. Dated September 10, 1996 and addressed to "Wacek," Zawodny in his characteristic calligraphic style wrote: "My knightly friend, in appreciation of his valiant heart and on the occasion of the publication of his first book - the Righteous Cause - the Righteous Man. Congratulations. Janusz." Shortly after this note was sent, Zawodny, who had said of Maliszewski's work that "no serious investigation of this subject [Katyń] can be written without it," decided to entrust his personal archives to Maliszewski.

The Zawodny archives will be utilized by Maliszewski to rectify the omissions and falsifications that have been part of the history of Katyń. These materials will be especially useful Maliszewski in ascertaining the different versions of testimonies going back to the 1946 *Facts and Documents*. There are also thirty-seven boxes of the Sukiennicki material at the Hoover Institution which have not yet been utilized. Publication of the actual, uncensored original depositions that formed the 1946 *Facts and Documents* should also be available to forensic medicine specialists and archeologists.

<center>• • •</center>

If God employs an avenging angel, then Maliszewski might fill the bill. Gentle yet strong, he exudes an old-world kindness even as he tries to rectify a half-century old horror. His work in aerial photography has earned him friends in many parts of the world. Russians who are members of *Memorial* are in touch with him. He is a member of the American Society for Photogrammetry and Remote Sensing. Our earth is filled with unidentified remnants of man's inhumanity. Maliszewski wants the eye of the camera to search for them in hitherto unfound burial pits. Ezekiel's prophetic imagery resonates in his work and words. But Maliszewski has other plans for aerial photography. He wants to use this tool to help establish precise locations for the destroyed monuments of ancient cultures, churches and synagogues smashed and burned to make room for roads and monuments glorifying tyrants. He would like to establish the correct dimensions of the battles of Waterloo and Borodino. Aerial photography as history's latest tool.

• • •

In a phone conversation, Maliszewski, a poet at heart, quoted fondly to me from James Joyce's *Ulysses*: "Ineluctable modality of the visible, at least that, if no more, thought through my eyes. Signatures of all things I am here to read, sea- spawn, sea-wrack, the lapping tide." "Ineluctable," has been Maliszewski's favorite word. His work has been a struggle, chosen by him and yet inescapable. He is a man surveying the murderous landscape of our times with the skill of science and the judgment of God's eye.

Chapter 11

How Communists and Nazis may have shared a "community of interest" in regard to the Polish elites, and how the crime of Katyń raises not only grave questions about leadership in the democratic West but cautions us about the nature of the nation-state.

On September 26, 1939, nine days after Stalin joined Hitler in dismembering Poland, the English cartoonist David Low drew "Rendezvous" for the *Evening Standard*. It was one of the most unforgettable images of the times. The two dicta- tors struck a mock, dance-like pose over the prostrate body of a Polish soldier. "The scum of the earth, I believe," said Hitler doffing his military hat. "The bloody assassin of the workers, I presume," Stalin responded, raising his worker's cap.

One of the most intriguing mysteries of our century may come to light as a result of the continuing (if partial) opening of the archives of the former Communist Party and its secret services. This is the question of German-Russian relations which twice in this century shook the foundations of the European state-system.[1] The financial aid given by the German government to Lenin and the dramatic introduction of that "bacillus" into war-torn Russia may be ascribed to wartime opportunism, but the fact that considerable cooperation between the German and Russian military and intelligence services continued in the 1920s and 1930s calls for a more complex analysis. The training of Russian cadres by German specialists, the development of advanced combat aircraft on Russian soil, extensive trade relations signaled by the signing of the Treaty of Rapallo on April 16, 1922 have been documented. Less well known (and largely ignored because they were overshadowed by the public record of mutual vilification) were contacts with German officialdom on the part of Lenin's emissary Karl Radek, and

[1]Dmitri Volkogonov, *Autopsy for an Empire: The Seven Leaders Who Built the Soviet Regime* (New York, 1998) p. 22, passim. Anthony Read and David Fisher, *The Deadly Embrace: Hitler, Stalin and the Nazi-Soviet Pact 1939–1941.* (New York, 1988), p. 15, passim. Also, John H. Waller, *The Unseen War in Europe: The Espionage and Conspiracy in the Second World War* (New York, 1996), p. 28, passim. Richard Pipes, *Russia Under the Bolshevik Regime* (New York, 1993) p. 240 ff.

mutual accommodations symbolized in the release of the Bulgarian Communist leader Georgi Dimitrov whom the Nazis accused of being responsible for the Reichstag fire. The two systems were actually mirror images of one another. The use of state terror and the network of camps existed in the Soviet Union almost two decades before it was instituted in Nazi Germany. Hitler's "Night of the Long Knives" of 1934 was followed by Stalin's extermination of thousands of his former comrades. The two men had much to admire and emulate. General Petro Grigorenko, who defected to the West in 1972, revealed in his *Memoirs* in 1982 that the Soviet secret services first used vans for gassing *kulaks* in the early 1930s in Omsk. If this startling revelation is true, this predated Nazi methods used by the SS in Chelmno, Poland, by a dozen years.[2]

There are many unanswered questions about contacts between Nazi Germany and the Soviet Union immediately preceding the Nazi-Soviet Pact of August 23, 1939, and in the two years before Hitler's attack on June 22, 1941. The sensitivity of these relations may be gauged by Gorbachev's reluctance while in office to even admit that his archives held the Hitler-Stalin protocols on the division of Eastern Europe, even though copies of these documents had been a matter of public record in the West for nearly half a century. When the Communist leader finally acknowledged their authenticity in 1990, we had one more example of a method that had stood the Communist leadership so well in the past: First declare brazenly that what the whole world accepts as truth is a lie. Then, when death and delay has robbed the matter of its urgency, agree that the so-called "lie" was indeed the truth. Finally, in a script that could only be crafted by a master of the theater of the absurd, welcome the praise of one and all for candor and reasonableness.

Possible cooperation between Soviet and Nazi secret services in 1940 killings of 27,000 Polish soldiers and Civil Service personnel on Russian soil has come under increasing scrutiny. A Polish scholar, Jerzy Lojek, in his *Agresja z 17 Września 1939 r.* (1990) [Aggression of the 17th of September, 1939] has cited the books: *Armia Podziemna* [Underground Army] by General Bor Komorowski, published in 1952, and W Cieniu Katynia [In the Shadow of Katyń] by Swianiewicz, published in 1968, which suggested that such cooperation did indeed take place. Swianiewicz in his work noted the comment made by Stanisław Mikołajczyk, the last legitimate representative of the Polish government, to Zawodny, that there was an understanding between the Germans and the Russians in 1939–1941 for the exchange of Polish prisoners, and that the Germans refused to live up to the terms of the agreement, in effect dooming the Polish officers to Russian hands. This, like the suspicions voiced by Lojek, suggests at the very least that the lives

[2]Petro G. Grigorenko, *Memoirs* (translated by G. P. Whitney. London, 1983).

of the Polish officers were of no great moment to either nation. Lojek, in his search for the "smoking gun," focused on the meetings between high Gestapo officials and the NKVD in Kraków and the nearby resort of Zakopane in early 1940. We know the names of the villas where they met and we have a photographic record showing NKVD and Gestapo enjoying sleigh rides together, but we do not know what was discussed. Still, it takes no great leap of imagination to conjecture that the fate of the Polish officers was on the agenda. Both powers certainly viewed the survival of such a patriotic and capable officer corps as an adversary in any future settlement. In fact, we know that shortly after the conferences in Kraków and Zakopane, the Germans commenced mass executions of Polish elites in Kraków and Warsaw, while the Russians began the process of assembling and subsequently killing the Polish officers collected in the camps of Ostashkov, Starobielsk and Kozielsk.[3]

It may be that crucial documents will never be found just as there is no piece of paper signed by Hitler directing the extermination of millions of Jews. But missing pages need not deter us from drawing logical conclusions about missing people. We are too often confronted by either those who believe that all events of great import are the product of a conspiracy, or by those who for reasons more ignoble than noble, as in connection with the Holocaust, challenge the tragic record, absent absolute written proof.

A term that may help explain what has escaped the scrutiny of scholars is "community of interest." When an event is perceived as vital to a body politic, the entire system is energized by that stimulus, like an amoeba that quivers when any part of it is touched. The Nazi and Soviet dictatorships, governed as they were by the same primitive urges, answered to the same murderous instincts. Hitler and Stalin understood each other as well as any such kindred criminal minds would. They could and did easily and automatically implement policies that would be unthinkable elsewhere. In their aim to subjugate Poland, a country they both despised and wished to destroy, they understood each other only too well.

More evidence might surface tomorrow to substantiate today's suppositions. While in Warsaw, Maliszewski met with Liebiedieva, one of the leading Russian researchers into that period. She was examining archival materials that could shed light on part of that mystery, the possibility that the Germans provided expertise or even assisted in the

[3]Jerzy Lojek, *Agresja z 17 Września 1939 r.* (Warszawa, 1990) p. 150, passim. Bor Komorowski, *Armia Podziemna* (London, 1952) pp. 50–1. Stanisław Swianiewicz, *W Cieniu Katynia* (Warsaw 1968) p. 329, passim.

transportation of the doomed Poles by rail to Ostashkov, Starobielsk and Kozielsk. Rail transport was a German logistical specialty, one without which the Holocaust would not have been possible. If such documentation can be found it would suggest a level of cooperation between NKVD and the Germans that might lead to more incriminating materials.

If there was any collusion in the meetings at Kraków and Zakopane, it was certainly not in the interest of either side to risk such a revelation. While one could accuse the other of the crime, as they later did, neither could even hint that there was any prior understanding about it. The fact remains that to this day neither Russians nor Germans have addressed the agendas of the Kraków and Zakopane meetings. Most of the records of the Gestapo have been destroyed while the Russians have not made theirs available. Norman Davies has suggested in his *Heart of Europe: A Short History of Poland* that it may be that the Katyń murders were organized by the NKVD and the SS, hence the reluctance to mention this crime for such a long time. In history, the absence of information may be as significant as its presence. If there was a meeting of minds at Kraków and Zakopane then the brutal partnership between the Germans and the Russians was based on blackmail and like all blackmail its value lay in not revealing it.[4]

Professor Władysław T. Bartoszewski in an introduction to a book by Dr. Salomon Slowes, *The Road to Katyń* (1992),[5] offered another startling hypothesis. He suggested that the NKVD and the Gestapo officials who met at Kraków and Zakopane discussed plans for Auschwitz as well. The extermination camp which opened its killing facilities in 1940, was initially designed to destroy the elites of the Polish nation. Tomasz Strzembasz and Krzysztof Jasiewicz in a postscript to the recently published *Dokumenty Ludobójstwa* [Documents of Genocide] have raised additional questions about the similarity of aims between the Nazis and the Communists. They noted that in 1940 German security police started action coded A-B, which, as in the Palmiry Forest executions near Warsaw, resulted in thousands of dead. They also called attention to the German-Soviet Protocol signed on September 28, 1939, which regulated border arrangements, specified that neither country will tolerate "agitation" against the other side and included a promise to inform each other and cooperate. The authors compared the deportation of over a million Poles to the farthest and most inhospitable regions of Russia where many perished to the death camps used by the Nazis.[6]

[4]Norman Davies, *Heart of Europe: A Short History of Poland* (New York, 1968) pp. 66–67.
[5]Solomon W. Slowes, *The Road to Katyń: A Soldier's Story* (Ed. Władysław T. Bartoszewski), Oxford, 1992.
[6]Tomasz Strzembosz and Krzysztof Jasiewicz, *Dokumenty Ludobójstwa*, op. cit.

The Nazis and the Communists had something else in common. Both of them specialized not only in destroying human life, but in obliterating traces of such actions. As one was abandoning territory to the other, each was feverishly removing any vestiges of mass murder. In 1943, as the Germans were leaving the area of Kiev and the ravine of Babi Yar where they had massacred close to 100,000 people, mostly Jews, they used dynamite to obliterate any signs of that atrocity. In 1944, as the Communists regained Smolensk and the Katyń forest, they exhumed, destroyed and scattered the remains of the Polish officers.

Yegor T. Gaidar, Russia's former Prime Minister and a man heartily disliked by the ultra-nationalistic, Communistic and frequently anti-Semitic coalition, has likened this group to the Nazis in 1930s Germany. What seemed like an extravagant comparison was actually very perceptive. Public expressions of mutual dis- gust aside, very little of substance separated Fascism and Communism from the start. Both were contemptuous of Western traditions and of the middle class. The history of their joint and yet separate pursuit to destroy that class whose habits they emulated as leaders but whose benefits they would deny their followers, is yet to be written.

Stephane Courtois' recent monumental work, *Le Livre noir du communisme* [Black Book of Communism][7] records the deaths of between 85 and 100 million victims in lands where communism held sway, and raises one of our century's crucial questions: Why were the crimes from Lenin to Pol Pot, crimes described by Courtois as those of "planetary dimensions," never considered not only equal to but surpassing those of Nazism and Fascism? Why was there no equivalent of a Nuremberg Trial for Communist leaders? Or as Martin Malia who reviewed the Courtois book put it, why was there "no 'de-Communization' to solemnly put Leninism beyond the pale of civilization?" The small stone from the arctic Solovki Islands brought by the *Memorial* and hidden from public view at the former Lubyanka prison entrance hardly does justice to victims of Communism. While there are no statues anywhere in Germany that pay homage to Hitler, Lenin's mummified remains are still visited and there are plans being discussed in Russia today to replace the statue of Dzierżyński, the founder of state terrorism, a statue that was removed during the first flush of freedom. And the executioners of the 27,000 Polish soldiers continue to live out

p. 159 ff.

[7]Cf. Martin Malia's review in *Times Literary Supplement* (March 27, 1998) pp. 3–4. Stephane Courtois et al. *Le Livre Noir du communisme: crimes, terreur, repression.* (Paris, 1998).

their pensioned retirement in Moscow.

• • •

It is one thing to find the Russians and Germans involved in mutual deceptions and another to see the West engaged in a policy of concealing the truth about Katyń. Zawodny in his 1991 essay Sprawa Katyńska w Polityce Amerykańskiej [The Question of Katyń in American Policy], published in Wojskowy Przegląd Historyczny, has taken both Roosevelt and Churchill to task for the political intrigues that have stained the honor of their respective governments.[8]

In the winter of 1942, according to Zawodny, the United States Ambassador to Moscow, Admiral William H. Standley, had already sent the State Department information that Polish prisoners in the Soviet Union were missing and expressed great fears for them. In a country where each citizen, let alone a foreign national, was carefully watched, the disappearance of a large number of military men of another country could only arouse the gravest suspicions. A little later, an American liaison officer in the Middle East, Colonel Henry Szymanski, and his British counterpart, Colonel Huls, collected materials on Katyń indicating that a tragedy may have taken place in connection with the Polish officers. Following the discovery by the Germans of the Katyń graves in April 1943, Colonel Szymanski sent General Strong, Head of Army Intelligence, a full report on the Katyń massacre. The American side collected enough materials on the matter to fill several volumes. Zawodny cites P. Carter, an intelligence specialist working directly under Roosevelt, as one who kept the President informed about this matter and included information from Polish Intelligence in London in his reports. There was no doubt that this information pointed the guilty finger directly at the Soviet Union.

In addition to the above, Colonel John Van Vliet and Captain Donald B. Steward, the two Americans who were prisoners of the Germans and attended the exhumation in April 1943, reported what they had seen at Katyń to General Clay ton Bissel, Head of Army Intelligence upon their liberation. They were convinced that the Russians had committed the massacre. Van Vliet's report was marked "Highly Secret" and he was told not to discuss it with anyone. These and other documents fully supported the view that the crime was committed by the Soviets. The only report that contradicted the above findings was one written by Kathleen Harriman (later Mrs. Stanley Mortimer), the daughter of Ambassador Averell Harriman and an employee

[8]Janusz Zawodny, "Sprawa Katyńska w Polityce Amerykańskiej," *Wojskowy Przegląd Historyczny*, XXXVI, Warszawa, 1991) pp. 279–283. Cf. "Służebna Rola Przeszłości," in *Rzeczpospolita* (15–16 November, 1997).

of the Office of War Information. She attended the Burdenko exhumation in 1944 and supported the Soviet version. As Zawodny pointed out, her opinion, a product of Soviet propaganda, was given greater weight by official Washington than the authoritative reports of all the others. It was the version Roosevelt preferred. When Maliszewski contacted her recently, Harriman still seemed to accept the Russian version even after a half century. She described Katyń as "terrible tragedy that the Germans aired in the hope it would cause friction between the British and ourselves and the Soviets."

The list of those American officials who sought to uncover the truth about Katyń before and after 1945 was not a long one, but it was respectable. Postwar Ambassador to Poland, Arthur Bliss Lane, some members of Congress (almost exclusively of Polish origin), and a few others tried to speak out but were either ignored or discouraged. When Marian Kreutz, an announcer on a Polish radio station in Detroit accused the Russians of the Katyń atrocity he was silenced by Senator Allan Cranston, then head of the Radio and Communications for the Office of War Information. Justice Robert H. Jackson, United States representative at the Nuremberg Trial, could not present materials that connected the Russians with Katyń since these were all classified as "Secret." Those who were privy to information about Katyń were punished. In December 1943, Colonel Szymanski was accused by his superiors of using information from anti-Soviet sources and was strongly reprimanded. Roosevelt's special envoy to the Balkans, George Howard Earle, through his contacts in Bulgaria and Rumania received confirmation of Russian culpability. When Earle placed all this material in front of the President, Roosevelt said to the special envoy: "George, this is German propaganda and intrigue. I am absolutely convinced that the Russians did not do this." When Earle wrote to the President asking for permission to publish his account of Katyń. Roosevelt replied within two days that he forbade any publication that cast suspicion on our ally, and that in any case, the ambassador was still on active service in the Navy. Following this letter, Earle was "exiled" to serve in Samoa.

Roosevelt's death and the conclusion of the war with Japan did not end the silent treatment on Katyń. When Józef Czapski arrived in the United States in 1950 and was asked by the Voice of America to tell of his experiences, his remarks about Katyń were excised from his proposed text. He was not even allowed to mention the word "Katyń." It was only in the wake of the North Korean aggression, at a time when anti-Communist sentiment was increasing, that Congress finally launched an investigation of its own into the Katyń atrocity. In September 1950, the Department of Defense, under pressure, finally made public a report by a twenty-eight-year-old Lt. Col. H. Van Vliet, who as an Allied prisoner was brought by the Germans to

witness their exhumations at Katyń. When he returned to the United States in 1945, he had made a full report to Army Intelligence but was told to keep it a secret. His original report was lost. Although at first, he was willing to concede that the German report was "a huge, well-managed, desperate lie to split the Western Allies from Russia," he concluded with great reluctance "that for once the Germans weren't lying." When Zawodny interviewed him again in 1988, the 74 year- old Van Vliet, himself a prisoner of war recalled that he could not imagine such a massacre of helpless men, each with his hands bound, shot in back of the head. He remembered that the Poles could not have been killed as the Russians claimed in 1941 and have such relatively unused footwear. "I had no doubt who committed it. It was the Russians."

The hearings into the Katyń Massacre held by Congress in 1951–52, redeemed, however belatedly and modestly, some measure of our national honor. Whatever the shortcomings of such an investigation, it at least provided a record that our government and the United Nations could ignore only at the risk of their commitment to truth. But the recommendations of the Madden Commission, as the Congressional committee was called, to pursue the evidence against the Soviets were not followed. Scholars such as Zawodny, who wrote authoritatively about Katyń, were hounded or ignored.

Many questions remain to be answered. Some of those who can answer them are still alive. California's Senator Cranston was a member of the Office of War Information (OWI). There is evidence that the Senator exceeded his authority in suppressing facts about Katyń during the war years. On whose instructions was information about Katyń kept from the American public? Can any light be shed on the wartime activities of the OWI in being an accessory to the Katyń campaign of misinformation? The late attorney-general, John Mitchell, much maligned for his role in the Watergate scandal, was an extremely able and effective counsel for the Madden Committee investigating Katyń and tried forcefully to elicit the truth about a possible cover-up. His voice was not heeded. Zawodny's outrage is understandable and justifiable. He wonders if we or the British governments would maintain silence for half a century if officers in American or British uniforms were slaughtered *en masse* as were the Poles. Indeed, those accused of murdering Allied soldiers were sought out, tried, and in some cases executed at the end of World War II. No such process was followed in regard to the Polish victims. It is difficult to challenge Zawodny's conclusion that if Roosevelt and Churchill decided to keep silent about Katyń for "reason of state," then Stalin too could justify the killing of 27,000 Polish officers, for "reason of state."

Many centuries ago, the Greek historian Thucydides, writing in the sixteenth year of the Peloponnesian Wars of the famous Dialogue between the Athenians and the Melians, provided a definitive argument for "reasons of state." The Athenians took little notice of the weaker inhabitants of Melos and their desire for independence and neutrality. "You know as well as we do," Thucydides quotes the Athenian generals, "that right is only a question between equals; while the strong do what they can, the weak suffer what they must." When the Melians countered that gods may grant them fortune, the Athenians replied confidently: "Of gods we believe and of men we know, that by a necessary law of their nature they rule wherever they can." The Athenians terminated the dialogue, put all the men to death and sold the women and children as slaves. Machiavelli's ideas on the rights of a sovereign state penned almost two thousand years later could scarcely improve on this earlier assertion of "reason of state."

• • •

Katyń has to do not only with the thousands of Polish officers whose bodies lie in still undiscovered graves, but with political decisions made at Yalta that placed all of Eastern Europe in Stalin's grasp more than a half-century ago. Unless new evidence is provided in our archives or in still undisclosed personal letters or papers of President Roosevelt, we are left with the reluctant conclusion that the American president conducted a catastrophic foreign policy. Churchill's remarks on Katyń to Soviet Ambassador Maisky in 1943, arguing that the war effort against Hitler determined all other policies, were understandable. British leaders were aware of Stalin's record and argued, in the words of one of them, that in the affairs of states, one should be guided by "the head rather than the heart." Whatever the merits of such an anatomical description of political choices, it at least does not make a fool of the listener. Churchill knew that Stalin was capable of the kind of evil that occurred at Katyń and chose to keep silent. Roosevelt, on the other hand, based on the available record, believed Stalin to be innocent of such a crime.

Reluctantly, we must conclude that when it came to Stalin's Russia the Allied leaders, Roosevelt in particular, were tolerant to the point of blindness. It is difficult to imagine an American president so lacking in information about a country that occupied one-sixth of the world's surface, even if reporters such as Walter Duranty of the *New York Times* hid the truth from the paper's readers. Since it was Roosevelt and the power of America that drove the engine of wartime and post-war policies, the responsibility for decisions that hoisted the Soviet Union to an unprecedented prominence in the affairs of the world must rest on the shoulders of the president and such

key advisors as Harry Hopkins. If Roosevelt knew the truth about Stalin and Katyń there can only be one explanation for his unwillingness to admit it. The President who had little concern for the perpetuation of the French and British empires and indeed sought their eventual downfall, did not concern himself with the end of Stalin's imperium. Indeed, he may have looked forward to having Russia as an American "sphere of influence." No American president, least of all Roosevelt who knew that American aid staved off disaster for the Russians, could have had any illusions about the "strength" of the Soviet Union and doubted America's power to reorder the world. It was very likely that Roosevelt looked upon the Soviet state as a "power" that could be bent to America's will, if we would but overlook her murderous government. If such was his cynical strategy, death mercifully shielded him from the inevitable failure that such a policy would bring. The bitter note to Stalin at war's end shows Roosevelt lashing out at a man who failed to play the limited role meant for him. Stalin, who lived to see all that he ever had hoped to achieve and more, also felt betrayed. The disappointment was mutual.

The agreements in Yalta to hold free and unfettered elections seemed even less than wishful thinking, considering that in most East European countries there were no such elections prior to World War II, and nothing in Stalin's career indicated the slightest interest in such a process. Unless one ascribes extraordinary Machiavellian strategies to Roosevelt's apparent "trust" of Stalin designed to draw the latter into betrayal of solemn promises, one can only conclude that he expected them to be kept. Perhaps he was convinced, as he told those around him, that he knew how to handle Stalin. Surely acquiescing to triumphant Soviet entry into Berlin and Prague was not simply a reward for past suffering, but a sign of future cooperation. Secure in their knowledge (not shared with the American electorate) of Russia's irremediable weakness, our leaders provided her not only with the wherewithal to survive Hitler's onslaught, but helped her to become, if only in appearance, a power equal to our own. The current explosion of nationalist fervor in the borderlands of the former Soviet Empire provides a clue to the possible concern. Stalin's assigned role was to be a pacifier, a gendarme, albeit one who would observe limits and minimal legal structures. Stalin's innate conservatism, his retreats, his clear policy not to develop a weapons system that would threaten America's lead, all these were clear signs that he understood our postwar strategy. His problem was in adjusting his ambitions to the constraints of both American policy with its abstract ideals, and his knowledge that he led a decimated, impoverished hovel of a country. The role he had accepted was however impossible to fulfill. His position, after all, rested on the bedrock of terror, a truth that successive American

governments did their best to conceal.

Roosevelt's expectation that after the war Stalin would observe juridical arrangements strikes one as a joke of cosmic proportions. Since Western leaders knew the truth about Katyń as it knew about other Stalin horrors, such a policy rested on a slippery surface of lies and treachery, hardly a foundation for future peace. The alternative could only be an admission of being accessories after the fact. But these were not ordinary crimes for which they might be judged. The Oval Office or 10 Downing Street endow ordinary people with extraordinary pretensions. Like Dostoyevsky's Grand Inquisitor, our leaders could surely decide that the multitudes with their need to believe in something expected hope rather than truth. Lacking any illusions, astounded at the degree of trust given them by the electorate, they would delay past their lifetimes the exposure of wartime lies, hoping that time will have smoothed the sharp edges of their betrayals. And those who were dead were dead.

It is in this sense that Katyń has come to symbolize one of the greatest opportunities presented and lost in this century. The tragic loss of 27,000 brave Polish soldiers could have served as an example to a postwar world weary of policies that served neither "the heart nor the head." It could have been a fitting memorial to a century of abandonment and murder. Had our government used Katyń as an example of Communism's perfidy and democracy's complicity, arguing that the latter was necessitated by a wartime alliance, it might have persuaded an American electorate to open a new chapter in history. President Truman and those leaders who followed missed that historic opportunity. The 27,000 joined millions of others who had died in vain.

• • •

Was any other course of action possible? Did it have to be a choice between "the head and the heart?" Could Katyń have been revealed as Stalin's crime while maintaining the wartime alliance? It may be true that even after the victory at Stalingrad, Stalin's capacity to wage war against Hitler was not possible without massive aid from the West. But it is also true that Stalin was quite capable of striking a bargain with Hitler even after catastrophic reverses, as meager but believable evidence suggests. As one considers Stalin's inexplicable rejection of all warnings of Hitler's plans to attack him, only two explanations seem plausible. He was either planning to attack first (and there has been some evidence for that) and was out- maneuvered, or he knew that the invasion was inevitable and was convinced that while he could not prevent it he could accept losses and survive a loser's peace. If the latter was his strategy, Hitler's murderous all-or-nothing

invasion proved to be a terrible miscalculation for Stalin. Lenin's willing-
ness to surrender large areas of Russia to Germany at the Treaty of Brest
Litovsk in 1918 and the pattern of retreats in Russian history was surely
an ever-present reality for Soviet leadership, and there was for Stalin more
than a historical coincidence when the Russian and German officers toasted
each other at that same Brest on September 18, 1939. If Stalin thought that
he could repeat the strategic retreat of 1918 he inexplicably failed to realize
that Hitler bore no resemblance to German military leaders in World War I.
But if Stalin was to be accused of mass murder at Katyń and thus placed in
the same dock with Hitler (as he surely deserved to be) could the alliance
against Hitler and the Japanese be maintained? One has to keep in mind that
the war in the Pacific was far from over. Could there be a public condem-
nation of Stalin over Katyń if it were coupled with an appeal to the Russian
people that for their sake, we would prosecute the war against Hitler? And
how would such a pronouncement influence a government quite capable
of eliminating not only unwelcome information, but all those showing the
slightest wavering in their loyalty? Stalin was an ignoramus about genetics -
his infatuation with Trofim Denisovich Lysenko's harebrained ideas proved
this - but he understood from his life's experience how rapidly a new and
pliant population can be created if one is willing to destroy entire families
of independent-minded people. Having found new military leaders to de-
fend Russia after destroying virtually the entire high command before the
German invasion surely had convinced Stalin that either anybody could be
a general (after all, was he not a generalissimo?) or that his process of selec-
tion worked. A decade of killings from the start of the First-Five Year Plan
to the outbreak of the war eliminated most potential leaders. The defection
to the German side early in the war of Lieutenant General A. A. Vlasov and
thousands of his followers was thus an act of extraordinary courage. But it
also meant that to embrace Stalin's opponents was to join hands with those
who became Hitler's allies.

And what was Stalin's view of Katyń? His response to the German ac-
cusations of mass murder, a charge he knew was true, was in keeping with
his experience with the outside world. Having condemned millions to death
and slavery while remaining the idol of many western intellectuals, having
first signed a treaty of friendship with Hitler and then seeing the West curry
favor with him when he was attacked by his ally, seeing his arch-enemy
Churchill, who once wanted to strangle the Soviet system at birth embrace
him as a partner in arms - how could he be blamed for assuming that a deni-
al of the Katyń atrocity would be particularly difficult? Especially since to
question him would mark one automatically a Nazi sympathizer. He knew
that the West would not believe the war-mongering Hitler, even if he had

told the truth, but would believe the peace-loving Stalin, even if he had lied.

Still, it is difficult to imagine that Stalin assumed the Katyń murders "never will out." He could not guarantee that every witness could be silenced and that even his agents who perpetrated the massacre could be trusted with the secret, no matter how thorough the precautions or terrible the retribution. He did the best he could to postpone that final reckoning. His mind was a model of efficiency. To out-live his enemies he had to kill them. He had built his empire on the bones of millions of his countrymen and expected no thanks for it. It was not in his character to say, as Frederick the Great once said of a military campaign that it was not worth the bones of a single Pomeranian grenadier. Like Lenin, and perhaps all of Russia's communist leaders, he considered his countrymen expendable and contemptible, unworthy of his concern. After all, in what other country could a leadership aiming to "overtake and surpass" the United States find so little to show after half a century? It was the effort not of a Hercules but of a Sisyphus. In the eighteenth century, Catherine the Great, another Russian despot wrote to her admirer, the *philosophe* Denis Diderot, that she envied him. He was at least able to write his great ideas on parchment while she could only write on the skin of her subjects, a more difficult and unyielding medium. Stalin's long and bloody rule proved just how right Catherine's assessment was. If it was a question of forgiveness, how could Stalin be expected to forgive a people that would only produce results if punished? And how meager were those results! More to the point, Stalin had lived to see many die at his hands, yet he heard his name praised all over the world. He had met the best that the West had to offer, and those statesmen lauded him. Churchill and Roosevelt risked wartime travel to meet with him. And they never pressed him to explain Katyń.

Above all we must not forget the effect of Communist penetration of Western societies in the period between the two wars, an unprecedented betrayal made possible by as yet insufficiently understood attitudes and habits within the middle class. Lenin and the Communists who followed him knew very little about economics and even less about politics, except those of murder. But their extraordinary psychological insight into the mindset of the Western middle class and its intellectual leaders is yet to be fully appreciated. Even if there had been a leader- ship in the West capable of perceiving the danger from both the left and the right, the work of Communist agents and their many sympathizers in high places had so corrupted the language of politics that a struggle against totalitarianism could only be presented as one against the Right. By not referring constantly to Communism as a variant of Fascism, the West lost its most potent weapon.

Having molded public opinion about the Soviet Union and its wartime sacrifices, our leaders became the prisoners of the very opinions they so assiduously cultivated. The struggle against Hitler rested on the assumption that a successful war could only be waged by Western democracies if this was a struggle of good against evil, as indeed it was. The notion that the West could join in an ideological struggle on the side of an ally who was presented as being as evil as the enemy could not be seriously entertained. This was, after all, the world of Woodrow Wilson's single-minded idealism, rather than the world of Prince Metternich's balance-of-power realism. The West was about to pay dearly for two historic mistakes - the Carthaginian peace imposed on a defeated Germany in 1919, and the failure to prevent the rise and spread of Bolshevism.

• • •

But surely what could be argued as a necessary acquiescence to silence about Katyń for the sake of wartime unity need not have been accepted once that struggle was over. A review of the record of Western silence on Katyń after the war is particularly baffling, insofar as the accumulated evidence and the start of the Cold War made such a position morally and tactically indefensible. The "misplacing" of the Van Vliet report on Katyń and other attempts to stifle those who wished to examine the matter publicly after 1945 make it clear that it was a matter of policy to continue concealing the truth and not holding the Soviet leadership account- able. There were, to be sure, political and strategic problems with airing Soviet atrocities such as Katyń after 1945. While the chief architect of the Pan-Soviet policy was dead, the political party he headed was still in power and recent revelations from the Russian archives prove that there were significant betrayals of American policies by high officials. No one need question Truman's dedication to blocking Communist expansion, but as Vice-President, he was party to the wartime decisions, and the public examination of those matters could have unforeseen consequences, both domestic and foreign. And however much both political parties protested the presence of Soviet power in Eastern Europe, neither could envisage a change in the *status quo* that we helped establish.

The way of raising the question of Katyń at the Nuremberg trial was an example of moral failure. The Russians themselves were permitted to bring it up. The Soviet prosecutor, Colonel Yuri Pokrovsky, even read excerpts from the fraudulent Burdenko report without any challenge from those who knew the charges to be false. It was a rare example in recorded history of a government, knowingly responsible for a horrendous massacre, preparing to charge another sovereign state that it knows was not guilty. Aware that

the West would not hold them culpable before the court of public opinion, the Soviets were free to assume that our society was as corrupt as theirs.

• • •

The Venona Collection, CIA's recently released encrypted Soviet telegrams from the 1940s, messages that our government and its allies intercepted and decrypted during a thirty-seven year period, offers a tantalizing view of the Katyń forest massacre as revealed by an anonymous letter. Dated August 7, 1943, four months after the Germans announced to the world the discovery of the bodies of Polish officers in Katyń forest, the letter was addressed to "Mr. Guver," (Russian spelling for FBI Director J. Edgar Hoover, there being no Russian letter for our "H"). In the words of Mr. Ben Fischer, a Staff Fellow at the Center for the Study of Intelligence at the CIA, the letter to "Mr. Guver" "proved to be a counterintelligence Rosetta stone enabling the FBI to track down Russian spies." It also mentioned a *rezident* Vassili M. Zarubin (a.k.a. Zubilin), an NKVD officer who had interrogated Polish officers at Kozielsk with a view of seeking among them defectors to the Communist side. The nameless author wrote that Zarubin, posted to Washington in 1941 and his deputy Markov (an alias for Lt. Col. Vassili D. Mironov), were implicated not only in the deportations of more than a million Poles, Jews, Ukrainians and Belorussians after the Soviet invasion in 1939, but also in the killings in Katyń forest. Astonishingly, (to put it mildly), the writer claimed that the Russians had an agent in "office in the White House." According to Fischer, the letter fell on "deaf ears" in Washington and London.[9]

There was deafness elsewhere. Documents released in 1997 as part of the Cold War International History Project at the Woodrow Wilson Center, have brought to light a second "secret speech" of Khrushchev given to a Polish Communist leader- ship. Much has been written about Khrushchev's "Secret Speech" at the 20th C. P. Congress in the evening 24–25 February 1956, but not until recently was the second secret speech found in the Polish archives. This speech in Warsaw followed the sudden death in Moscow of Bolesław Bierut, the leader of the Polish Communist Party who collapsed

[9]For a recent account on Zarubin (a.k.a. Zubilin) who was posted by Stalin to Washington in 1941, see *CIA Center for the Study of Intelligence Newsletter*, Winter-Spring, 1997 (No.7), Benjamin Fischer, "'Mr. Guver,' August 7, 1943: Anonymous Soviet Letter to the FBI," pp. 10–11. The most recent work on Venona intercepts is: John Earl Haynes and Harvey, Klehr, *Venona: Decoding Soviet Espionage in America* (Yale University Press, 1999), pp. 44–46, pp. 230–231 and passim. The authors use the name "Zubilin" throughout and speak of his "unclear association" with Katyń, an oddly qualifying statement since his role in deceiving the captives is adequately documented in other studies.

and died shortly after reading that Stalin was now considered a criminal. Khrushchev accompanied Bierut's body to Warsaw and remained there for a week to help settle the question of succession. Speaking at the Polish Communist Party Plenum, Khrushchev began by affirming that his history-making secret speech at the 20th Party Congress told everything. "We didn't hide anything," he assured them. He spoke at length to the Polish comrades about people imprisoned and tortured. He spoke disparagingly about the late dictator and admitted that Stalin was an ignoramus about agriculture who "didn't see a live peasant for probably thirty years." He confided that "if he [Stalin] had lived a little bit longer ... [he] would have started another war." Khrushchev's rambling speech to the Polish leadership included a comment that Russia might have avoided the war altogether were it not for Stalin and certainly would have defeated the Germans sooner "and with less blood." He mentioned that there was a possibility of having removed Stalin when the war started, but "if we at that time had announced that we dismissed Stalin from the leadership ... a better present to Hitler could not be imagined ... this would mean the death of the country." Still, Khrushchev concluded with a strong defense of Stalin. He was after all a Marxist, a revolutionary, and if "he destroyed his own people" that was happening every- where and unfortunately "artillery fired on its own army." He quoted Stalin as saying that in order for the working class to succeed, "many thousands and mil- lions of workers had to die ... it's possible that there are mistaken victims ..." but [Stalin said] "history will forgive me." Khrushchev warned that "future mistakes are possible" because "the enemy is very insidious ... if we're going to be cowardly, it means we are cowards." There was stormy applause when he finished. Not one of his Polish comrades was brave enough to ask about Katyń.[10]

Plato in his prescription for an ideal leader in *The Republic* urged that such individuals combine the qualities of philosopher and king, an idea that has fascinated students of philosophy and politics. Machiavelli in his *Prince* referred to the characteristics of a lion and a fox when considering proper traits of leadership. It may be time to cease endowing those in power with such abstract attributes. The history of human societies is a record of misplaced faith, of investing those who lead with qualities we never consider appropriate for ourselves. It may be time to stop the endless debate of what makes a farsighted leader and examine the human propensity to be a blind follower.

[10]"Khrushchev's Second Secret Speech," *Cold War International History Project,* Woodrow Wilson International Center for Scholars, Washington, D.C., No. 10 (March, 1998) pp. 44–49.

Epilogue

Maliszewski has continued to use his aerial photography skills in areas other than Katyń forest. He helped Dr. Ianoid of the United States Government Holocaust Museum in Washington to establish photographic proof for what the Germans actually did at Babi Yar, the site of a horrendous massacre of Kiev's Jewish population. Maliszewski met Ianoid when Schochet lectured about the Jewish officers killed in Katyń at the YIWO Institute in 1991. At that time the Bundesarchiv took over the East German *Stasi* archives records which included German photographic material of World War II. Maliszewski's analysis of these photo- graphs not only established a more precise representation of the Babi Yar massacre but made possible an understanding of attempts to hide it. The Luftwaffe images showed conclusively how the Germans dynamited the sides of the ravine.

Poirier has praised Maliszewski's interpretation of the Babi Yar imagery describing it as "excellent, presented logically, correlated well to the non-imagery collateral data." Praise indeed, coming from one of the most experienced aerial photography specialists in our government. In a letter to Maliszewski, Poirier also mentioned the fact "that the Luftwaffe flew high-resolution reconnaissance over a number (perhaps all) extermination sites." So far as is known, they flew over Katyń, Treblinka, Sobibor and Birkenau. This suggested to him "that there is more imagery ... yet to be found."

One of the interesting aspects of Maliszewski's Babi Yar interpretation is the extent to which it corroborates the memory of eyewitnesses, a problem that was of particular interest to Maliszewski in his Katyń research. There was testimony from Orlov, who claimed that he saw the Babi Yar massacre from a hiding place in a nearby factory. Maliszewski, using a "line of sight" analysis, that is, looking at the possible obstacles between Orlov's hideout and the site of the massacre, was able to disprove the testimony. As Poirier noted in one his letters: "you should be able to determine if he really could see the site from the factory and whether obstacles (trees, buildings, etc.), would have blocked his view. I would guess that in that terrain it would be difficult to find 1,600 unobstructed meters, let alone see details of execution without binoculars." Poirier recalled that he was prepared to give testimony on "line of sight" evidence in a war crimes trial of a guard at the Birkenau concentration camp. The guard admitted to being

there, but he claimed he could not see anything from his post. By "line of sight" analysis, Poirier could prove that the guard did have a clear view of the gas chambers and was lying. There is a difference between honest researchers, such as Poirier and Maliszewski who wish to establish a certitude for the awful statistics of extermination, and the historical revisionists who cloak their falsehoods in a mantle of scholarship. As in his study of Katyń imagery, Maliszewski's aim has been to establish a truthful version of an event. He has faithfully carried out Zawodny's dictum "to follow the truth."

* * *

In the meantime, the story of the Katyń massacre continues to present new challenges to researchers whose work is often held hostage to political imperatives and the reluctance of the living to come to terms with the dead. The Russian archives have been partly opened but crucial files, such as Stalin's personal papers and those of the secret police, are still not available. Scholars who have tried to gain access to documents regarding the Katyń massacre, the Wallenberg case, the Cuban missile crisis, the invasion of Czechoslovakia in 1968, the Korean Airlines Flight 007, have reported that these files while "revealing" are incomplete and that highly censored revelations have been used - or sometimes misused - as pawns in the troubled political and diplomatic arena. While the Nazis destroyed many of their records, almost all of those that were seized by Western Allies were returned to West Germany. Russian authorities never even made known what Nazi records they had retrieved. Most of them were kept in Moscow and virtually hidden from scholarship for half a century. If there is, for example, a record of what transpired at Zakopane in 1939 at the meetings between the Gestapo and NKVD, that is not likely to see the light of day.

The Russians have not shown an interest in resolving the issue of Katyń. The Duma has not accepted legal responsibility for the crime thus preventing it from being docketed in a Russian court. There has never been a Nüremberg-type trial to deal with crimes such as Katyń and those executioners still alive have not had to face justice. The Katyń families have not had any legal satisfaction, nor have they received any compensation. The demise of the Soviet empire has not brought with it an adherence to truth. At an exhibit of World War II photographs from the Russian Army Museum recently arranged by Russian businessmen at the Ronald Reagan Building in Washington, a time-line chart prepared by the exhibitors and sold as a souvenir program omitted the Hitler-Stalin Pact, the invasion of Poland and repeated the lie that the Germans were responsible for Katyń[1] And in a move

[1]Benjamin J. Stein, "Can we Talk?" *American Spectator*, (November 1998), 66, cited by Benjamin B. Fischer, of the CIA's History Staff in his "Stalin's Killing

whose obviousness needs no emphasis, Russian officials have stressed recently that the Poles were guilty in the deaths of 83,000 Red Army prisoners captured in the Polish-Soviet War in 1920. Russian Procurator Yuri Diomin has asserted that he was surprised that Poles showed such "solicitude" for the 16,000 prisoners (sic!) that perished in Katyń and neglected to show like concern for the 83,000 that died in Polish custody. Polish historians, for their part, have estimated that between 16 - 18,000 Russian prisoners died from disease and difficult wartime conditions in the 1920 conflict.[2] Polish newspaper *Życie Warszawy* [Warsaw Life], reported that it was Gorbachev who ordered an "anti-Katyń" campaign in April 1990 (he directed Russian historians: "You must find some sort of anti-Katyń") and this resulted in two works that pointed a finger at Piłsudski and the "Polish atrocities" in the 1919–20 Polish-Soviet conflict.[3]

On August 23, 1998, a Polish publication, *Wprost*, featured a report from a Polish correspondent that in Tavda, in the Urals, there may be graves of Polish officers killed in 1940. This report was based on the remembrances of an 84-year-old veteran of the Gulag. He had heard such rumors from fellow prisoners building a canal.[4] While governments are very unlikely to admit their culpability in mass murder (as in the recent Bosnian atrocities), individuals struggling with their consciences sometimes do. In March, 1989, a Russian historian Akimov Arutiunow sat down to interview a former member of the NKVD. "You know, I carry a great sin. I have executed Poles." He mentioned Tavda, near Ekaterinburg, as the place where the shootings took place. The killings allegedly took place in the early 1940, at the time of the Katyń massacres. Proof is difficult to obtain. The documents of the local government of that period went up in smoke three years earlier. If the report was true, it is possible that the victims were Poles from Western Ukraine and Western Belarus. These prisoners were transported to Kiev, Kharkov and Kherson and there is no trace of these victims once they left Minsk. Is it possible that these were the victims at Tavda? The vastness of Russia made her the "ideal" location for the dispersal of the dead.

• • •

Field," CIA Studies in Intelligence, p. 58.
[2]"Gorbachow szukał anty-Katynia," *Nowy Dziennik*, (November 23, 1994). Also, "Tragiczny los jeńców rosysjskich z 1920 r.," *Nowy Dziennik*, (December 3–4, 1994) and "Bolszewiccy jeńcy w polskim objektywie," *Przegląd Polski*,(September 28, 1995). Cf. Fischer, *op. cit.*, p. 61.
[3]"Gorbaczow szukal anty-Katynia", supra.
[4]"Czwarty Katyń," *Wprost*, (Sept. 23, 1998), pp. 74–76

American interest in Katyń continues. In addition to the many monographs and articles on the subject, memorials have been erected at several sites, including a striking statue of a kneeling hussar in Doylestown, Pennsylvania. There are other memorials planned such as the five-story high National Katyń Memorial in Baltimore's Inner Harbor, the largest bronze memorial in the United States, to be dedicated in the year 2,000. The artist Andrzej Pityński has created a Katyń memorial on the Jersey City waterfront. States such as Alaska and New Jersey have issued commemorative proclamations. There are Web sites on the Internet - one by the Archaeological Institute of America keeps track of excavations at Katyń and sites suggested by Maliszewski's pioneering research.

Scholars in East Europe have not forgotten. On May 5, 1999, Maliszewski and Schochet were invited to present the results of their research at a symposium in Prague: *Neznana Fakta o Katynskych Zlocinech* [Unknown Facts about the Katyń Murders] sponsored by the Academy of Sciences of the Czech Republic. This meeting marked the fifty-ninth anniversary of the crime. Maliszewski presented aerial and collateral evidence and argued that he could "prove his thesis that multiple concealments sites exist in each of those localities, rather than the specific gravesites in investigated at Katyń, Miednoje and Kharkov." Schochet who has already presented the best evidence so far on the numbers of Jewish victims among the Polish officer corps (including his research into the life and death of Chief Rabbi of the Polish Armed Forces, Baruch Steinberg), reviewed his evidence. One of the lesser-known facts about the Katyń casualties noted at the symposium was that approximately 300 Polish citizens residing in the Czech Cieszyn (Teschen) region that had been incorporated into Poland after the Munich Pact, were arrested during the period of German-Soviet treaty, deported to Russia and executed in April- May, 1940.

Maliszewski and Mecislav Borak of the Czech Academy of Science are partners in a project to locate hidden underground chambers of the Nazi era. Hitler had ordered the construction of these to facilitate advanced weaponry research.

On a recent trip to the Czech Republic Maliszewski found the entrance to a hitherto undiscovered portion of a vast underground complex. There has been much speculation about such chambers holding missing Gestapo archives, Reichsbank gold and even the Amber Chamber. Maliszewski hopes that his discoveries will reveal the truth of these and other rumors.

• • •

On April 14, 1999, the 59th anniversary of the Katyń crime was marked by ceremonies at the monument at Warsaw's Muranów district. In contrast

to the surreptitious observances and whispered references that I noted only ten years ago, Warsaw, Kraków and other cities now assign a prominent place to Katyń memo- rials. Polish President Alexander Kwaśniewski has made an official state visits to Russia, Belarus, and dedicated on June 27, 1998 a memorial to Poland's dead at Kharkov in the Ukraine where the names of the dead Polish officers from Starobielsk were read in the presence of their relatives. But Russia, the nation responsible for these crimes, whose vast regions are the resting place of so many victims, has yet to raise on its own soil a proper monument.

On April 17, 1997, the New York Polish paper *Nowy Dziennik* featured an article "When Will the Underground Bell Toll?" The reporter, Stanisław Jankowski, interviewed Andrzej Przewoźnik. They discussed a planned erection of a sanctuary for the remains of those massacred in Katyń and other places. In spite of the wishes of many of the families of Katyń victims, Przewoźnik stated that it was not feasible to exhume identified remains from Katyń, Miednoje, Kharkov and other places because the remains can no longer be identified. The KGB used special drills in digging enormous graves which tended to scatter and obliterate remains. In addition, the re- mains of the Polish officers were commingled with victims of earlier purges and even with remains of Red Army soldiers who had been prisoners in Germany. Przewoźnik was of the opinion that it was more fitting to me- morialize all the victims where they were buried. After all, they were all victims of the same oppressive system. Discussions with Russians officials led to a decision that there will be memorial complexes to honor all the vic- tims of totalitarian repression. The Polish military cemetery will be part of that complex. Architects and sculptors have been assigned to create designs for these memorials in Katyń, Miednoje and Kharkov. Each memorial will feature a cross and an underground bell. Since among the dead were Jews, Protestants and Greek-Orthodox, the cemetery will have an ecumenical character with symbols referring to different faiths. These memorials were to be finished in two or at the most three years. Nothing has been done so far to implement these plans. In the meantime, relatives of the Polish victims come to Katyń to light candles and sing hymns over what they assume are the resting places of their dear ones.

In Russia the Communist Party is pressing for the return of the statue of Feliks Dzerżyński, the founder of Soviet secret police, to its pedestal out- side the former KGB headquarters on Lubyanka square. It was torn down in 1991 when Yeltsin carried the hopes of Russia on his shoulders. Lenin still reposes in his Mausoleum and a cadre of faithful pathologists continue to monitor the "vital signs" of his mummified remains. But for the Poles (and multitudes of others) lying in countless and nameless graves in the vastness

of Russia the underground bell has not yet tolled.[5]

[5]Stanisław Jankowski interviews Andrzej Przewożnik, "Kiedy Uderzy Podziemny Dzwon," *Przegląd Polski,* (April 17, 1997) Cf. John Thornill, "The Fallen Colossus," *Financial Times,* (December 31, 1998), p. 11.

God's Eye: The Katyń Forest Massacre

Illustrations

Plate 1. Luftwaffe photograph of Bezludovka

This photo was taken prior to the ground occupation of south Kharkov by Ger mans in September 1941. There is a large hill near a railway siding just outside the village of Bezludovka, which is about 15 kilometers south of Kharkov. According to testimony in the possession of Polish authorities, a Ukrainian woman claimed that in the spring of 1940 some Polish officers were unloaded from trains here and taken to the hills for execution. According to Stefan Śnieżko, the woman's description of this hill was coincidentally close to the features of Katyń. The photo shows the forested hill, in the middle of which is a clearing with no forestry purpose. One can discern many pits in this clearing. A road leads to this area and an NKVD structure is near the station. Despite this compelling evidence, no official examination of this terrain has taken place. Śnieżko never replied to the evidence forwarded him by Maliszewski. The official Polish position is that all of the Starobielsk prisoners have been found near Piatachatka. Maliszewski believes that the scientific literature does not support this conclusion.

Plate 2. Miednoje, Russia, with inset

Map produced with modern US satellite data, showing locations of areas of disturbed terrain evident in WWII vintage Luftwaffe aerial imagery. The Polish mass graves are at area "G." Maliszewski believes that additional Polish graves may be at area "E."

Plate 3. Miednoje, Polish and other mass graves

A sketch by Maliszewski: In the dense cluster of red shapes near the village of Jamok, were mass graves were found containing officers from Ostaszkov. Digging at the other sites of disturbed terrain, also shown in red, was forbidden by the Russian authorities.

Plate 4. Miednoje, Area "E"

The "dogbone" shapes of 1, 4–10, and 18–19, conform to the shape a bulldozer makes on entering and leaving a long trench. Tokarev testified that such trenches were dug in the spring of 1940 by Soviet bulldozers. This site was off-limits to Polish investigators. Nikolai Danilov of the Odessa "Memorial" wrote to Maliszewski (who had given him this map) and said that the local authorities in Tver seized the map when it was shown to them, cordoned-off the area and forbade Tver: *Memorial* members from inspecting the site. Śnieżko, aware of the site, has made no public comment. Maliszewski believes that two sites, one at Jamok (area "G") and the other

at Miednoje (Area "E") were created to conceal the murdered Ostashkov Poles.

Plate 5. Kharkov, Dzierzhinski Rayon

The map was generated for Maliszewski by the U.S. Government at the request of Professor Zbigniew Brzezinski. It shows areas of interest to Maliszewski including A, B, and E. The *Czarna Droga* [Black Road] area near the village of Piatachatka contains mass graves associated with the Starobielsk officers. Maliszewski believes that additional mass graves may exist south of Kharkov at Bezludovka and also possibly at area "B" in this map.

Plate 6. Kharkov, Ukraine

Maliszewski believes that the original mass graves near Piatachataka were at signals "a" through "a - 5," and that such were so heavily disturbed at the 1942 Battle of Kharkov that reburial was performed later, evident in the imagery of August 15, 1943 at various locations around the sites marked with Roman numerals. Three areas with Roman numerals were found to have murdered Starobielsk prisoners.

Plate 7. Kharkov, Ukraine Map 2

This map shows a superimposition of anomalies and features evident in imagery of August 15, 1943 and June 8, 1944. The heavy black lines show clearance of the forest due to bombing.

Plate 8. Kharkov, Ukraine Area "A"

Areas 1 and 2 are NKVD *dachas*. Before and during WWII the forest was fenced-off and entry was forbidden. Areas 2 and 3 show, in red, the signatures of smaller pit graves that could have contained between 30 to 50 people. It is likely that these were created during the 1930s *Yezhovschina* period of terror. The area is now reforested and no entry was permitted to Polish investigators.

Plate 9. Kharkov, Four photographs

These photographs show changes in area "B" from 1941 through 1944. Area "B" contains signatures of mass graves. It is now the site of a tower.

Plate 10. Kharkov, Ukraine Area "B"

The structure at signals 6, 7, and 8 are those of military and police. Signal 9 shows a compound. B–1 is the kidney shape, containing signatures of mass graves that were never investigated. Signals 10–13 show probable mass grave sites.

Plate 11. Kharkov, Ukraine Inset study "B"

Three trench-like anomalies are shown as well as nine pits. Maliszewski speculates that high ranking Polish officers may be buried here in con-

tradistinction to the Piatachatka site where few high-ranking officers were found. The area was off- limits to Polish investigators and now contains a tower.

Plate 12. Katyń Map 1959

U.S. Army Map Service 1959 map showing the Katyń forest and Gniezdovo station. The original map omits details of forest roads. Maliszewski has superimposed various signals. 1. Katyń forest mass gravesite. 2. The "Lesopolosa" site where Maliszewski discovered the true detrainment site and also a structure that may be associated with executions. 3. Gniezdovo station.

Plate 13. Katyń Flight Overlay Mylar

Showing the position of the numerous Luftwaffe images. "Confidential" has been stamped eleven times by American censors, circa 1950.

Plates 14 and 15. Katyń, Photo and Map (pair)

This is the site of the "Lesopolosa" that the Russian witness Krivozertsov indicated in his Ancona testimony in 1946 was the position northwest of the Gniezdovo station where the Poles were taken off the trains. Krivozertsov's testimony was later manipulated to come into agreement with Professor Swianiewicz's statement that the detrainment site was at the station. This is a considerable distance from the station. "A" indicates a structure that Maliszewski believes may be associated with the murders. "B" is the rail spur. Soviet interest in this area was equal to Katyń forest in that this photo and the photo of the bulldozer in the forest are of the same date, April 28, 1944. Many vehicles and personnel of the NKVD are in the vicinity of the "Lesopolosa."

Plate 16. Katyń, Winter, January 8, 1944 map

This map was created by Maliszewski showing his observations of Soviet activity, "footprints in the snow." This was in preparation for the later Burdenko Commission presence on the terrain. Not only was the NKVD interested in the Polish graves, but, as indicated by their test holes, in the mass graves of others buried in the environs in the 1930s.

Plate 17. Katyń, Photo "36"

Area "5" shows the NKVD bulldozer wrecking the PKC cemetery and empty- ing the layers of corpses. Areas 02–06 indicate mass graves created in the 1930s. (It is possible that these contain children of the victims of the purges, murdered after they became a problem for Stalin). Areas 07–010 are also NKVD burial grounds. Area 6 contains graves of Soviet citizens discovered by Germans in 1943.

Plate 18. Katyń, Photo "40"

Showing the Katyń graves being bulldozed, and northerly, the first indication of the presence of a trench discovered by CIA analyst, Robert Poirier.

Plate 19. Katyń, Photo "39"

"C" is the smoke rising from the operating bulldozer. The deep shadow line at "A" indicates a deep excavation.

Plate 20. Stalinets

Drawing from a German repair manual. When the Germans captured Soviet equipment, they quickly produced a manual of the machine. They could not remove the embossed "Stalinets" markings. Stalin had them placed in exactly the same position as on the original Caterpillar machines he had pirated.

Plate 21. Katyń

This map, drawn by Maliszewski from his observation of Luftwaffe original photographs, was the model used by the scientists working for the *Rada Ochrony Pamięci* to locate the graves. Subsequent maps (and academic papers) produced officially by the Poles did not credit Maliszewski's pin-point accuracy. Area "H" shows the original 1940 mass graves. Area "G" shows the 1943 PKC cemetery. The dotted square shows the general location of the cemetery Stanisław Bujnowski noted at Katyń in 1957, the probable location of the 900 corpses re-interred by the Burdenko Commission in 1944. "L" is the trench discovered by Robert Poirier, CIA analyst.

Plate 22. Katyń, Map of Kozielsk

U.S. Army Map Service in-set showing the location of the Kozielsk camp where the Polish officers, later found murdered at Katyń, were held as prisoners by the Soviets. On this map the camp is labeled as *Dom Otdykha Imeni Gorkogo* [The Gorky Rest Home]. It was a monastery before the Revolution.

Plate 23. Katyń, Photograph

Taken by the Luftwaffe on October 14, 1943, it shows the location, below, of the Dniepr River and the NKVD *dacha*. In the center is the PKC cemetery erected by the Polish Red Cross in 1943.

Plate 24. Katyń, Photograph In-set

A close-up view of the PKC cemetery. The two smaller squares on top of the large lower right square are the graves of generals Smorawiński and Bohaterewicz.

Plate 25. Katyń, Annotated photograph

Area "K" shows the camera field of the Soviet propaganda photograph

of General Berling's "Red" Polish soldiers parading in January 1944. Area "A" is the trench discovered by CIA analyst Robert Poirier that has never been investigated. Area "G" is the Smolensk highway near which the Burdenko Commission removed Polish corpses in its 1944 investigation. The square surrounding area 3 and 2 is the site where Stanislaw Bujnowski noted a memorial in 1957 It is significantly closer to the road than the present Katyń memorial. Maliszewski believes that the 900-plus corpses exhumed by the Burdenko Commission may be buried here.

Plate 26. Sanok, Molotov-Von Ribbentrop Division of Poland

This is one of a series of German annotated aerial images showing the line of demarcation in the partitioning of Poland in 1939. Area "W" is an original German annotation showing a bridge across the San River. Maliszewski, with micro-enlargements of this area, identified a prisoner exchange point near the bridge.

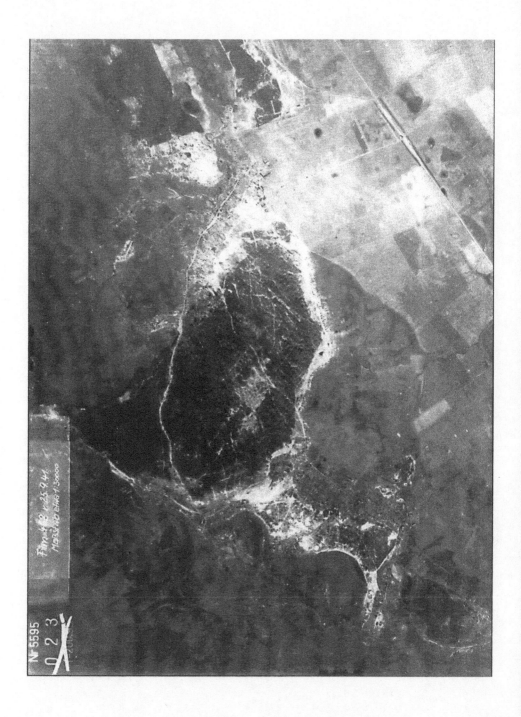

Plate 1. Luftwaffe photograph of Bezludovka

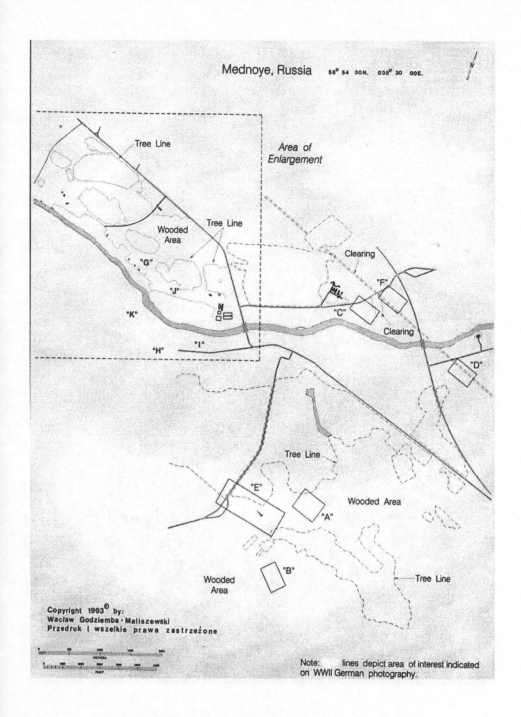

Plate 2. Miednoje, Russia, with inset

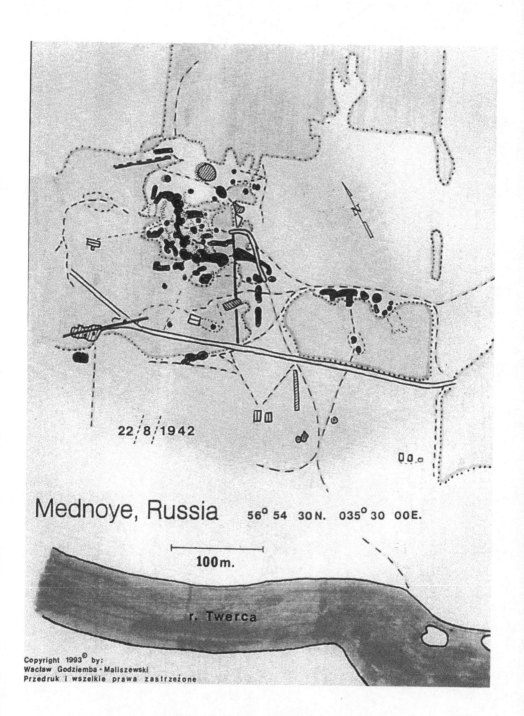

22/8/1942

Mednoye, Russia 56° 54 30N. 035° 30 00E.

|——————— 100m. ———————|

r. Twerca

Plate 3. Miednoje, Polish and other mass graves

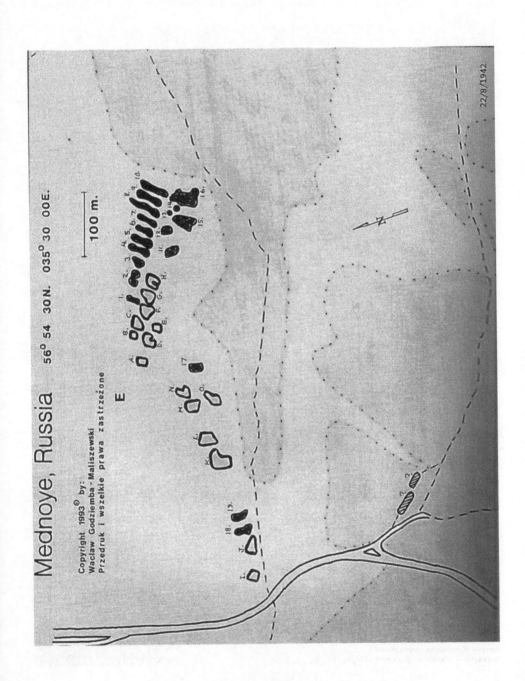

Plate 4. Miednoje, Area "E"

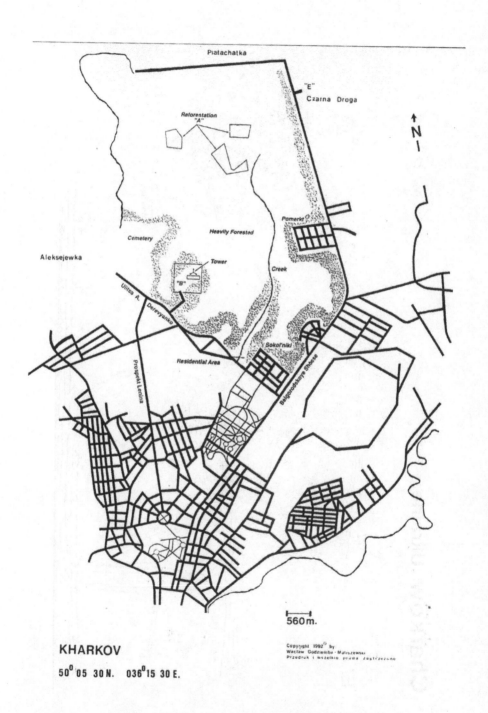

Piatachatka

"E"
Czarna Droga

Reforestation
"A"

N

Pomerki

Heavily Forested

Cemetery

Tower

Aleksejewka

Creek

"B"

Ulitsa A.
Derevyanko

Sokol'niki

Prospekt Lenina

Residential Area

Bialgorodskoye Shosse

560 m.

KHARKOV

50°05 30 N. 036°15 30 E.

Plate 5. Kharkov, Dzierzhinski Rayon

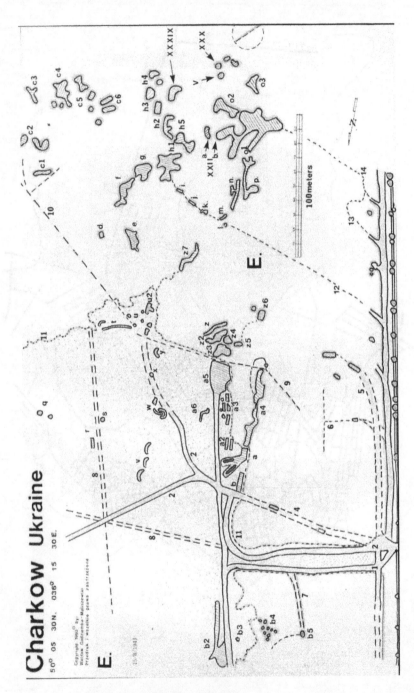

Plate 6. Kharkov, Ukraine

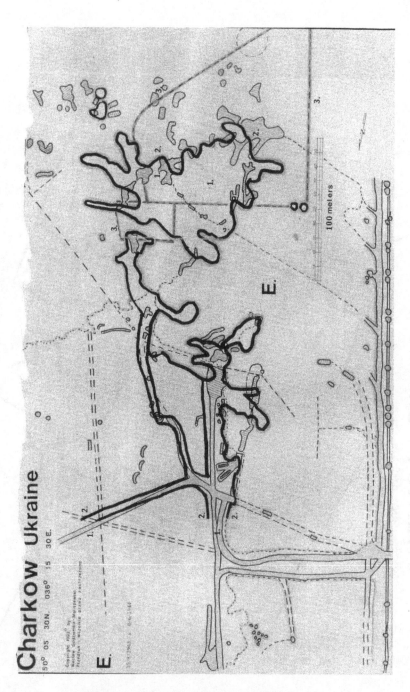

Plate 7. Kharkov, Ukraine Map 2

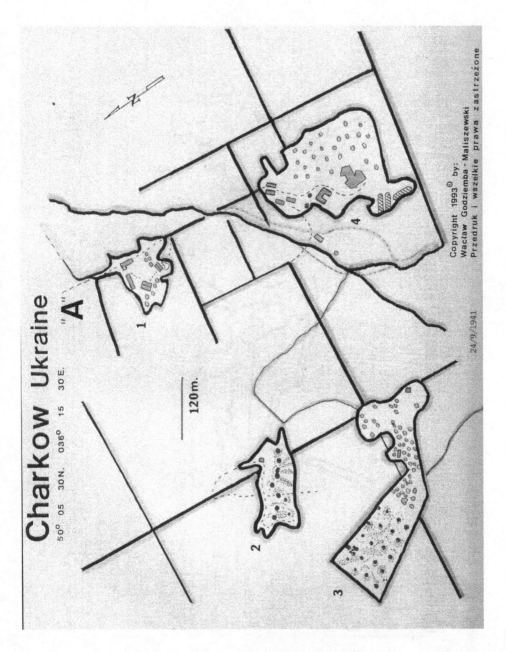

Plate 8. Kharkov, Ukraine Area "A"

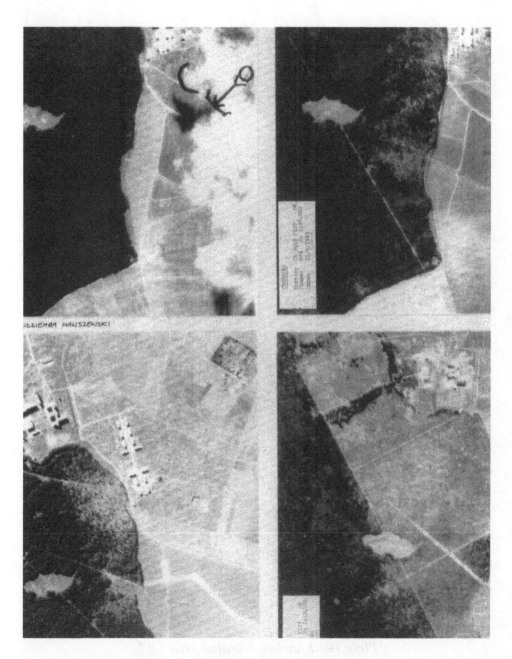

Plate 9. Kharkov, Four photographs

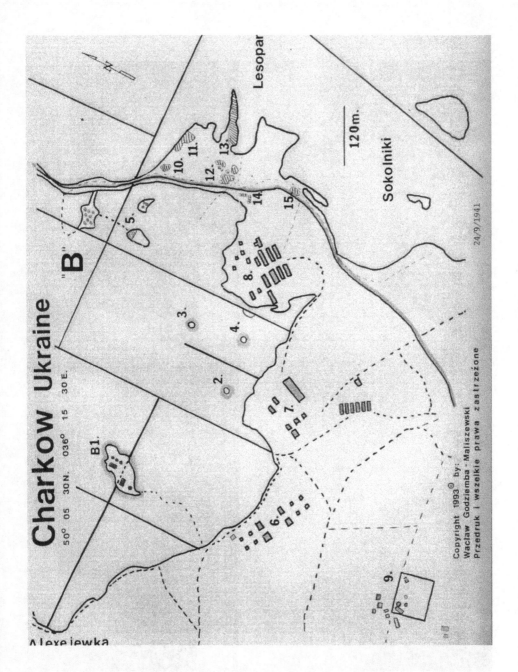

Plate 10. Kharkov, Ukraine Area "B"

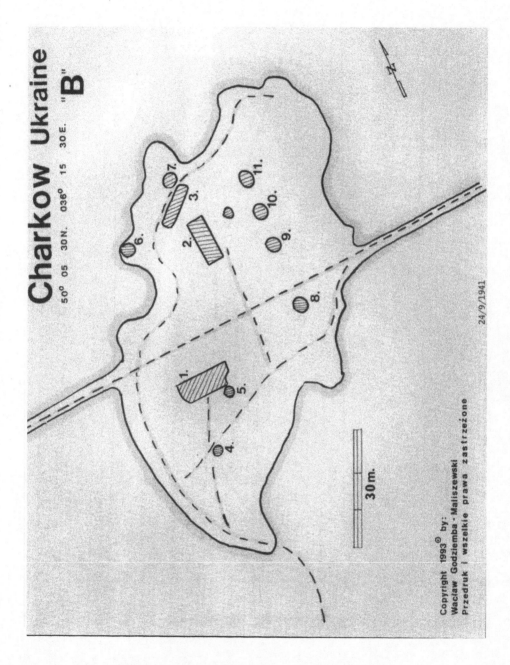

Plate 11. Kharkov, Ukraine Inset study "B"

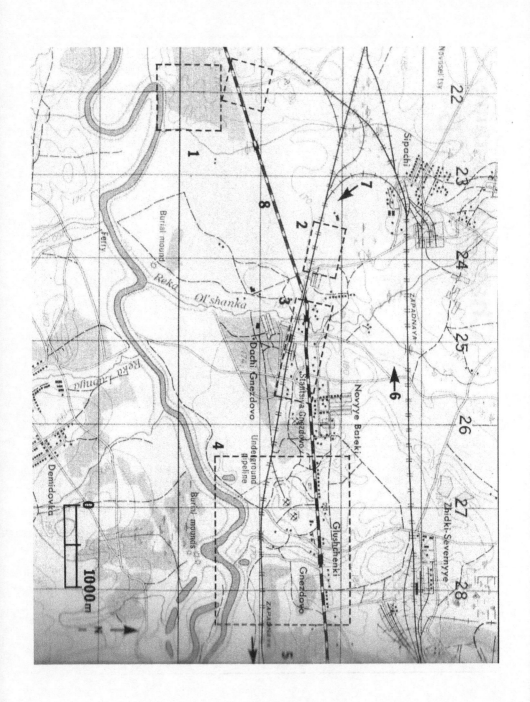

Plate 12. Katyń Map 1959

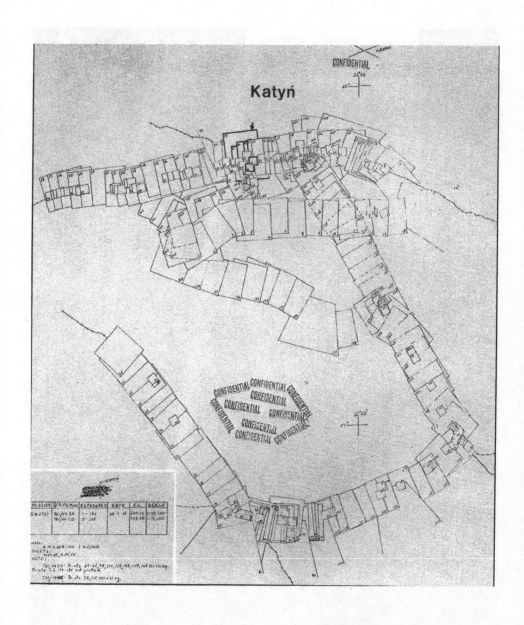

Plate 13. Katyń Flight Overlay Mylar

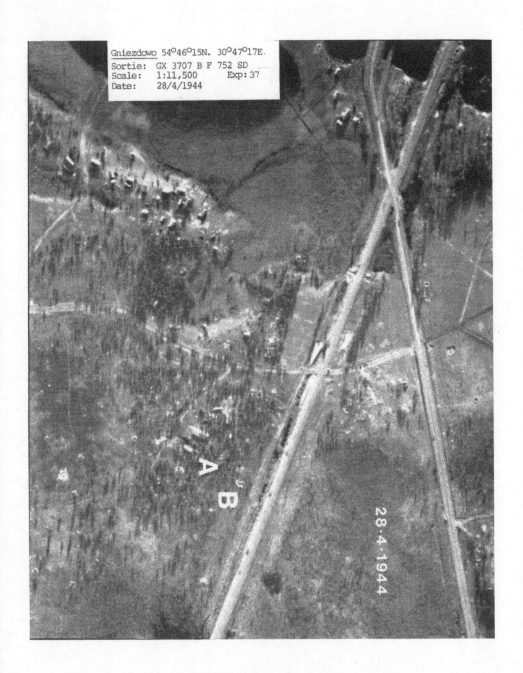

Gniezdowo 54°46°15N. 30°47°17E.
Sortie: GX 3707 B F 752 SD
Scale: 1:11,500 Exp: 37
Date: 28/4/1944

Plate 14. Katyń, Photo (1st of pair)

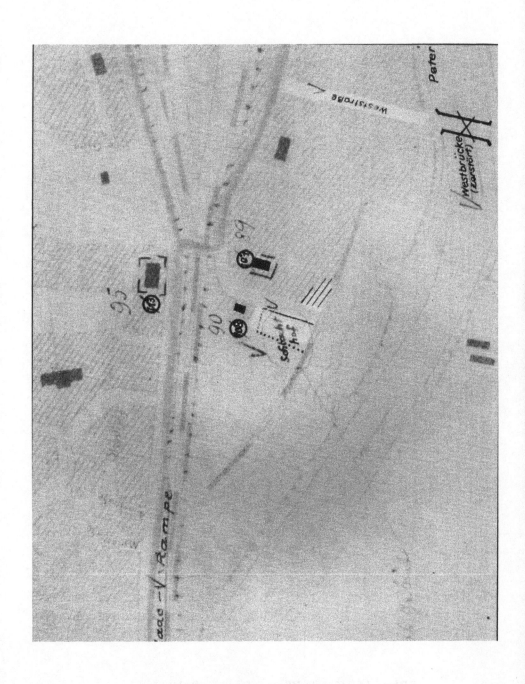

Plate 15. Katyń, Map (2nd of pair)

God's Eye: The Katyń Forest Massacre

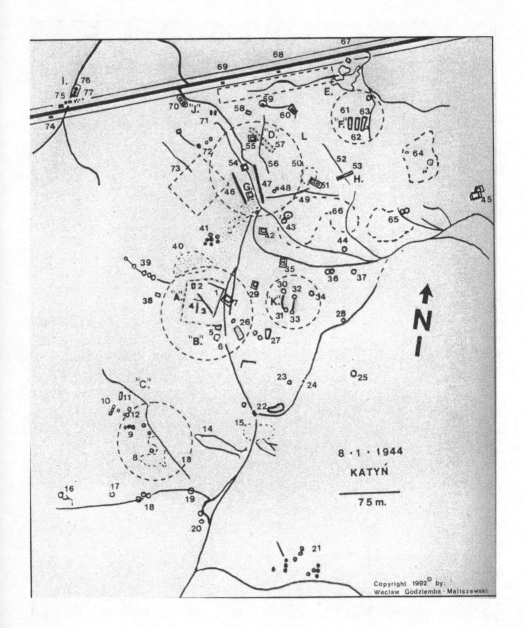

8 · 1 · 1944
KATYŃ

75 m.

Copyright 1992© by:
Waclaw Godziemba · Maliszewski

Plate 16. Katyń, Winter, January 8, 1944 map

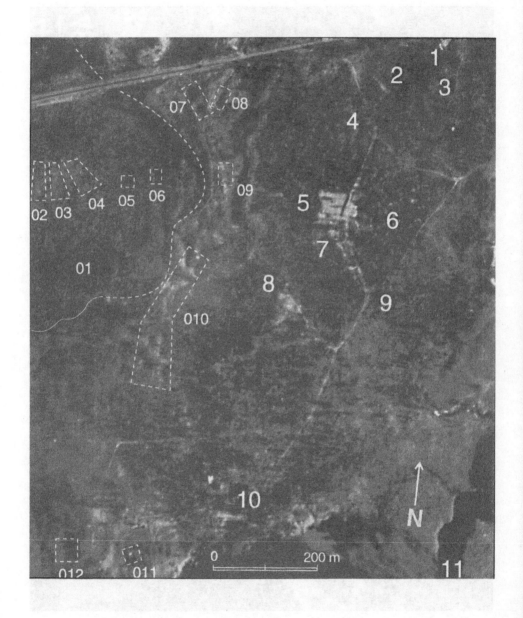

Plate 17. Katyń, Photo "36"

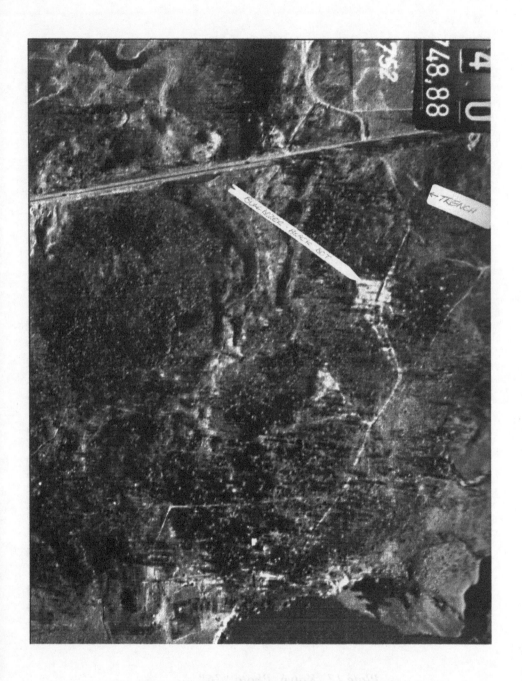

Plate 18. Katyń, Photo "40"

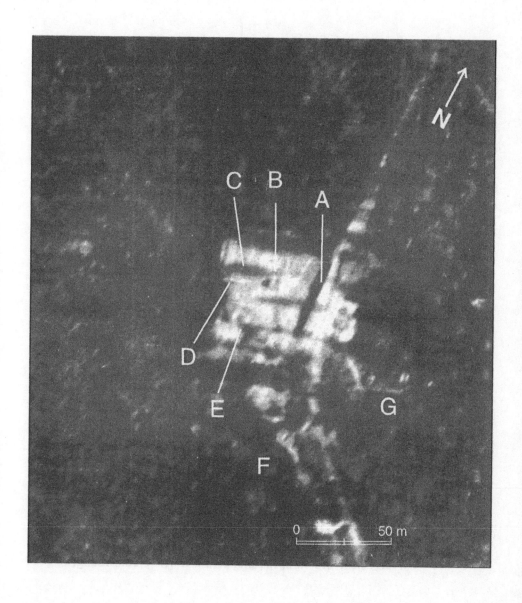

Plate 19. Katyń, Photo "39"

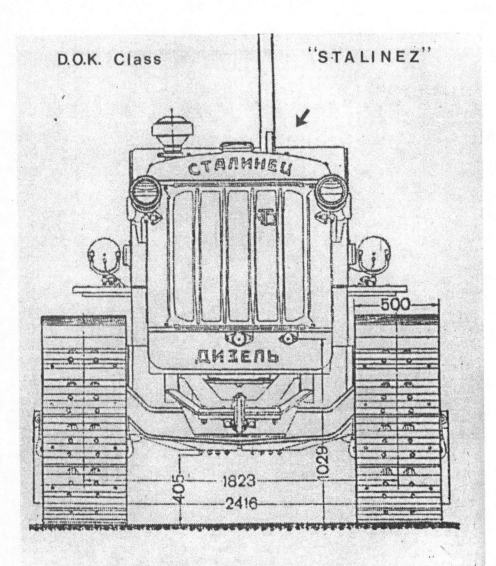

Bild 2　Vorderansicht des Raupenschleppers mit Hauptabmessungen

Plate 20. Stalinets

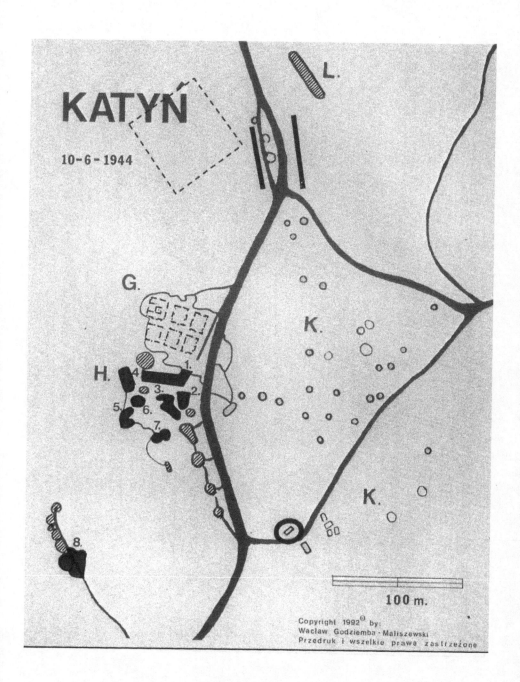

Plate 21. Katyń

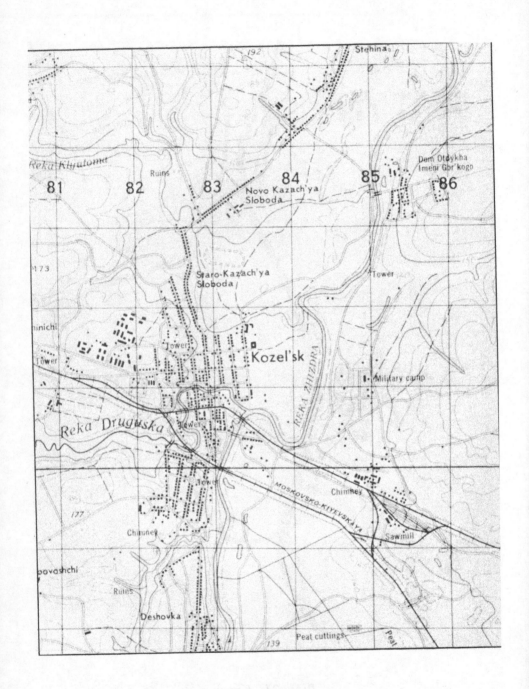

Plate 22. Katyń, Map of Kozielsk

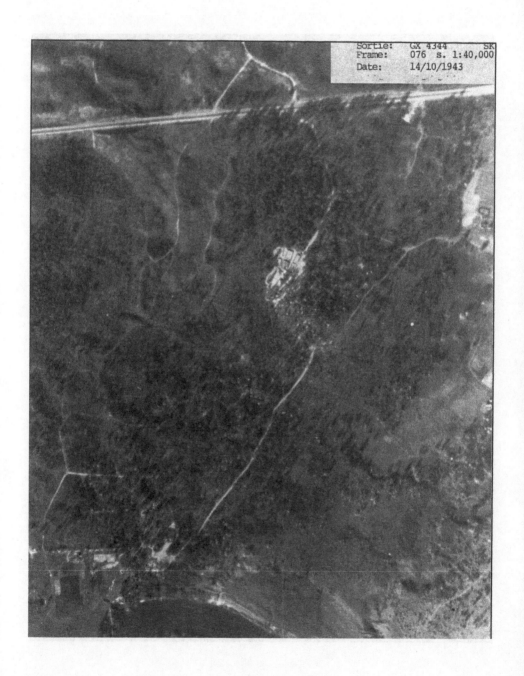

Plate 23. Katyń, Photograph

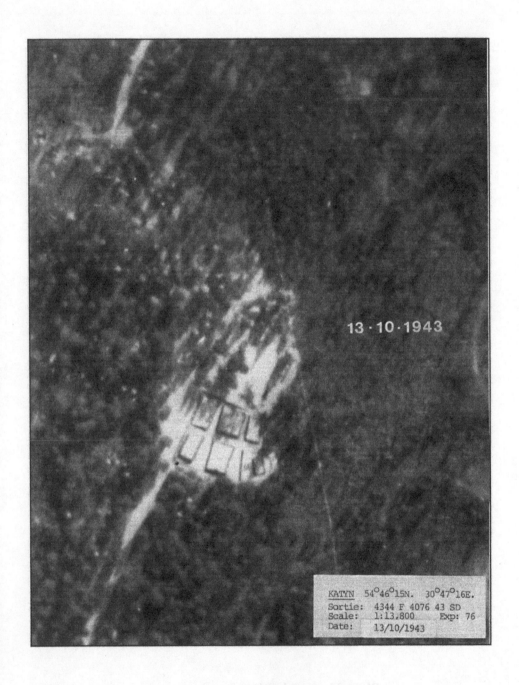

13 · 10 · 1943

KATYN 54°46°15N. 30°47°16E.
Sortie: 4344 F 4076 43 SD
Scale: 1:13,800 Exp: 76
Date: 13/10/1943

Plate 24. Katyń, Photograph In-set

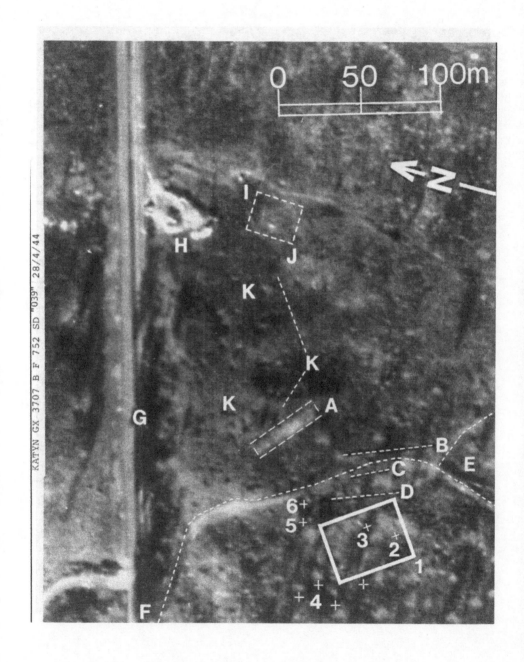

Plate 25. Katyń, Annotated photograph

Plate 26. Sanok, Molotov-Von Ribbentrop Division of Poland

Katyń Bibliography

Bibliographical Note

Useful bibliographies may be found in the following:

Godziemba-Maliszewski, Wacław, "Katyń: An Interpretation of Aerial Photographs Considered with Facts and Documents" (English and Polish) in *Fotointerpretacja w Geografii: Problemy Telegeoinformacji* (Warsaw, 1995)

Harz, Maria, "Materiały do bibliografii zbrodni Katyńskiej za okres Kwiecień 1943 - Wrzesień 1989," *Wojskowy Przegląd Historyczny*,1989, No. 4

Harz, Maria, "Materiały do bibliografii zbrodni Katyńskiej," in *Wojskowy Przegląd Historyczny* (1991), No. 2

Liebiedova, Natalia, (Liebiediewa, Natalia) *Katyń:zbrodnia przeciwko ludzkości* (Warsaw, 1997)

Paul, Allen, Katyń: *Untold Story of Stalin's Polish Massacre,* (New York, 1991)

Tarczyński, Marek, *Uwagi o stanie badan nad zbrodnią Katyńską: Problemy i zagadki,* (Warsaw, 1990)

Zawodny, Janusz K., *Katyń* (Paris, 1989)

Monographs and Documents

Abarinov, Vladimir, *The Murderers of Katyń,* (New York, 1993)

Amtliches Material zum Massenmord von Katyn, Berlin, Zentralverlag der NSDAP, Franz Eher Nachf. (1943)

Babbington-Smith, Constance, *Air Spy,* (New York, 1957)

Breitman, Richard, *Official Secrets: What the Nazis Planned, What the British and Americans Knew,* (New York, 1998)

Brookes, Andrew J., *Photo Reconnaissance,* (London, 1975)

Brugioni, Dino, *Eyeball to Eyeball: The Inside Story of the Cuban Missile Crisis,* (New York, 1990)

Charmley, John, *Grand Alliance: The Anglo-American Special Relationship, 1940–57,* (New York, 1995)

Conquest, Robert, *The Great Terror* (London, 1968)

Contract, Alexander, *The Back Room: My Life with Khrushchev and Stalin,* (Vantage Press, n.d.)

Czapski, Joseph, *The Inhuman Land*, (London, 1951)

Czapski, Joseph, "The Story of the Lost Polish Officers," in *Polish Telegraphic Agency,* Jerusalem Branch, (1943), Hoover Institution

Crime of Katyń: Facts and Documents, Polish Cultural Foundation, 3rd Ed., (1965) Davies, Norman, *God's Playground: A History of Poland,* 2 vols. (Hoover Institute Press, 1985)

Davies, Norman, *Heart of Europe: A Short History of Poland,* (New York, 1968)

Day, D. A., (ed. *et. al.*,) *Eye in the Sky: The Story of the Corona Spy Satellites,* (Smithsonian, 1998)

Dokumenty ludobójstwa, Instytut Studiów Politycznych, (*Katyń*) Polska Akademia Nauk, (Warszawa, 1992). English Edition: *Katyń: Documents of Genocide,* (eds. Wojciech Materski and Janusz K. Zawodny (Warsaw, 1993)

Facts and Documents Concerning Polish Prisoners of War Captured by the USSR during the 1939 Campaign (for private circulation only), [ed.] W. Sukiennicki, (London, February, 1946)

FitzGibbon, Louis, C. KatyÂ: A Crime Without Parallel, (London, 1971) FitzGibbon, Louis, C. *The Katyń Cover-Up* (London, 1972)

Gilbert, Martin, *Road to Victory: Winston Churchill, 1941–45* (London, 1986) Gross, Jan T., *Revolution from Abroad,* (Princeton, 1980)

Gross, Jan T., "Polish POW Camps in the Soviet Occupied Western Ukraine," in Sword, Keith (ed.) *The Soviet Takeover of the Polish Eastern Provinces, 1939–1941,* (London, 1991)

Haynes, John, Earl and Klehr, Harvey, *Venona: Decoding Soviet Espionage in America,* (Yale University Press, 1999)

Hearings of the US House Select Committee to Conduct an Investigation of the Facts, Evidence and Circumstances of the Katyń Forest Massacre, 82nd Congress, 1st and 2nd Session, 1951–52, 7 parts (US Government Printing Office, 1952) Washington, D.C.,

Heller, Mikhail and Nekrich, Aleksandr, *Utopia in Power: The History of the Soviet Union from 1917 to the Present,* (New York, 1986).

Jazborowska, Inessa *et al.*, *Katyń: Zbrodnia chroniona tajeminicą państwową* [Á Murder Protected as a State Secret], (Warsaw, 1998)

Kardell, Franz, Die Katyn Lüge:*Geschichte einer Manipulation: Fakten, Dokumente und Zeugen* (Munchen, 1991)

Karta, Rosja *a Katyń,* Mitzner. Piotr, *et al.*, (Warszawa, 1994) Komorowski, Bor, *Armia Podziemna,* (London, 1952)

Kostrzewski, Andrzej and Jankowski, Stanislaw, *Półwieczne Zbrodnie: Katyń-Twer-Charkow* (Warszawa 1995)

Krzyzanowski, Jerzy, (ed.), *Katyń w Literaturze: Międzynarodowa antologia poezji, dramatu i prozy,* (Lublin, 1995)

Laqueur, Walter, *The Dream that Failed: Reflections on the Soviet Union* (New York, 1994) Liebiedieva, Natalia, "Operation 'Unloading of Special Camps,'" in *Katinskaia Drama,* (Moscow, 1991).

Liebiedeva, Natalia, *Katyń: Zbrodnia przciwko ludzkości [Katyń: Crime*

Against Humanity], (Warsaw, 1998)

Lojek, Jerzy (Leopold Jerzewski), *Agresja z 17 Września 1939 r.*(Warszawa, 1990) Lojek, Jerzy (Leopold Jerzewski), *Dzieje Sprawy Katynia* (Białystok 1989).

Mackiewicz, Joseph, *The Katyń Wood Murders*, (London, 1951)

Mackiewicz, Józef, *Katyń: Zbrodnia bez Sądu i Kary* (Warszawa, 1997)

Maliszewska, Czesława, testimony taken by the underground Polish Army (A.K.), Poland, Ambasada (USSR) n.d. Box 46, file 294, *Hoover Institution*

Maliszewski, Wacław-Godziemba, "Interpretacja zdjęć lotniczych Katynia w świetle dokumentów i zeznań świadków," [Katyń: An Interpretation of Aerial Photographs Considered with Facts and Documents] in Fotointerpretacja w Geografii: Problemy Telegeoinformacji (Special volume) 25, (Warsaw, 1996)

Mikke, Stanisław, *"Śpij Mężny" w Katyniu, Charkowie i Miednoje*,(Warszawa, 1998),(Warszawa, 1998)

Nieciunski, Witold, *Przemoc i Masowe Zbrodnie Hitleryzmu i Stalinizmu* [Violence and Mass Murder of Hitlerism and Stalinism], (Warsaw, 1998)

Novgorod-Seversky G. [Rev. J. Sergeyenkov] "Chudovishchnye bol'shevitskie Zlodeianiiya v Katynskom Lesu, pod Smolenskom i v Gorode Vinitse ... n.p. [Monstrous Bolshevik Crimes in Katyń Woods near Smolensk and in the Town of Vinnitza], typescript (*Library of Congress*, 1947)

Paul, Allen, *Katyń: The Untold Story of Stalin's Polish Massacre* (New York, 1991) Pipes, Richard, *A Concise History of the Russian Revolution* (New York, 1995)

Poirier, Robert G., *The Katyń Enigma: New Evidence in a 40–Year Riddle* (CIA document, 1981)

Radzinsky, Edvard, *The Last Tsar* (New York, 1992)

Radzinsky, Edvard, *Stalin: His Life, His Death* (New York, 1996)

Read, Anthony & Fisher, David, *The Deadly Embrace: Hitler, Stalin and the Nazi-Soviet Pact, 1939–1941,* (New York, 1988)

Remnick, David, *Lenin's Tomb* (New York, 1993) Rossi, Jacques, *The Gulag Handbook* (New York, 1989)

Schochet, Simon, "An Attempt to Identify the Polish Jewish Officers who were Killed in Katyń," *Working Papers in Holocaust Studies*, No. 2, (New York, 1988)

Schochet, Simon, "Polish Jewish Officers who were Killed in Katyń: An Ongoing Investigation in Light of Documents Recently Released by the USSR," in *The Holocaust in the Soviet Union: Studies and Sources on the Destruction of the Jews in Nazi-Occupied Territories of the USSR, 1941, 1945,* (New York, 1993), 237–247

Siemaszko, S. Z., "The Mass Deportation of the Polish Population to the USSR, 1940–41," in Sword, K., McMillan (eds.) *The Soviet Take-Over of the Polish Eastern Provinces, 1939– 1941* (London, 1993)

Slowes, Solomon, *The Road to Katyń: A Soldier's Story(ed) Władysław Bartoszewski* (Oxford, 1992)

Smith, Hedrick, *The New Russians* (New York, 1976)

Stanley, Roy M., *World War II Photo Intelligence* (London, 1981)

Sudoplatov, Pavel, *Special Tasks: The Memoirs of an Unwanted Witness—a Soviet Spymaster* (New York, 1994)

Swianiewicz, Stanisław, W Cieniu Katynia (Paris, 1986)

Szapiro, Pawel, Wojna Śydowsko-niemiecka: Polska prasa konspiracyjna 1943–1944 o powstaniu w getcie Warszawy (London, 1992)

Thompson, Eva M., "The Katyń: Massacre and the Warsaw Ghetto Uprising in the Soviet- Nazi Propaganda War," in *World War II and the Soviet People* (St. Martin's Press, 1994)

Tucholski, Jędrzej, *Mord w Katyniu* (Warsaw, 1991)

Viatteau-Kwiatkowska, Alexandra, *Katyń: 1940–1943, L'armée polonaise assassinée* (Brussels, 1982)

Volgokonov, Dimitri, *Autopsy for an Empire: The Seven Leaders Who Built the Soviet Regime* (New York, 1998)

Wałęsa, Lech, *The Struggle and the Triumph: An Autobiography* (New York 1992)

Weinstein, Allen and Vassiliev, Alexander, *The Haunted Wood* (New York, 1999)

Zawodny, Janusz, *Death in the Forest: The Story of the Katyń Forest Massacre* (Notre Dame, 1962)

Zawodny, Janusz, *Pamiętniki Znalezione Katyniu* (Paris, 1989)

Zawodny, Janusz, *Katyń*, Editions Spotkania (Paris, 1989)

Periodicals

Czapski, Joseph, "In a Cruel Land," *Bostonia* (Winter, 1992)

Chlebowski, Cezary, "Luftwaffe nad Katyniem," *Mówią Wieki* (1990)

Dobbs, Michael, "Gorbachev's Veracity Challenged," *Washington Post* (January, 1993) Erdheim, Stuart G., "Could the Allies Have Bombed Auschwitz-Birkenau," *Genocide and Holocaust Studies,* VII, 2, 129–179 (1997)

Fox, Frank, "Visiting the Deceased: Poland's All Saints' Celebration," *The World & I,* (November, 1991)

Fox, Frank "Jewish Victims of the *Katyń,* Massacre," *East European Jewish Affairs,* 23, 1 (1993)

Fox, John P., "Der Fall Katyn und die Propaganda des N-S Regimes," in *Vierteljahrshefte fur Zeitgeschichte,* III, (1982), 462–499

Gazeta Policyjna, Numer Specjalny Historyczny (1992)

Grzelak, Czesław, "Agresja Związku Sowieckiego na Polskę we Wrześniu 1939 r." *Zbrodnia Katyńska: Droga do Prawdy, Zeszyty Katyńskie* (Warszawa, 1992)

Jaczynski, Stanisław, "Obozy Jenieckie w ZSRR," Zeszyty Katyńskie, IX

Jankowski, Stanisław, "Pięć Cmentarzy pod Smoleńskiem," *Przegląd Pol-*

*ski,*November 17 (1994)

Jankowski, Stanisław,, "Spacerem do Katyńskiego Lasu ...," *Przegląd Polski* (April 21, 1994)

Jankowski, Stanisław, "Odnaleziono Katyńskie Dokumenty," *Przegląd Polski* (May 9, 1991)

Janowski, E., "Katyńska nekropolia," *Wojskowy Przegląd Historyczny* (1990) Warszawa

Janowski, E., "Katyńska nekropolia," *Wojskowy Przegląd Historyczny* (1990) Warszawa

Juracek, Judy, A., *Surfaces: Visual Research for Artists, Architects and Designers* (New York, 1996)

Kalicki, W., "Waszych tysiace, naszych miliony," *Gazeta Wyborcza,* (1994) 27 Września Kolanowski, B. Lojek, P. Sawicki, Z. and Wiśniowski, J., "Prace polskich Geodetów wojskowych w Katyniu i Miednoje,"(1992) 4, *Wojskowy Przegląd Historyczny*

Kozlinski, Z., "Operacja Wernyhora," Magazyn Świąteczny (1992) 52, Warszawa Legris, Michel, "Katyń: le jour ou les Russes avourront," in L'Express (1990)

Levy, Richard, H., "The Bombing of Auschwitz Revisited: A Critical Analysis," *Holocaust and Genocide Studies*, X, 3, 267–298 (1996)

Levitski, Andre "Crimes impunis de Katyń et Vinnytsia," in *L'Etat Européen* (July-September 1988)

Liebiedeva, Natalia, "The Katyń Tragedy," *International Affairs*, No. 7 Moscow (July 1990)

Lojek, Piotr, "Zdjęcia Lotnicze Lasu Katyńskiego," *Wojskowy Przegląd Historyczny* (1991)

Lojek, Piotr, "Wykopy sondażowe i badania terenowe w Lesie Katyńskim 1991–1992," Wojskowy Przegląd Historyczny

Madon-Mitzner, Katarzyna, , "Tydzień Śmierci", *Karta* (Warszawa, 1992)

Mielecki, Zbigniew, "Dowody Zbrodni Katyńskiej Odnalezione w Polsce w Latach 1991– 1992," Zbrodnia Katyńska: Droga do Prawdy (Ed). Mark Tarczyński, Zeszyty Katyńskie, (Warszawa, 1992)

Morawski, Jerzy, "Czy Pan Zabijał??" *Spotkania,* (1991)

Mycke-Dominko, M., "Zmiany na obszarze Lasu Katyńskiego w latach 1942–1944 na podstawie zdjęć lotniczych," *Fotointerpretacja w Geografii,* 22 (1992) Warszawa. Nadolski, Andrzej and Glosek, Marian, "Archeologiczne Aspekty Akcji Badawczej w Charkhowie i w Miednoje," in *Zbrodnia Katyńska,* 25, (1991)

Nasilkowski, Władysław Dr., "Zeszyty Naukowe," Katedra i Zakład Medycyny Sńdowej, *Śląskiej Akademii Medycznej,* Nr. 5, (1996)

Pazniak, Zianon and Shmyhalou Yauhen, "Kurapaty - The Road to Death," *Literatura i Macvo* (1988)

Pieńkowski, Tadeusz, "Doły Śmierci i Cmentarze Polskich Oficerów w Lesie Katyńskim," in *Wojskowy Przegląd Historyczny,* XXXIV, No. 4, (1989)

Pieńkowski, Tadeusz, "Cmentarze w Lesie Katyńskim," *Lambinowicki Rocznik Muzealny,* 15 (1992) Opole

Pieńkowski, Tadeusz, "Wykopy sondażowe w Lesie Katyńskim," (1992) *Biuletyn Katyński* (1) Kraków

Pieńkowski,Tadeusz,"Wykorzystanie interpretacji zdjęć lotniczych do badań terenu lasu Katyńskiego," *Fotointerpretacja w Geografii* (1993) 23, Warszawa

Pieńkowski,Tadeusz,""Losy Polskich JeÂców Wojennych Wyprow- adzanych Pojedyńczo lub w Niewielkich Grupach od Paździer- nika 1939 do Marca 1940 Roku z Obozów NKWD w Kozielsku, Starobielsku i Ostaszkowie," *Studia Dziejów Rosji i Europy Środ- kowo-Wschodniej,*XXXII, (Warszawa, 1997)

Rodziewicz, S., "Sprawozdanie z prac ekshumacyjnych w Charkow- ie, Miednoje, i Lesie Katyńskim," *Wojskowy Przegląd Historyczny* (1992) 2, Warszawa

Rurarz, Zdzisįaw, "Nieznane zdjęcia cmentarza Katyńskiego," *Kontakt,* No. 7, (1988)

Schochet, Simon, "Próba Określenia Tożsamości Polskich Oficerów Po- chodzenia Żydowskiego - Jeńców Obozów Sowieckich," *Przegląd Polski* (New York, November 21, 1990)

Schochet, Simon, "Polscy oficerowie pochodzenia Żydowskiego - Jeńcy Katynia na tle walk o niepodległość (Próba Identifikacji)" *Instytut Piłsudzkiego,* XXI (1988), pp. 152–165

Siemaszko, Z. S., "Ujawnione dokumenty Katyńskie—dokumenty, ale jakie?" (1993), *Zeszyty Historyczne,* 11, Paris

Siemaszko, Z. S., "Brytyjczycy Zaangańowani w Sprawy Polskie," *Zeszyty Historyczne* (Paris, 1995)

Tarczyński, Marek, "Uwagi o Stanie Badań nad Zbrodnią Katyńską," *Zeszyty Katyńskie,* No. 1 (Warszawa, 1990)

Tarczyński, Marek, "Listy Wywozkowe z Obozu w Ostaszkowie," *Wojs- kowy Przegląd Historyczny,* No. 2, (1991)

Tarczyński, Marek (ed), *Zbrodnia Katyńska: Droga do Prawdy; Historia, Archeologia, Kriminalistyka, Polityka, Zeszyty Katyńskie* (Warszawa, 1992).

Tarczyński, Marek, "Dokumenty Katyńskie," *Wojskowy Przegląd Histo- ryczny,* XXXV, Nos. 3–4, (1990)

Tarczyński, Marek, "Soviet War Crimes Against Poland During the Sec- ond World War and its Aftermath," *The Polish Review,* XLIV, (1999), 183–211

Todorov, Tzvetan, *Facing the Extreme: Moral Life in the Concentration Camps* (New York, 1996)

Tolz, Vera, "The Katyń Documents and the CPSU Hearings," *Europe/Ra- dio Liberty,* I, No.44, (Nov. 6, 1992)

Valkenier, Elizabeth, "'Glasnost,' and Filling in 'Blank Spots,' in the His- tory of Polish-Soviet Relations, 1997–1990," *The Polish Review,* XXXVI, 3, pp. 247–268.

Vinton, Louisa, "The Katyń Documents," *Radio Free Europe/Radio Liberty* II, No. 4 (January 22, 1993)

Watson, George, "Rehearsal for the Holocaust," *Commentary,* June 1981

Zawodny, Janusz, "Sprawa Katyńska w Polityce Amerykańskiej," *Wojskowy Przegląd Historyczny*, XXXVI, No. 1 (Warszawa, 1991), pp. 279–283

Zawodny, Janusz, "Katyń po 50 latach: Bilans i gruba kreska," *Przegląd Polski, Nowy Dziennik*, (April, 1, 1993) New York

Zawodny, Janusz, "Waszyngton-Moskwa kulisy roku 1944," *Tygodnik Powszechny*, 49, Kraków

Zhavoronko, Gennady, "Katyń: What Lies Behind its Silence?" *(Moscow News*, 1990)

Newspapers

Daily Telegraph	*East-West Digest*	*Evening Standard*
Financial Times	*Gazeta Wyborcza*	*The Guardian*
Independent Times	*Moscow News*	*Novoe Russkoe Slovo*
Nowy Dziennik	*Nowy PrzeglÁd*	*Polska Zbrojna*
PrzeglÁd Polski	*Rzeczpospolita*	*Soviet War News*
Spotkania	*The New York Times*	*The Washington Post*
Tagesspiegel	*Tygodnik Powszechny*	*Tygodnik SolidarnoÍÍ*
Warsaw Voice	*Wprost*	*Życie Warszawy*

INDEX

Jozef Pilsudski
Hero of Poland

Antoni Lenkiewicz

The Pulaski Reader

Compiled and translated by
Peter J. Obst

The Polish Army
in 1939

Vincent W. Rospond

Case White
The German Army in the
Polish Campaign -
September 1939

William Russ

Frank Fox came to the United States from his native Poland in 1937. During the war he served in Military Government in France and Germany. He holds a doctorate in history from University of Delaware and taught at Temple University and West Chester University. He was the recipient of research grants from the American Philosophical Society and the Eleutherian Mills (DuPont) Foundation.

His writings have appeared in a variety of scholarly and popular publications, including *Jahrbiicher far Geschichte Osteuropas, French Historical Studies, Pennsylvania Magazine of History and Biography, East European Jewish Affairs, New York magazine, PRINT, The World & I,* and *Affiche.* He contributed a chapter on Polish poster art for Tony Fusco's reference work *Posters* (New York, 1994) His essay "Poland and the American West" has been published by Washington State University Press in Western Amerykanski, a catalog for the 1999 exhibition at the Gene Autry Museum of Western Heritage. He has edited and translated from Polish a wartime memoir, *Am I a Murderer? Testament of a Jewish Ghetto Policeman*, published in 1996 by Harper/Collins,and has written poetry for a cantata based on that work which premiered in Philadelphia in 1997. In 1998 he was invited to lecture at the National Museum in Warsaw on the occasion marking the 30th anniversary of the Polish Poster Museum.

Rafal Olbinski, one of the premier illustrators of our times, is an artist whose style uniquely combines realism and surrealism. Resident in New York since his arrival from Poland in 1981, he has been the recipient of over a hundred awards. Recently, his poster was chosen to represent the current New York School of Visual Arts show "The Carousel" at New York's Grand Central Station, and has been seen by thousands daily. His illustrations have appeared in such publications as *Der Spiegel, Newsweek, Ttme, Atlantic Monthly, Playboy, New Yorker; Fortune, Omni,* and *Business Week*. His work is in the collections of the Library of Congress, Deutsche Bank, Carnegie Foundation and in many private and corporate collections. In 1994, he was the recipient of the Oscar for the "World's Most Memorable Poster", and awarded the prestigious Savignac Prize. The following year his poster was chosen to represent the City of New York and in 1996, he received an award from the Society of illustrators for the Best Poster. He has had numerous one-man shows in America and abroad and his opera posters have been commissioned by the New York, San Francisco, Cincinnati, and Philadelphia opera companies.